Journal of Consciousness Studies
controversies in science & the humanities

Vol. 7, No. 8–9, August/September 2000

SPECIAL FEATURE ON 'ART AND THE BRAIN', PART II
Edited by Joseph A. Goguen and Erik Myin

I: Commentaries on the paper 'The Science of Art' by V.S. Ramachandran and William Hirstein

II: Papers delivered at the Cognitive Science Conference on Perception, Consciousness, and Art Vrije Universiteit Brussel, 17–19 May, 1999

Continued overleaf

Cover illustration: Claire Harper

Published in the UK and USA by Imprint Academic, PO Box 1, Thorverton EX5 5YX, UK
World Copyright © Imprint Academic, 2000

JCS is indexed and abstracted in *PsycINFO*® and *The Philosopher's Index*.

CONTENTS (CONTINUED)

III: Further Refereed Papers and Reviews

Note: Artworks on pages 2, 16, 28, 36, 56, 86, 98, 112, 136 and 156 originally were submitted to the consciousness postcard art exhibit held in conjunction with the 'Brain and Self' conference in Copenhagen and Elsinore, Denmark, August 1997. Cindi Laukes was the curator. A catalog, *Elusive Mind*, is available by contacting the Center for Consciousness Studies, Department of Psychology, University of Arizona, Tucson AZ 85721 or by e-mail at *center@u.arizona.edu.*

ABOUT AUTHORS

Jennifer Church (Department of Philosophy, Vassar College, Poughkeepsie, NY 12601, USA.) is professor of philosophy at Vassar College. She has published articles on consciousness, emotion, imagination, rationality and irrationality, self-ownership, Kant and Freud. A forthcoming book is entitled *The Difference that Consciousness Makes*.

Rafael De Clercq (Centre for Logic, Institute of Philosophy, Kard. Mercierplein 2, 3000 Leuven, Belgium.) studied philosophy in Leuven and London, and is currently a research assistant of the Fund for Scientific Research — Flanders (Belgium).

Glenn English (4045 Shell Road, Sarasota, FL 34242-1139, USA.) is a multimedia artist residing in Sarasota Florida. He is cofounder of the Art With Brain in Mind discussion list on the World Wide Web. He has an MFA from the University of Pennsylvania.

Joseph A. Goguen (Department of Computer Science University of California at San Diego, La Jolla, CA 92093-0114, USA. *Email: goguen@cs.ucsd.edu*) is a Professor of computer science and engineering and Director of the Meaning and Computation Lab at UCSD. He graduated from Harvard and received his PhD from UC Berkeley. From 1988 to 1996, he was the Professor of Computing Science at Oxford University, following ten years as a Senior Staff Scientist at SRI International and a Senior Member of CSLI at Stanford University. He has also taught at Berkeley, Chicago, and UCLA, and in 1999, was a Fellow of the Japan Society for the Promotion of Science.

E.H. Gombrich (19, Briardale Gardens, London NW3 7PN, UK.)

Art and the Brain II

Investigations ... *ence of Art*

edited by
Joseph A. Goguen
and
Erik Myin

ISBN 0907845126

IMPRINT ACADEMIC

David Lapp

C.L. Hardin (Department of Philosophy, Syracuse University, Syracuse, NY 13244, USA.)

Amy Ione (PO Box 12748, Berkeley, CA 94712-3748 USA. *Email: ione@Lmi.net*). Best known as an international lecturer, a painter, and a writer, Amy Ione has long explored the nature of creativity, cognition, and areas of convergence in innovative art and science practices. Her academic studies have been widely published in the books and journals of several disciplines, including an invited contribution to the *Encyclopedia of Creativity* (Academic Press, 1999). Her artwork has been commissioned by the City of San Francisco, exhibited internationally, and is found in many collections. More information about her art and academic research can be found at http://users.Lmi.net/ione.

David Jonas (University of New South Wales, Sydney, 2052, Australia) is a computer manager at the University of New South Wales, specializing in image processing.

Jennifer Anne McMahon (Building 5, Division of Communication and Education, University of Canberra, ACT 2601, Australia. *Email: jennym@comedu.canberra.edu.au*) took a PhD in philosophy from the Australian National University in 1977. She also has degrees in fine art and in arts education, and has worked and exhibited as a visual artist. She has published articles on the perceptual constraints underpinning and defining aesthetic perception and is currently completing a book on beauty and cognitive science entitled *Aesthetics and Cognition in Visual Beauty*. She teaches arts education at the University of Canberra, Australia.

Adam P. Micolich (Physics Department, University of Oregon, Eugene, OR 97403-1274, USA.) is a post-doctoral researcher at the University of Oregon specializing in the fractal analysis of patterns.

Erik Myin (Centrum voor Empirische Epistemologie, Vrije Universiteit, Brussel, Pleinlaan 2, B1050 Brussel, Belgie. *Email: emyin@vub.ac.be*) is currently researcher at the Department of Philosophy and the Artificial Intelligence Laboratory at the Free University of Brussels (VUB) where he obtained a PhD in Philosophy. In1994/95 he was a visiting fellow at the University of California, San Diego. His publications are on cognitive science oriented philosophy of mind. He is an amateur sculptor. His homepage is athttp://homepages.vub.ac.be/~emyin

Alva Noë (Department of Philosophy, UCSC, Santa Cruz, CA 95064, USA.) is a philosopher at the University of California at Santa Cruz. He received a PhD in philosophy from Harvard University and a BPhil from Oxford University, and he has been a Research Associate of the Center for Cognitive Studies at Tufts University. His published articles cover topics in the philosophy of perception, philosophy of mind, and other areas. He is currently collaborating with Kevin O'Regan on the development of a sensorimotor contingency theory of perceptual consciousness. He is a co-editor with Evan Thompson of *Vision and Mind: Selected Readings in the Philosophy of Perception* (MIT Press, forthcoming), and he is editing a special issue of this journal to be entitled, *Is the Visual World a Grand Illusion?*

Vilayanur S. Ramachandran (Center For Brain and Cognition, University of California, San Diego, La Jolla, CA 92093-0109, USA.) is director of the Center for Brain and Cognition, and professor of neurosciences and psychology at the University of California, San Diego, and adjunct professor of biology at the Salk Institute. Having trained as a physician and obtained an MD from Stanley Medical College, he received a PhD from Cam-

bridge where he was elected a senior Rouse Ball scholar. After early work on visual perception, Ramachandran has become best known for his work in neurology. He is the recipient of many honours and awards.

Robert Solso (Department of Psychology, University of Nevada, Reno, NV 89557, USA. *Email: Solso@scs.unr.edu*) has been interested in cognition and the visual arts and, in the paper which appears here, presents a new way to examine artistic performance and consciousness. His previous work have focused on prototype formation, facial perception and cognitive psychology. He is currently director of the cognitive laboratory at the University of Nevada and past president of the Western Psychological Association.

Richard P. Taylor (Physics Department, University of Oregon, Eugene, OR 97403-1274, USA.) is a Professor of Physics at the University of Oregon, where he leads a research team investigating fractals and chaos in a diverse range of physical systems. In addition he previously trained as a painter and has a degree in Art Theory. Trained in both art and science, one of Taylor's aims is to encourage interactions between science, art and psychology.

Donnya Wheelwell is the *nom de guerre* of a science professional who wishes to remain anonymous to avoid the scorn of her colleagues. She loves language and sports, especially feminist poetry, discourse analysis, running and volleyball.

JCS-Online

Change of listserve address

JCS-Online is a general discussion group on consciousness studies from a broad, multi-disciplinary perspective. The discussion, based around the articles in JCS, is carefully moderated and the number of postings restricted maximum six per day).

Owing to pressure on space in the journal, book reviews, conference reports, short papers and other topical material are posted first on the online service, appearing in print as and when space permits.

Owing to technical difficulties with our previous listserve provider, we have changed to egroups.com. **This means all existing subscribers will need to resubscribe.**

To participate or listen in to the discussion, send a blank email to jcs-online-subscribe@egroups.com.

Details at http://www.egroups.com/group/jcs-online

All enquiries to the moderator, Len Maurer, at
len@maurer.demon.co.uk

Joseph A. Goguen

What Is Art?

Editorial Introduction

What is art? What is beauty? How do they relate? Where does consciousness come in? What about truth? And can science help us with issues of this kind? Because such questions go to the very heart of current conflicts about Western value systems, they are unlikely to receive definitive answers. But they are still very much worth exploring — which is precisely the purpose of this collection of papers, with particular attention to the relationships between art and science.

I: What is Art?

The very last essay of Paul Gauguin was on the importance of the question 'What is art?' A trip to the dictionary (noting also cousin words such as 'artifact', 'artisan', 'artificial' and 'article') may suggest that 'art' refers to something skilfully constructed by human artists. However, the artists themselves have been pushing the boundaries of any such definition, challenging our preconceptions, and leaving most philosophers, psychologists and critics well behind — to say nothing of the general public.

Let us first consider 'found art', also called 'readymade' art, which challenges the role of the artist as the constructor of art. An especially famous example is Duchamp's urinal, the submission of which to the 1917 New York Exhibition of the Society of Independent Artists generated considerable controversy, resulting in its exclusion by the society's board of directors. This object has a pleasingly smooth form, which follows its function in a most logical way. Presumably it was more the function that offended the bourgeois sensibilities of the board than the form itself, or the lightened role of the artist. Some other examples are Warhol's Campbell soup cans, Damien Hirst's dead animals floating in large tanks of formaldehyde ('Mother and Child, Divided', a dissected cow and her calf, winner of the 1995 Turner Prize — continuing the tradition of upsetting the bourgeoisie, but enlarging the role of the artist to include the comissioning of tanks), and the exhibition of various configurations of objects like rocks, trees, and ropes (many artists have followed this line, e.g., Barry Flanagan).

Journal of Consciousness Studies, **7**, No. 8–9, 2000, pp. 7–15

Environmental art pushes the definitional boundaries by placing art outside the museum, in a (more) natural environment. Well known examples include earthworks, e.g., by Robert Smithson, and wrapped buildings by Christos. Conceptual art challenges the materiality of art, by using physical forms that may themselves be relatively prosaic or even boring, such as hand-lettered posterboards, perhaps to suggest a concept, or a reconceptualization of an existing situation. In addition, there are traditions, such as performance art and body art, that give new roles to the artist, e.g., as part of the artwork, and also challenge current ideas about the boundaries among various art forms, e.g., between theatre and visual art, or between music, literature and theatre; current performance traditions in rock music do the same (e.g., Beck). We might also consider high fashion, interactive video games, graffiti, antique furniture, websites, etc.

It should not be forgotten that non-Western perspectives can be very different. For example, traditional societies do not distinguish between art and craft, and may not have designated specialists who regularly and exclusively perform such tasks. Moreover, art and craft are often fused with religion.[1] In Japan, the arrangement of rocks, plants and water has reached an extremely sophisticated level in the construction and maintenance (often over hundreds of years) of formal gardens; the traditions of arranging flowers ('ikebana') and of cultivating miniature trees ('bonsai') are also relevant, and today have a considerable popularity in the West. Another form of distancing between art and artist comes from the use of random operations. In literature, this was made famous by William S. Burroughs' use of 'cutups' in his novels (*Naked Lunch*, etc.), following the use of a similar technique in art by Brian Gyson. John Cage also used chance operations in his musical compositions; he particularly favoured variants of the methods used in *I Ching* divinations. In such cases, the role of the artist becomes more like that of the critic: to evaluate and then select some results as superior to others.

From all this, we should conclude that social context plays a key role in determining what art is, or even if it is. Clearly the Western tradition is evolving, to the point where anything can be presented as an art object, and where the role of the artist is subject to wide variation. In addition, evidence from other cultures shows that the very notion of art is culture-dependent, so that what appears in one tradition as an aid to meditation, or an indication of rulership, or an aid to drinking water, may appear in a museum case in another tradition.

II: What is Beauty?

Beauty is often taken to be the measure of quality for art. In the Enlightenment tradition, epitomized by Kant, the beauty of objects is judged in absolute terms by rational autonomous subjects. Insofar as this view fails to distinguish between art and nature, it fits well with the dissolution of this boundary in contemporary art, and more generally, with the dissolution of the boundary between the natural and the artificial (or virtual) in post modernism. Moreover, it neatly disposes of the

[1] Two examples are icons in the Eastern Orthodox Christian tradition, and Tibetan thanka paintings, both of which are (ideally) produced in a spirit of deep devotion.

problem of the cultural relativity of the nature of art, by rendering it irrelevant: everything is art, and everything is subject to judgements of beauty in exactly the same way. However, the Enlightenment view is burdened with other difficulties, many of which can be seen to arise from its presupposition of mind–body and subject–object dualities. Such issues are of course by now very familiar in consciousness studies.

Perhaps the simplest theory, and one which was widely held until recently, is that art is beautiful to the extent that it imitates nature; we might call this the correspondence theory of beauty.[2] This provides (or appears to provide) a simple rational criterion. But unfortunately, this criterion depends on not only a separation between subject and object, but also between art and nature,[3] and therefore it falls prey to the previously discussed problem that the very notion of art is culturally relative, rather than being a universal *a priori* given. In fact, and perhaps even more disastrously for this theory, it is also unclear what counts as nature, given triumphs of modern science and technology such as the rise of the virtual (e.g., special effects in movies), the strange products of bioengineering, and the ever slowly dawning realization that humans are natural. It is also evident that this theory fails to account for much of contemporary art, which is often radically non-representational. And finally, it is not very clear that there can exist any very good rational basis for judging how well art works imitate nature; it is easy to cite many problematic cases (e.g., unicorns, or the work of landscape, bonsai, and ikebana artists). But perhaps we are beating a dead horse here; so let us move on.

Another unsatisfactory approach to beauty attempts to measure it by the viewer's emotional response. Let's call this the 'I know what I like' approach. There is little hope for such an approach in its naive form, which is purely subjective. However, there are more sophisticated forms, in which scientific instruments are used to measure the response, and large datasets are collected, in order to average out individual variations and eliminate outliers. As a result of this methodology, conclusions will tend towards primitive factors that are valid for the lowest common denominator of the sampled population. Also, like the correspondence theory of beauty, this approach presupposes a strong split between subject and object. On the positive side, least common denominator results might include many interesting and important low level perceptual phenomena. On the negative side, the limitation to relatively crude response measures will exclude all of the more complex forms of judgement that are built on top of mere perception, and that seem so important for understanding great art. Although such approaches could produce useful guidelines for several aspects of design, they probably have much less value for fine art. On the other hand, their results should be a significant input to any mature theory of art, and would deserve the same admiration for stability and reliability that is associated with the best fruits of the scientific method.

[2] After the correspondence theory of truth in semantics, with which there is a close analogy. This theory is well illustrated by many eighteenth century English estates, whose large gardens and parks are carefully landscaped to achieve a casual 'natural' beauty, which seamlessly merges into the surrounding countryside.

[3] Notice that without this distinction, everything is natural and thus everything is already maximally beautiful.

The Romantics had an entirely different point of view. As John Keats famously wrote (in the Spring of 1819) in his 'Ode on a Grecian Urn':

> When old age shall this generation waste,
> Thou shalt remain, in midst of other woe
> Than ours, a friend to man, to whom thou say'st
> 'Beauty is truth, truth beauty' — that is all
> Ye know on earth, and all ye need to know.

Although this clearly echoes Plato,[4] I presume that Keats intends the Romantic notion of 'artistic truth', which generally meant some kind of emotional truth, i.e., an accurate expression of the feelings of the artist, rather than truth in some philosophical or scientific sense, such as corespondence to (some notion of) reality.

Heidegger has gone more deeply into Kant's philosophy of art than did Kant himself or his followers. Kant's notion of the absoluteness of art is explicated by Heidegger as follows (Kockelmans, 1985):[5]

> ... the beautiful for Kant is that which never can be considered in function of something else (at least as long as it is taken as the beautiful). ... When all such interest is suppressed, the object comes to the fore as pure object. Such coming forth into appearance is the beautiful.
>
> Thus art is for Kant the beautiful presentation of some form, and through it, the presentation of an aesthetic idea which lies beyond the realm of the concepts and the categories. Through this beautiful presentation of an aesthetic idea the artist infinitely expands a given concept and, thus, encourages the free play of our mental faculties. This implies that art really lies beyond the realm of reason and that the beautiful is conceptually incomprehensible.

This theory of the beautiful as the pure presentation of form has much in common with the romantic view. However we should carefully note that it excludes the role of the artist, the cultural context of the art object, and the preparation of the viewer, all of which seem crucial.

Heidegger's own theory of art has much in common with (his version of) that of Kant, but he takes Kant's ideas further, drawing also on his vitalizing reinterpretations of Nietzsche and Hegel, and of course taking a phenomenological perspective; perhaps surprisingly, Keats' poem again resonates, although it requires a very different interpretation. The following quotes are from Heidegger (1960):

> Art is . . . the becoming and happening of truth.
>
> *Beauty is one way in which truth appears as unconcealedness.*
>
> Truth is the unconcealedness of that which is as something that is. Truth is the truth of being. Beauty does not occur alongside and apart from this truth. When truth sets itself into the work [of art], [beauty] appears. Appearance — as this being of truth in

[4] Discussions of relations among of the good, the true, and the beautiful go back (at least) to Plato (−360), in the *Republic* and various dialogues. This theme has been echoed, expounded, varied, and developed through the ages, e.g., by Aristotle, Cicero, Saint Augustine, Boethius, Aquinas and Kant, and it continues into the present, where these three are generally taken to be the quite distinct domains of ethics, logic and aesthetics, respectively.

[5] Although we cite a somewhat dubious secondary source, it is used only as a convenient repository for quotations.

the work and as work — is beauty. Thus the beautiful belongs to the advent of truth, truth's taking of its place. It does not exist merely relative to pleasure and purely as its object.

Heidegger's notion of 'truth' comes from (his interpretation of) the ancient Greek word *aletheia*, which he takes to mean non-concealment, the condition of the possibility of understanding or interpretation. This differs greatly from the notion of truth in science, as the following quote, again from Heidegger (1960), makes clear:

> . . . science is not an original happening of truth, but always the cultivation of a domain of truth already opened, specifically by apprehending and confirming that which shows itself to be possibly and necessarily correct within that field.

Heidegger's approach to art allows for culture, under the heading of what he calls 'world', it explicitly includes the artist, and it takes account of viewers. Also Heidegger's approach applies equally well to representational and non-representational art, e.g., conceptual art, found art, and earthworks. But very abstract philosophical views of this kind, though they may help with avoiding certain misunderstandings, and with deconstructing other theories of art, do not seem to provide much help understanding particular works of art, and this seems to me a serious defect.

Another theory of beauty, often dubbed 'modernist', says that an object is beautiful to the extent that its form conforms to its function.[6] This is perhaps as well illustrated by Duchamp's urinal as anything (though that may not have been the artist's intention). On the other hand, this criterion is hardly applicable to useless objects, such as impressionist paintings, cubist sculpture, and poetry (though all these can of course be put to various uses, such as making money, impressing friends, and reducing stress). Moreover, this aesthetic produced, or at least justified, architectural monstrosities in the 1950s and '60s, for example, the huge crime-ridden high-density low-income high-rise housing projects, that many communities throughout the world are now trying to get rid of. It seems fair to say that this theory is pretty much discredited as a general theory of beauty, though it retains some currency in such areas as industrial design, due in part to the great success of the Bauhaus movement. Incidentally, the above discussion constitutes a good illustration of the dependency of *theories* of art upon social and cultural conditions. For not only art, but also theories of art, depend upon, reflect, and vary with the social conditions of their production, including of course the cultural milieu.

In his *Poetics*, Aristotle (–330) defines art as imitation, but he is not so naive as to call for the imitation of nature, but rather of 'men in action'. Moreover, here as in most things, Aristotle takes a balanced approach, and does not attempt to reduce art, or the measure of art, to any one thing. In particular, he does not propose any notion of beauty as the measure of art, but rather introduces a number of quality criteria, concentrating on the example of tragic drama, but also discussing

[6] Despite its name, this theory goes back at least to Plato (–360), and his reduction of art to to utility is consistent with his distrust of artists for their capability for political disruption.

several other art forms, e.g., lyre playing. Aristotle says that the aim of tragedy is to arouse fear and pity in the audience though the imitation of heroic action; his criteria of excellence include unity of time and place, skilful use of language, especially metaphor, several aspects of plot structure, including certain key types of scene, and aspects of character development. His approach skilfully combines analytic, historical, ethical, and pragmatic views of drama and, of course, it has been enormously influential, and remains so to this day. It seems that for Aristotle, as for many contemporary artists, beauty is at most a secondary concern.

On this last point, and much else, I would agree with Aristotle. An additional point is that beauty is even more difficult to define than art, as well as being even more culturally relative and time-variant. But before passing to our main question, we should note that Aristotle's approach is not applicable to non-representational art.

III: Art and Science

The method of science calls for precise repeatable measurements, and for an objectivity that excludes all subjective factors on the part of the experimenter. This is very different from the method of art — indeed, it is nearly the opposite. That artists directly engage their subjectivity in their work is one of the few assertions that is very widely held among the highly diverse plethora of contemporary artistic movements. Moreover, repetition (at the time of creation) is anathema to most artists,[7] and this proclivity is much reinforced by the nature of the art market, which tends to value scarcity (other things being equal). Objective measurement also differs greatly from the creative aspect of art, though it may of course be used in the technical support of artistic production (e.g., mixing paint, tuning musical instruments, fitting together parts of a sculpture, using perspective).

These considerations imply that art and science must play significantly different kinds of role in any relationship that may be forged between them. One very simple theory is that art and science explore such completely disjoint domains in such completely different ways, that it is impossible for there to be any meaningful relationship between them. While this might be comforting to many, it is clearly false. For example, during the Renaissance advances in geometry fueled a corresponding advancement of perspective in painting. Advances in technology have obviously been essential enabling factors for many contemporary art forms, such as cinema, and electronic music. Many other examples could easily be given, some of which seem to involve rather complex interconnections between art and science (e.g., the video-based art of Nam Jun Paik, which appears to use the medium to criticize it).

A relationship that excites little controversy, because it seems to raise few deep philosophical questions, is the use of science to authenticate art, for example,

[7] For example, Monet famously painted the same cathedral many times — but they are all different, often radically, e.g., in using a very different colour scheme (cf. Myin, 2000, p. 54). Anthony Freeman adds the following remark: 'Paradoxically, the scientist reveals truth by coming up with consistently identical results, while the artist reveals truth by coming up with consistently different results.'

through chemical analysis and carbon dating of pigment, canvas, and other material. The use of the fractal dimension computations of Taylor, Micolich and Jonas (this volume) to authenticate or date the drip paintings of Jackson Pollock also has this character. Such applications should not be confused with the much more controversial reduction of art to science, e.g., via measurements of viewers' physiological responses to art. While such reductive approaches have difficulty taking account of factors like culture and the role of the artist (Ione, this volume, page ...), they are potentially applicable to non-representational art, as noted by Ramachandran (this volume). Moreover, there is little doubt that artists and art lovers can learn some valuable things from scientific studies of perception, as well as from related subjects such as the neurophysiology and cognitive psychology of vision; e.g., psycho-acoustics is a well developed area of musicology that has been applied many ways in music.

Conversely, some might wish to reduce science to art, by emphasizing the creative side of scientific research, and then claiming that this differs little from painting or musical composition. While such a claim seems valid as far as it goes, it fails to impart much insight, and it also leaves out a great deal that seems important, such as the mathematical character of most scientific theories, and the repeatability requirement for scientific experiments that was discussed above.

Both art and science are part of culture and, as such, both their nature and their relationships are bound to be complex, and to change over time and location. It therefore seems naive to expect to find any simple (or even complex) description that reflects the timeless essence of their relationship. As for the future, it would seem wise to expect the unexpected, given how rapidly art, science, and technology are all evolving at present. For example, how will the internet relate to art, as it progressively matures and permeates society? Some things seem relatively clear: we will surely see much more of digital media, and of the digital manipulation of art forms; and probably we will see radical new integrations of media when network bandwidth becomes sufficiently great. But will this make much difference? We will see new kinds of art, but will we see new kinds of aesthetics? Probably we will see new theories of art as well, but will they be any better than the old ones?

IV: Conclusions

This essay has explored some the most popular definitions and theories of art and beauty. We seem forced to conclude that it is difficult, or even impossible, to define art and beauty, or to adequately classify the complex relationships between art and science. Since we don't know precisely what art is or what role it plays in our lives — and the huge variety of positions that have appeared in *JCS* suggest that we also don't know precisely what consciousness is or what role it plays — there would not seem to be a very solid basis for considering the relationship between art and consciousness. Moreover, it is clear that nearly all of whatever brain activity it is that corresponds to aesthetic experience is unconscious, and it is even doubtful that the ideal viewer of a great artwork *should* be conscious,

because one (often claimed) effect of great art is to merge subject and object in an ecstatic epiphany that transcends individual consciousness; see Goguen (1999) for some related discussion. Finally, I have repeatedly argued that scientists and philosophers interested in art should take an inclusive view of what art is, rather than focusing just on painting and perhaps sculpture, and that they should also try to find ways to take account of the role of the artist, the cultural context, and the artistic sophistication of the viewer, if they aspire to a truly adequate theory.

Conclusions like those of the previous paragraph will be disappointing to many philosophers, and to the purveyors of grand theories of any kind. But perhaps such conclusions are refreshing in a way; perhaps clearing away the conceptual baggage of definitions and theories can help us to approach art in a fresh way, so that we can experience it more deeply and authentically, which is surely no bad thing. Also, these explorations, however tentative and mutually contradictory, are valuable in actualizing this conceptual clearing as a process, and the issues involved are deep, affording us an opportunity to reflect on what it means to be human. This is the value of asking the question 'What is art?'. Finally, dramatic scientific advances like fMRI, and the continuing decline of dualistic theories of consciousness in favour of embodied theories, offer solid grounds for thinking that genuine progress can in fact be made in the scientific and philosophical understanding of art, as is also supported by the fine papers in this volume.

V: What the Authors Say

As might be expected, the authors in this special issue display a splendid diversity of opinion on the difficult issues that are highlighted in this introduction, as well as on many other issues.

For example, the authors in the section of commentaries on the paper by Ramachandran and Hirstein (1999) — hereafter abbreviated R&H — exhibit a wide range of responses. The distinguished art historian E.H. Gombrich argues that the R&H approach fails to take account of much of the art found in today's musuems, while in his reply to Gombrich, Ramachandran claims that Gombrich has not paid sufficient attention to certain aspects of what is actually in museums. Ione, who is an artist, argues forcefully for the need to take account of artists in discussing art, and also claims that the underlying Platonic presuppositions of the R&H approach greatly limit its applicability. McMahon applauds the way that R&H avoid a Kantian antinomy, 'that there are genuine judgements of beauty and that there are no principles of beauty,' but also argues that their approach fails to distinguish beauty from other forms of pleasure; moreover, she proposes models involving both low level perception and higher level processing as a more prom- ising solution. Wheelwell argues, with perhaps excessive rhetoric, that the R&H reduction of beauty to evoked skin conductance response fails to get at the most important aspects of art, and that it confuses beauty with arousal; she also intro- duces a bracing feminist perspective.

The second of the three parts of this volume consists of selected papers from a conference entitled 'Perception and Art' held in Brussels in May 1999, as one of

two components of the 'Cognitive Science Conference on Perception, Consciousness and Art'. An introduction to these papers by Erik Myin appears on pages 43–55 of this volume; I especially like the Gibsonian perspective that Myin takes in his essay.

The third part of this volume consists of two additional papers. The first of these, by Alva Noë, is a lovely meditation on the experiental nature of some contemporary art and philosophical implications of the perspective behind this art (though written in the reverse order). In particular, Noë highlights the transparency of perceptual consciousness as a problem for philosophy, art and cognitive science, and claims that it is resolved by taking an active, embodied and temporally extended view of perception. The work of the sculptor Richard Sera is presented as exemplifying this view.

The second paper, by Taylor, Micolich and Jonas, is a fascinating empirical study of the drip paintings of Jackson Pollock, using the notion of fractal dimension from chaos theory. It is found that these paintings have a fractal character (i.e., exhibit self-similarity), and that their fractal dimension gradually increases with the date of the painting, from 1.12 in 1945 to 1.72 in 1952. This regularity raises the possibility of using fractal dimension to authenticate 'newly discovered' Pollock paintings (if any such appear), and even to determinate their approximate date. The paper goes on to relate Pollock's art to theories about automatism and the role of the unconscious in art, that were current in his time. This paper also speculates that the abundance of fractal patterns in nature makes them a naturally attractive form for art and artists.

Finally, I should mention the two book reviews in this volume, written by English and by Goguen. The first of these covers a book entitled *Reframing Consciousness* that contains 63 papers from a conference held in Wales in 1998, on the intersection of art, consciousness and technology, while the second applies a strengthened Gibsonian viewpoint to a recent book by Maurice Hirshenson, *Visual Space Perception*, from the field of experimental psychology.

Acknowledgements

I thank Erik Myin and Anthony Freeman for their comments and suggestions, Wesley Phoa for inspiration from an essay, and my wife Ryoko for her patience.

References

Aristotle (–330), *Poetics*, trans. S.H. Butcher, Dover, 1997.

Goguen, J.A. (1999), 'Editorial Introduction', *Journal of Consciousness Studies*, **6** (6–7), pp. 5–14 (Special Issue on *Art and the Brain*).

Heidegger, M. (1960), 'The origin of the work of art', in *Poetry, Language, Thought*, trans. A. Hofstadeter (London & New York: Harper & Row, 1975).

Kant, I. (1790), *Critique of Judgement*, trans. J.C. Meredith (Oxford: Oxford University Press, 1997).

Kockelmans, J. (1985), *Heidegger on Art and Art Works* (Dordrecht: Martinus Nijhoff).

Plato (–360), *The Republic*, trans. D. Lee (Harmondsworth:Penguin Books, 1979).

Ramachandran, V.S. and Hirstein, W. (1999), 'The science of art', *Journal of Consciousness Studies*, **6** (6–7), pp. 15–51 (Special Issue on *Art and the Brain*). The full text is available on http://www.imprint.co.uk/rama

Mary Street *Fill Circle*

Breathe Rønning

E.H. Gombrich

Concerning 'The Science of Art'
Commentary on Ramachandran and Hirstein[1]

To the historian of art, it is evident that the two authors' notion of 'art' is of very recent date, and not shared by everybody. They claim: 'The purpose of art, surely, is not merely to depict or represent reality — for that can be accomplished very easily with a camera — but to enhance, transcend, or even to *distort* reality' (Ramachandran and Hirstein, p. 16). They do not explain how one could photograph Paradise or Hell, the Creation of the World, the Passion of Christ, or the escapades of the ancient gods — all subjects that can be found represented in our museums. Nor is it more legitimate to generalize from certain Indian conventions of representing the female nude than it is for the academic tradition to take the Venus de Medici for the same purpose. Even a fleeting visit to one of the great museums might serve to convince the authors that few of the exhibits conform to the laws of art they postulate.

RESPONSE FROM V.S. RAMACHANDRAN

I thank Professor Gombrich for taking the trouble to respond to our article on the 'Science of art'. Unfortunately he appears not to have understood our main argument.

In our introduction we say that the purpose of art is not to merely copy what is out there since that can be done with a camera. This idea has been stated many times in the past by art historians and Gombrich is correct to point out that it isn't original. But we weren't *trying* to be original; we were saying it only to introduce the article. The most original section of our essay — in my view — is the section dealing with abstract art, which has never been satisfactorily explained in the past. The point I made in this section is so elementary, once it is explained, that most 'experts' (especially art historians) find it annoying when they first hear

[1] Ramachandran, V.S. and Hirstein, W. (1999), 'The science of art: A neurological theory of aesthetic experience', *Journal of Consciousness Studies*, **6** (6–7), pp. 15–51. The full text is available on http://www.imprint.co.uk/rama

about it. (The 'why didn't I think of that?' reaction.) Indeed many of commentaries on the article — even some of the favourable ones — seem to have missed this point, so I will repeat it here briefly.

The key insight comes from Tinbergen's work on sea gull chicks (Tinbergen, 1954). He found that a gull chick will beg for food from its mother by pecking on a red spot near the tip of her beak. Interestingly even a disembodied , isolated beak will also elicit pecks — you don't need a mother attached. Indeed you don't even need a beak: a long strip of cardboard with a red spot near the tip is just as effective. And most remarkable of all, Tinbergen found that a very long thin stick with *three* red stripes near the end is much more effective than even a real beak — even though it looks nothing like a beak to us! Although Tinbergen doesn't explain why, he had inadvertently created a 'super beak' and the chicks go crazy.

Why does this happen? I suggested in the essay that this is because neurons in the chick's visual pathways, e.g. in the nucleus rotundus or hyperstriatum, may be coding 'form' in ways that are not immediately obvious — for in truth we have no idea how 'form' is really represented in the gull or human brain, or what the figural primitives of our perceptual grammar are. The neurons that signal 'Mother's beak' for example may have their receptive fields 'wired up' in such a way that a long skinny stick with three red stripes is actually more effective in driving the 'beak percept' neuron than a real beak For instance, the neuron and receptive field responding to the red spot may actually be wired up to embody the rule 'The more red contour the better' and so you can fool the neuron by using the stick with three stripes. As a result the neurons are activated even more by this odd pattern than by a real beak, and a stronger signal is sent to the chick's limbic (emotional) brain centres so the chick is emotionally excited. The visual system often uses 'short cuts' or heuristics of this sort to economise on visual information processing. The scheme works well enough in nature because, statistically, the only thing in the chicks visual world that is likely to activate these neurons is its mother's beak. After all the chick is unlikely to ever encounter a mutant pig with a beak or a researcher waving a stick! So the chick's visual coding scheme incorporates a short cut that is nearly infallible in nature but is easily fooled by a researcher who knows what the coding scheme is (or has stumbled on the coding scheme through trial and error).

Now this brings me to my punch line about art. If the seagulls had an art gallery they would hang this 'Long stick with three stripes' on the wall, worship it, pay millions of dollars for it and call it a Picasso. But they wouldn't know *why* it was so effective since it doesn't resemble anything they know. It isn't 'realistic'. Perhaps neurons in their brains are screaming 'Wow! What a beak!' And that, I think, is precisely what abstract art is. We don't know what the 'form primitives' of human vision are but the practitioner of abstract art has (either through trial and error or through intuition) hit on patterns that activate visual 'form' neurons even more powerfully than the natural stimuli for which that the neuron was originally (whether through natural selection of imprinting and learning). So a Picasso nude or any good cubist portrait in this view may be activating the ' human female' form representation cell assemblies in the brain — and the corresponding

limbic/emotional pathways even more effectively than an actual nude! (Just as the stick with three stripes works better than a real beak.) And bear in mind that we have only considered 'form' so far. There are over thirty specialised visual areas in the human cortex — each concerned with a different aspect of vision such as colour, depth or motion. So one can think of the equivalent of 'caricatures' or the 'stick with stripes' in an abstract colour-space rather than form-space, and this might help explain at least some of the evocativeness of a Monet or a Van Gogh. We have abstract canonical representations (memories) of water lilies in our visual pathways and perhaps Monet's paintings are the equivalent for 'water lily' of what the stick is for 'beak'. So we stand awe struck in front of the water-lily painting wondering why mere smudges of paint with abnormally heightened artificial looking colours should be so much more beautiful than a realistic photo of the same scene. We are behaving exactly like seagull chicks.

These ideas have the advantage that, unlike the vague notions of philosophers and art historians, they can be tested experimentally. For example we can make the counterintuitive prediction that a 'face' neuron in the inferotemporal cortex that is known to respond mainly to faces should be activated even *more* by an 'unrealistic' Picasso type face than a photo. Or a stronger GSR (galvanic skin response — a measure limbic/emotional activation that is not necessarily available to conscious introspection) might result from a Picasso nude or a Monet water lily than from a photo of a nude or a water lily.

Our essay also outlines seven other 'laws' or principles, making a total of eight. But as I make clear in the essay, these are not intended to be comprehensive; indeed we have barely scratched the surface of the problem of artistic universals. There are probably many other laws or principles — such as 'balance' and 'visual rhythm or repetition'. More importantly, we have nothing to say about the manner in which an individual artist exploits the laws — his or her — 'originality'. This is not something we can even begin to address scientifically — at least not yet!

What we have tried to do, though, is to bring together strands of evidence from many disciplines such as experimental psychology ('peak shift') ethology (Tinbergen's findings) neurology, psychophysiology and evolutionary biology. Without such an interdisciplinary synthesis the meaning of art will always remain elusive. It may be one reason why people specialising in the psychology of art or on art history alone have made very little progress in understanding the meaning of art. Even the distinguished professor Gombrich, who has speculated on these topics for almost fifty years, has had very little to say about the neural or evolutionary basis of art — especially abstract art.

Finally, may I respectfully suggest that professor Gombrich follow his own advice and visit any good art gallery — preferably one that has not just 'western' art but also has Indian and African art. He will then see that many of these principles such as grouping, contrast, 'peak shift' and 'super normal stimuli' — such as the stick with three stripes — in 'form' space (as well as other abstract multi-dimensional spaces and colour space), perceptual 'problem solving', and symmetry are in fact widely used by artists of all cultures. I would readily admit,

however, that there is probably a great deal more to art than what is embodied in these principles.

References

Ramachandran, V.S. and Hirstein, W. (1999), 'The science of art: A neurological theory of aesthetic experience', *Journal of Consciousness Studies*, **6** (6–7), pp. 15–51. The full text is available on http://www.imprint.co.uk/rama
Tinbergen, N. (1954), *Curious Naturalists* (New York: Basic Books).

Amy Ione

Connecting the Cerebral Cortex with the Artist's Eyes, Mind and Culture

V.S. Ramachandran and William Hirstein's thought-provoking article 'The science of art: a neurological theory of aesthetic experience' (1999) and the accompanying commentaries raise serious questions about what a science of art is. Unfortunately this short piece will only be able to address them broadly.

Overall the problems arise from (1) the exclusion of neurological studies of artists, (2) the exclusion of the artist's experience, and (3) the premises of the theory, which are based on problematic *valuations* related to aesthetics and spirituality. With these valuations, for which there is no scientific proof, the model is unable to sufficiently address the scope of what artists do and what art forms are. While it is my view that the Ramachandran and Hirstein theory is fundamentally flawed, it is likely the flaws are due to implicit assumptions rather than explicit intentions.

First, it is important to note that the exclusion of the artist, who is a specialist, brings too narrow a framework to the theory. Art is a *practice* and it is one in which the artist forms a relationship between 'seeing' and the object produced over time. When the first paragraph explicitly states that 'the paper proposes a list of "Eight laws of aesthetic experience" — a set of heuristics that artists either consciously or unconsciously deploy . . .' (Ramachandran & Hirstein, 1999, p. 15), it seems the artist's role is to be recognized. Yet, as Wallen (1999, p. 68) and Lanier (1999, p. 65) point out, the model essentially removes the experience of the artist from the analysis. The different ways in which the artist, the interested viewer and the novice 'see' and perceptually evaluate hypotheses seems to be too critical a variable to be put aside in a biological analysis, especially if we are to convincingly distinguish how those who are specialists or have abnormalities might differ from the general case.

Scientific studies are beginning to document these differences and to show that the history of an individual has a tremendous impact on how the brain sees. One recent study demonstrated that there appear to be differences in the neurological structures and processes when we compare artists with novices. In this case researchers tracked the interactions of the eye, hand and brain using movement

Journal of Consciousness Studies, **7**, No. 8–9, 2000, pp. 21–27

sensors, and PET/fMRI mappings of an artist's brain and the brains of non-artists. Comparing the scanned images the researchers found that the artist showed greater activation in the right middle frontal area than did the novices. This part of the brain is usually related with more complex association and manipulation of visual forms as well as planning the fine motor responses of the hand (Riding, 1999; Solso, 1999). At this point results are more informative than conclusive since only one artist was studied. Nonetheless it does suggest that experimentally discoverable distinctions between artists and non-artists exist and could offer a tangible basis for deriving neurological conclusions that directly relate to how artists employ their brains.

Oliver Sacks' work with the colour-blind artist Jonathan I. also offers more specific data about an artist's brain than the kind of empirical information Ramachandran and Hirstein use in their model. The Sacks study, which suggests exploring brain plasticity, offers a good avenue for clarifying questions about neural processing in general and in art production as well. After an automobile accident this painter, who had always relished colour, found he could not see colour at all. In this case the subject adapted his painterly approach and his brain recorded these adaptations structurally. As Sacks' points out, this kind of case allows us to trace how plastic the cerebral cortex is, and how the cerebral 'mapping' of body image, for example, may be drastically reorganized and revised not only in cases of injury but in consequence of the special use or disuse of individual parts (Sacks, 1995).

Both of these studies provide the kind of neurological information that seems essential if the theory is to fully gauge how the product an artist produces is related to the artist as the first viewer as compared to later viewers who only engage with a completed form. To be sure, this kind of activity might come under the law of perceptual problem solving, which was introduced but not discussed in the study. I have raised it here because Ramachandran's response to earlier commentators briefly alludes to the perceptual processing law when he mentions that 'the visual system "struggles" for a solution and does not give up too easily'. However, this response contains no references to how an innovative artist evaluates hypotheses, whether this evaluative process differs from the general case, and why artists often invent new technologies to enhance their presentations.

This absence of a clear approach to artistic and interactive learning is one reason I don't find the model convincing. The other is that the context presented includes cultural incongruities that I am not convinced can be put aside by saying this is a scientific model in which it was a somewhat deliberate decision to delete the cultural dimension of art (Ramachandran, 1999, p. 74). As Mitter notes, despite the inclusion of Hindu art to make particular points, the model is founded upon a Western bias that is supported by the adoption of a (perhaps implicit) Platonic framework. Mitter (1992) has spoken elsewhere on how the Platonic inference of universality was fitted into models of Indian art historically and how these earlier modes explained the relation between art and religion by taking refuge in metaphysical generalizations derived not only from Plato but from Western

Romantic aestheticians of the nineteenth century. As Mitter explains, and his work is worth exploring, the tenet that art was an 'uncaused spiritual activity' reduced art criticism to the level of irrational mysticism.

While Ramachandran and Hirstein do not imply they are asserting a level of irrational mysticism, their speculative theory is like the earlier models in defining universals in Platonic terms. Before turning to Platonic idealism *per se*, it is important to point out that Platonic idealism allows Ramachandran and Hirstein to include numerous axiomatic inferences that are unlikely to be resolved by simply expanding the research pool beyond the predominantly Western and North American sample used in the experiments referenced in the paper. A larger sample will not resolve issues such as the one Ruth Wallen points to when she notes that saying the eight laws of aesthetic experience are loosely analogous to the Buddha's eightfold path to wisdom is preposterous given the tremendous conceptual gap between the model Ramachandran and Hirstein introduce and the Buddhist understanding of the human mind (Wallen, 1999, p. 70).

Considering together Mitter's research into metaphysical biases and Wallen's concerns that Buddhist ideas have been misapplied here, reiterates the need to ask if a model that does not detract from art's spiritual and aesthetic value (Ramachandran, 1999, p. 73) is the same as a theory presented as one that will speak to human artistic experience and the neural mechanism that mediate it (Ramachandran & Hirstein, 1999, p. 15). While this brief commentary cannot address the complex philosophical issues that are pushed aside if we assume these two positions are equal, it seems that ignoring the differences between the Buddhist and Hindu traditions artistically and fundamentally is a significant problem. Another problem embedded within the theoretical design is that the axiomatic valuations of the theory leave too much in question in regard to the model's definitions of universals, art and aesthetics. Is this theory aligning fundamental differences among domains too casually? In light of Ramachandran's comment that the reductionistic theory does not detract from art's spiritual value, it also seems prudent to ask whether 'spirit' should be an axiomatic tenet of a biological, scientific theory.

The valuation of art in aesthetic and spiritual terms also needs to be carefully considered in light of (1) the Platonic foundations on which the Ramachandran and Hirstein model rests, (2) the fact that a Platonic foundation does not give a theory a scientific base so much as an idealistic one, and (3) how the Platonic coupling of art with spiritual and aesthetic valuations has been particularly damaging to artists and art ever since Plato, who believed artists were divinely inspired, banned artists from the *Republic* (398a). While it is generally recognized that Plato was an artist, many forget he was also wary of those artists who were talented enough to use their art to persuade others to follow paths that did not lead to his ideal of Truth. In sum, as insightful as Plato's writing is, his artistic and memorable images, like the Cave and the charioteer, were conceived as a part of a picture that placed truth outside time. Thus truth becomes very much a matter of interpretation in the domain in which we live and Platonic idealism ultimately

leaves little mechanism for those with 'flawed' understandings to state their case.[1] Similarly the Ramachandran and Hirstein theory sweeps the exploratory experience of the individual artist into a single grandiloquent nexus so tightly and philosophically structured that it effectively stifles all possibility of creative aspiration and exploration.

The exclusion of data related to specialists is what makes the Platonic notions of particular concern. Simply put, the measures are focused on aligning an abstract notion of underlying essences with data collected from a naïve population. As Tyler so insightfully said: 'Indeed, can one talk of a definitive essence at all when art may be viewed not as an object but as a developing relationship between the artist and the artwork, and subsequently between the artwork and the viewer?' (Tyler, 1999, p. 673).

What is of grave concern to this reviewer is seeing a Platonic theory coupled with perceptual research on naïve subjects to formulate a biological theory about art. Although the Platonic assumptions may be implicit rather than intended, the philosophical idealism is not neutral. Karl Popper has spoken of the idealistic, Platonic valuations in terms of how one can never prove a truth outside time. He has also noted that the choice of idealism is not simply an intellectual affair, or a matter of taste, because it places universals in an abstract field which is outside the field of communicable discourse. Since an abstraction cannot be addressed in the realm of our lives any problems that emerge cannot be scientifically resolved. Truth ultimately ends up not being a choice between knowledge and faith, but only between two kinds of faith. The new problem is which is the right faith and which is the wrong faith? (Popper, 1962).

But questions of faith need not enter into a scientific equation. What artists do and what they learn over the course of a lifetime is surely a part of art and better understood by considering the artists who produce it. When Ramachandran and Hirstein overlook this they miss the degree to which art forms offer wonderful venues for neurologically analysing complex relationships between inner and outer domains. This is not because artists represent something subjective that we can then analyse to speak about a first-person perspective, although some artists may perceive their work in this way. Rather the form the visual artist, for example, solidifies offers a means to evaluate how the brain has translated the information the eye sees, regardless of whether the product appears abstract or representational when we view it — simply because the artist uses her cerebral cortex, her materials, her sense of touch and her eyes when bringing the finished work into being. More to the point: the artist's mind, like the viewer's, interprets what the eye sees, more or less.

'More or less' is the key element here. As scientific experiments have shown the kind of active seeing that fuses stereoscopic information differs from passively perceiving a surface casually. Likewise, we can view art superficially or actively engage with the form. Our perceptions are also subject to various

[1] Murdoch (1977) offers an excellent summary of Plato's view of art and how it informed Western thinking.

constraints. As Gregory points out, it would be hard to conceptualize how some-one who has no concept of a Dalmatian would be able to group the black and white splotches and see the hidden dog Ramachandran and Hirstein reference (Gregory, 1999, p. 55) when discussing grouping and binding. Van Gogh's work illustrates an additional contextual dilemma which we must consider when we design theories. If we say van Gogh's art is of an exceptional aesthetic quality, why didn't it resonate with the community at large while he lived? If it doesn't qualify as aesthetic, why does it resonate with so many now? Likewise, the Ramachandran and Hirstein model contains no mechanism for contextually con-sidering why an innovative artist like Paul Cézanne asserted 'the eye educates itself'(Gasquet, 1927/1991, p. 163).

Perhaps these omissions explain why some *useful* distinctions between art and science are not considered. A primary one is that art, like science, is a hands-on endeavour, yet the production of art forms includes a freedom not found in scien-tific investigations. Introducing this distinction is not intended to suggest that there are no rules and that a credible artist does whatever comes naturally, hoping she will be divinely inspired. Rather artists commonly bring attention, experi-ment, technique and skills that are developed over the course of a lifetime to their efforts to communicate something to the viewer, even if the viewer is only the art-ist at work. Neurologically we can explore this relationship in terms of artistic cognition, for we can compare the artist's brain processes with the formal work. This is not to infer we can derive a one-to-one correspondence. Rather, what is of utmost importance is that whatever the motivation is that brings the artist to cre-ate, and motivations vary significantly, all art shares one characteristic: the art-ist's motivations must be given form if there is to be any art (or artists) for us to evaluate at all.

The cognitive processes that lead to the art form also inform how (and whether) an art object or process is successful, although success is not generally defined by applying the kind of criteria required to validate a scientific experiment. The rubrics are more pluralistic. While beauty might be an important quality for some artists, others incline to social commentary, religious ideas, sexual arousal, mar-ketable genre, or products that will shock, horrify or disgust viewers. This variety underlines that while individual artists might characterize their work as emotion-ally, spiritually or formally driven, there is no overall agreement. Only that a form is produced is indisputable. As a result, while laws such as grouping, binding, contrast extraction, allocation of attention, symmetry, etc. are useful in scientifi-cally understanding perception, even an artist's perception in a general sense, we lose a great deal neurologically if we push aside what the artist's experience as an artist is.

Earlier this discussion noted that the Ramachandran and Hirstein theory might have been more convincing if neurological studies on the experience of artists had been included. Empirical studies outside the cognitive science framework also would add foundation. Conservators, for example, often need to understand exactly how an artist composed a work so that artwork can be kept in a stable con-dition and restorations will be transparent. Using chemical analyses and infrared

imaging techniques these scientists have looked beneath the visible surfaces and compiled a compelling body of data that documents precisely how artists produce works later viewers see. With the knowledge gained in conservation laboratories, specialists have been able to restore diverse objects to their original 'look' and to do so in ways that are invisible to the general viewer. Had Ramachandran and Hirstein combined cognitive studies with the conservation data amassed on artistic conceptual approaches and application procedures they might have more convincingly addressed: (1) an artist's perceptual approach, (2) the qualities surface viewing fails to decipher in regard to the complexity of art objects, and (3) the qualities research subjects cannot see in a laboratory or even a museum setting.

Overall the eight laws as framed stretch the empirical information we have too far and bind unresolved areas too tightly. No doubt the scientific data we now have is useful in bracketing general tendencies, but surely it fails to offer a scientific answer for how we best integrate the narrow, rigorous technical realm of scientific investigations with the social, psychological, cognitive and practical concerns that clearly inform art practice and appreciation. The vast differences among the domains referenced in the Ramachandran and Hirstein model also suggests that the word 'universal' can be used in more than one way and should thus be applied with great care.

In summary, one builds a relationship with art forms over time, as one does with people. Given this relational element, I applaud the efforts of Ramachandran and Hirstein to foster dialogue among artists, visual physiologists and evolutionary biologists. Nonetheless, I concur with the earlier commentators who pointed out that several key areas need to be addressed if the model is to be pertinent to art. A useful model would address the point that in making and viewing art we discover that art forms, like people, are complex. Axiomatic assumptions that effectively delete this complexity and the areas of controversy surrounding the modes under investigation do not begin the dialogue on a level playing field.

References

Gasquet, Joachim (1927/1991), *Cézanne*, trans. C. Pemberton (London: Thames and Hudson Ltd.).

Gregory, R.L. (1999), 'Object hypotheses in visual perception: David Marr or Cruella de Ville?', *Journal of Consciousness Studies*, **6** (6–7), pp. 54–6 (Special Issue on *Art and the Brain*).

Lanier, J. (1999), 'What information is given by a veil?', *Journal of Consciousness Studies*, **6** (6–7), pp. 65–8 (Special Issue on *Art and the Brain*).

Mitter, Partha (1992), *Much Maligned Monsters: A History of European Reactions to Indian Art* (Chicago and London: The University of Chicago Press).

Murdoch, Iris (1977), *The Fire and the Sun: Why Plato Banned The Artists* (Oxford: Oxford University Press).

Popper, Karl R. (1962), *The Open Society and its Enemies*, 2 vols. (New York: Harper Torchbooks).

Ramachandran, V.S. (1999), 'Author's response [to commentaries]', *Journal of Consciousness Studies*, **6** (6–7), pp. 72–5 (Special Issue on *Art and the Brain*).

Ramachandran, V.S. And Hirstein, W. (1999), 'The science of art: A neurological theory of aesthetic experience', *Journal of Consciousness Studies*, **6** (6–7), pp. 15–51 (Special Issue on *Art and the Brain*).

Riding, Alan (1999), 'Hypothesis: the artist does see things differently', *The New York Times*, Tuesday 4 May 1999.

Sacks, Oliver W. (1995), 'The case of the colorblind painter', *An Anthropologist on Mars: 7 Paradoxical Tales* (1st edn., New York: Alfred A. Knopf).

Solso, Robert L. (1999), 'Brain activities in an expert versus a novice artist: an fMRI study', working paper.

Tyler, Christopher W. (1999), 'Is art lawful?', *Science*, **285**, pp. 673–4.

Wallen, R. (1999), 'Response to Ramachandran and Hirstein', *Journal of Consciousness Studies*, **6** (6–7), pp. 68–72 (Special Issue on *Art and the Brain*).

Jean Clad *Connection*

Nicole Chesney *The Artist Wears Glasses*

Jennifer Anne McMahon

Perceptual Principles as the Basis for Genuine Judgments of Beauty

The Problem of Beauty

The modern formulation of the problem of beauty was developed by Kant as the antinomy of taste (Kant, 1987, p. 211). The antinomy consisted of the thesis that a judgment of taste is not based on concepts, for otherwise one 'could decide by means of proofs'; and its antithesis that a judgment of taste is based on concepts, for otherwise one 'could not lay claim to other people's necessary assent to one's judgment'.

The problem has been represented more recently by Mary Mothersill as a matter of two true but apparently contradictory theses (Mothersill, 1984). On the one hand, judgments of beauty are genuine judgments. That is, they are judgments grounded in objective properties of the beautiful object. On the other hand, we know something is beautiful by how it makes us feel, rather than by first identifying the presence of necessary or sufficient conditions for beauty in the beautiful object. In fact, logically necessary or sufficient conditions for beauty are not forthcoming. In the words of Mothersill's second thesis, there are no principles of beauty.

The feeling of beauty is a feeling of clarity as if one had found a solution to a problem. It is a feeling that is compatible with the possibility of experiencing perception as a solution to a problem; a deeply satisfying and pleasurable feeling.

Attempts to identify logically necessary or sufficient conditions for beauty always result in features which themselves have no logically necessary or sufficient conditions; features which are aesthetic qualities such as harmony, unity-in-variety, complexity-unity-intensity and so on. One can never predict in advance that an object will evoke an experience of beauty based on it possessing certain perceptible features. There is always the possibility of voiding features that cannot be predicted in advance. Yet, in each individual case of beauty, we can and do defend judgments by pointing to certain combinations of base properties; certain configurations. Hence Mothersill's two theses, that there are genuine judgments of beauty and that there are no principles of beauty, are logically contradictory but are both true regarding our experience of beauty.

Journal of Consciousness Studies, **7**, No. 8–9, 2000, pp. 29–35

Now Mothersill suggests a remedy to this conundrum. She argues that the apparent contradiction emerges from the false assumption that the only way to ground genuine judgments of beauty is through principles of beauty of the kind that can be articulated as properties in the object which are necessary or sufficient for beauty. Mothersill suggests instead that if the basis of genuine judgments of beauty were neurophysiological laws, then judgments of beauty could be grounded without issuing in principles of beauty (of a logical kind). Neurophysiological laws might point to how certain characteristics of certain objects employ perceptual processes in such a way as to cause pleasure. This would shift the emphasis when defining beauty from objective properties in the beautiful object to neurophysiological principles activated in a certain way in the viewer of the beautiful object.

As such, the principles identified by V.S. Ramachandran and William Hirstein seem likely candidates for resolving the problem of beauty (Ramachandran and Hirstein, 1999). They would represent or explain the relation between certain properties of the beautiful object and the viewer's pleasure, in such a way that would ground judgments of beauty and also explain why beauty is ineffable. After all, it is the way perceptual principles are employed in the course of perceiv-ing the beautiful object that causes the pleasure. We cannot subsume these princi-ples under a concept as we can the incoming data which give rise to logical condition-governed concepts, because these principles are a part of the architec-ture of the mind; hence, beauty's ineffability.

Ramachandran and Hirstein implicitly recognize that it is not the identification of aesthetic properties in the object that can help us understand beauty. Instead, it is the identification of the kinds of perceptual processes that the perception of the beautiful object activates in the viewer that is the key to understanding the nature of beauty. Unfortunately, the flaw which undermines Ramachandran and Hirsteins' attempts is a confusion regarding what constitutes an experience of beauty. They conflate pleasurable responses of a sexually titillating nature and other agreeably sensuous pleasures with the pleasurable response evoked by beauty.

Two Traditions of Beauty

The problem of beauty has been addressed through various philosophical styles and a number of different metaphysical/religious commitments. Generally, two traditions of beauty can be identified as running across all traditions/commit-ments according to the kind of pleasure recognized as evoked by beauty. One tra-dition, which I refer to as the Pythagorean Tradition (McMahon, 2000), recognizes only a contemplative, sober kind of pleasure evoked by formal rela-tions in the object as a response to beauty; a pleasure not unlike the feeling of hav-ing solved a deep and troublesome problem, like a mist rising to reveal a sparkling clarity. This tradition differentiates between beauty, the good and the agreeably sensuous.

The second tradition, which I call the Pleasure-Principle Tradition, recognizes all pleasures evoked by perception (taste, touch, sight, hearing and smell) as caused by beauty, which in effect collapses the good, and the agreeably sensuous, into beauty.

There are many disagreements between the different perspectives represented by these two traditions that are caused by a failure to recognize the underlying assumptions of each position. The nature of beauty regarding its subjective/objective status, and its culture/species-specific basis, are interpreted very differently between the two groups. It is not that the two groups disagree about the features of a common experience; they are in fact both talking about different kinds of experience.

The Pythagorean Tradition of beauty has had poor press in the twentieth century largely because of misrepresentation; most notably through Clive Bell's theory of significant form and other narrowly formalist theories (Bell, 1914). A second influence was that, due to a post-Hegelian confusion that collapsed the metaphysics of beauty into an ontology of art, the possibility of beauty came to be understood as dependent on whether beauty figured in a definition of art. These two points considered together meant that if art was not defined according to some kind of formalism, then beauty was an outmoded concept. This line of influence inspired its adherents who wanted to resurrect beauty as relevant to art; to extend the meaning of beauty to include all responses caused by all artworks. The illogical twist in this thinking is exemplified in statements made regarding the beauty of ugliness (not a contradiction in terms, according to this confusion, because some artworks are ugly!).

Clive Bell's theory of significant form is narrowly formalist in that it does not recognize that the relations between ideas or concepts within an intellectual construct can give rise to an experience of aesthetic form and, hence, beauty. Recent work on the interface between perceptual and higher-level processing makes it possible to speak literally rather than metaphorically of the perception of intellectual constructs (see the discussion of 're-entrant processing' as such an example, in Posner and Raichle, 1994). The Pythagorean Tradition has always countenanced the possibility that mathematical theories, scientific theories, literature and behaviour can be experienced as beautiful along with artworks and nature. This tradition takes account of the very real difference between the kind of pleasure experienced in, say, the beauty of a mathematical theory as compared to the kind of pleasure evoked by sensuous voluptuous nudes, or the smooth rich taste of cheesecake.

The Pleasure of Beauty Compared to the Agreeably Sensuous

The evolutionary explanations for sexually derived pleasures and the pleasure of certain food tastes are very different from an explanation for our ability to experience beauty (i.e., beauty as it is understood in the Pythagorean Tradition, which is the sense in which I shall be using it from here on). For example, a male finding pleasure in voluptuous female nudes is responding to signs of fertility in a way

which will have the utmost chance of ensuring that he procreates. Furthermore, in responding pleasurably to taste textures and sensations associated with high calories, we are responding in a way that will encourage us to take in high-energy food (perhaps maladaptive in a relatively sedentary society such as ours in the West).

The nature of beauty, on the other hand, given its role in the development of mathematical and scientific theory, suggests an evolutionary explanation more along the lines of facilitating creative problem-solving. Anecdotal evidence from certain prominent mathematicians and scientists suggests that aesthetic concerns of unity are our only guide when moving beyond established conceptual frameworks in order to solve problems in a new way.[1] Conversely, James McAllister argues that the experience of beauty facilitates the stabilization of new paradigms (McAllister, 1989; 1996). According to McAllister, the new paradigm itself is accomplished through empirical discovery.

In any case, if the concept beauty is to denote something more than just a personal response on a par with 'this feels good'; if a consensus in judgments of beauty is possible and such an expectation appropriate; and the peculiar phenomenology of beauty (feeling of solving a problem even when the beautiful object is an art work) is to be explained; then a theory of beauty needs to delineate the pleasure of beauty from other pleasures. The Pythagorean Tradition solved this dilemma by recognizing only the pleasure caused by certain relations between an object's elements as the experience of beauty. As such, all objects (not only concrete objects but also intellectual constructs and temporally extended phenomena like music and performance) are possible objects of beauty, but, significantly, not all of the beautiful objects' aspects are relevant to a judgment of beauty.

In some cases, a particular aspect of an object, say its anticipated benefits to the viewer, holds our attention so completely that one is precluded from perceiving/apprehending its beauty. This is what certain ancient and mediaeval philosophers meant when they argued that a man who can only gain enjoyment from the satisfaction of appetites cannot perceive/apprehend beauty (Tatarkiewicz, 1974). It relates to what Aquinas (thirteenth century) meant by the difference between aesthetic and biological pleasures (Aquinas, 1964–76), and also to what Shaftesbury meant in the eighteenth century by employing the term 'disinterested pleasure' in relation to the pleasure experienced in beauty (Stolnitz, 1961). Furthermore, when an object arouses disgust, anger or desire, this kind of engagement can also preclude the kind of contemplation characteristic of the apprehension of beauty by ensuring that one is focussed on aspects other than those relevant to a judgment of beauty.

Perceptual Principles, Beauty, and Art

The analogy drawn by Ramachandran and Hirstein between their enterprise and the relation of Chomsky's work to literature (Ramachandran and Hirstein, 1999,

[1] For example, Albert Einstein is famously associated with this belief. See a discussion of his correspondence with Niels Bohr in McAllister (1996). For other examples see: Poincare in Ghiselin (1952); Dirac (1963); Weinberg (1993).

p. 50) is asymmetrical. Chomsky's work did not help us understand Shakespeare, that is true, but Chomsky did not claim to be analysing the principles of literature. He was concerned with the nature of language. Ramachandran and Hirstein, on the other hand, purport to be analysing art, not vision; hence we can reasonably expect their analysis to help us understand art better. And well it might, but not in the way that they themselves recognize.

The questions that need to be addressed in order to understand beauty are what kind of mental processes could simultaneously:

(i) account for the experience of beauty in such a way that both its subjectivity (I know something is beautiful by how it makes me feel rather than by first identifying the presence of necessary or sufficient conditions of beauty in the object) and objectivity (a judgment of beauty is grounded in objective properties in the object) can be understood as complementary rather than contradictory. In other words, we need to provide a rational basis for beauty which does not translate into principles (logically necessary or sufficient conditions for beauty); and

(ii) provide grounds for differentiating between the pleasures of the agreeably sensuous, the good, and the beautiful.

Ramachandran and Hirstein's principles address (i) but not (ii).

Rather than making a contribution to our understanding of beauty, the perceptual principles discussed by Ramachandran and Hirstein could be drawn upon to explain what kind of perceptual principles are exploited through certain art styles. In particular, their principles could be drawn upon to explain and identify the kind of relationship between an artistic representation and the world out there. For example, the isolation of one modality and the 'peak shift effect' might explain the relation between expressionistic pictorial representations, say of the Fauves in France and the Brucke artists in Germany of the early 1900s, and the world out there. This eschews the terms of the philosophical debate regarding whether pictorial representations resemble, denote, or symbolise their objects.[2] Instead, Ramachandran and Hirstein's principles focus upon the perceptual principles exploited by each of the various art styles in a way which promises to be more fruitful in providing an understanding of what artists are up to. Semir Zeki (1999) has begun a similar enterprise in terms of neurological explanation. However, neurology as evidenced in Zeki's work is only illuminating concerning art which exploits visual elements in relative isolation, either colour (Rothko), colour and line (Mondrian and Malevich) or movement (Alexander Calder's kinetic sculpture). Ramachandran and Hirstein's approach promises to be more fruitful because they draw upon psychological explanation, which has more to say about visual preferences concerning more complex combinations of visual primitives such as perceptual unities.[3]

[2] For example, see Goodman (1968); Gombrich (1977); Neander (1987); Lopes (1996).

[3] See my commentary on Zeki's *Inner Vision: An Exploration of Art and the Brain* at http://mitpress.mit.edu/e-journals/Leonardo/reviews/a-raw.html.

My suggestion as to the kind of perceptual principles which might hold the key to understanding the nature of aesthetic form and beauty are those principles which underpin the processing (detection) of within-object relations. According to Glyn Humphreys and Dietmar Heinke (1998), the processing of 'between-object' relations draws upon view-dependent primitives and the processing of 'within-object' relations draws upon view-invariant primitives. The latter necessarily involves some form of construction of the perceptual form from perceptual primitives as part of the process of perception.[4] If what we experience as aesthetic form or beauty is some kind of play on the processes involved in processing within-object relations (constructing perceptual form) during the course of perceiving certain objects, then the apparent problems of beauty would be resolved. The idea would be that the perception of certain objects employs perceptual processes involved with detecting within-object relations in such a way as to cause us to experience perception (consciously the object) as a solution to the problem of constructing a cohesive form, which itself is pleasurable.[5] It might be that the perception of certain objects employs these perceptual processes in a way that epitomizes their normal operations or employs them in a non-typical way, which causes us to experience something of the processes of perception itself. We would not normally be knowledgeable of the true source of the experience, attributing the feeling of pleasure to the objective properties of the object. Such an explanation would address the peculiar phenomenology of beauty. It would provide an explanatory basis for the possibility of a disinterested pleasure — a non-egocentrically based pleasure. It would also provide the explanatory grounds for differentiating beauty from the good and the agreeably sensuous.

Just one more observation before summing up. An interesting characteristic of the perceptual principles identified by Ramachandran and Hirstein is that they are analogous to creative problem-solving heuristics. Consider that principle (1) is about pushing boundaries; (2) about grasping salient points; (3) recognizing patterns; and so on. There are all kinds of stories we could tell about how perceptual principles might be mimicked in cognitive processes to account for the relation between perceptual principles and creative problem-solving heuristics, but this must be left for another time.

Conclusion

In sum, the particular perceptual principles identified by Ramachandran and Hirstein are not the basis for genuine judgments of beauty. This general approach, however, does seem to represent the only one open to us for understanding the nature of beauty within our present scientific paradigm. Furthermore,

[4] For an explanation of the difference between view-dependent (image-based) and view-invariant (constructivist) theories of vision see Tarr and Bülthoff (1998).

[5] Evolutionary-wise, perception having evolved through interaction between organism and environment, we could assume that principles of perception reflect something about the world out there. This might contribute to an understanding of the relation between aesthetic form and scientific theories that have application. The story might go something like this: theories that satisfy or reflect the relations favoured by perceptual principles also reflect the structures underlying the world out there.

Ramachandran and Hirstein's work demonstrates that understanding the nature of perceptual processes offers much promise for clarifying, re-construing and perhaps even dissolving certain problems in philosophical aesthetics; the nature of artistic representation being a case in point.

References

Aquinas, St Thomas (1964–76), *Summa Theologiae* (London & New York: Blackfriars).

Bell, Clive (1914), *Art* (London: Chatto and Windus).

Dirac, P.A.M. (1963), 'The Evolution of the Physicist's Picture of Nature', *Scientific American*, **208** (5), pp. 45–53.

Gombrich, Ernst (1977), *Art and Illusion* (Oxford: Phaidon Press).

Goodman, Nelson (1968), *Languages of Art* (New York: Bobbs-Merrill Company).

Humphreys, Glyn W. and Heinke, Dietmar (1998), 'Spatial representation and selection in the brain: Neuropsychological and computational constraints', *Visual Cognition*, **5** (1–2), pp. 9–47.

Kant, Immanuel. (1987), *Critique of Judgment*, trans. Werner S. Pluhar (Indianapolis: Hackett).

Lopes, Dominic (1996), *Understanding Pictures* (Oxford: Clarendon Press).

McAllister, James (1996), *Beauty and Revolution in Science* (Ithaca: Cornell University Press).

McAllister, James (1989), 'Truth and beauty in scientific reason', *Synthese*, **78** (1), pp. 25–51.

McMahon, Jennifer Anne (2000), 'Beauty' in *The Routledge Companion to Aesthetics*, ed. Berys Gaut and Dominic Lopes (London: Routledge), pp. 227–38.

Mothersill, Mary (1984), *Beauty Restored* (Oxford: Oxford University Press).

Neander, Karen (1987), 'Pictorial representation: A matter of resemblance', *British Journal of Aesthetics*, **27** (3), pp. 213–26.

Poincare, Henri (1952), 'Mathematical creation' in *The Creative Process*, ed. Brewster Ghiselin (New York: Mentor), pp. 33–42.

Posner, Michael I. and Raichle, Marcus E. (1994), *Images of Mind* (New York: W.H. Freeman and Co.).

Ramachandran, V.S and Hirstein, William (1999), 'The science of art', *Journal of Consciousness Studies*, **6** (6–7), pp. 15–51 (Special Issue on *Art and the Brain*).

Stolnitz, Jerome (1961), 'On the origins of "Aesthetic Disinterestedness"', *The Journal of Aesthetics and Art Criticism*, **20** (2), pp. 131–43.

Tarr, Michael J. and Bülthoff, Heinrich H. (1998), 'Image-based object recognition in man, monkey and machine', *Cognition*, **67**, pp. 1–20.

Tatarkiewicz, Wladyslaw (1974), *The History of Aesthetics, Vols. I & II* (The Hague: Mouton).

Weinberg, Steven (1993), *Dreams of a Final Theory* (London: Vintage).

Zeki, Semir (1999), *Inner Vision: An Exploration of Art and the Brain* (Oxford: Oxford University Press).

Soren Hald Jorgensen

Handholding Me

Donnya Wheelwell[1]

Against the Reduction of Art to Galvanic Skin Response

This essay exposes several problems with reductionist approaches to art, placing some specific focus on 'The Science of Art' by Vilayanur S. Ramachandran and William Hirstein (1999). Their article seems to be representative of this genre in general, though particularly egregious in certain dimensions. My approach will differ greatly from that of a neuroscientist, philosopher, or psychologist, since I primarily take a critical feminist, social-literary perspective. I will argue that reductionist approaches to art are an intoxicating composite of arrogance, insight, confusion and precision, an amalgam that challenges the commentator to distinguish what is worth praising, what is worth attacking, and what is best left alone. In particular, I will demonstrate that Ramachandran and Hirstein (hereafter, R&H) confuse arousal (in a certain technical sense) with beauty, with the disastrous result of excluding most of what is usually taken to distinguish 'high' art from its 'lower' forms, such as advertising, industrial design, and pornography.

Arrogance

Great art is generally taken to express the most refined sensibilities and highest aspirations of humanity. Its value is that it lifts us above our mundane concerns with livelihood, family, status, reproduction, friends, and the pursuit of superficial pleasures, though, of course, great art may also serve to recontextualize such concerns. In view of this traditional social role for art, it is offensively arrogant to try to reduce it to some simple empirical measurement, such as the galvanic skin response. Scientists of this stripe presume to tell us lesser mortals what art *really* is, while in reality ignoring everything that makes art valuable for us in the first place. Only the priest-like status conferred upon scientists by the enormous success of technology makes it possible for them to attempt to colonise the humanities in such a brutal manner.

[1] The research reported in this paper has been opposed in whole or in part by agencies too numerous to mention. I hope that readers will not allow my occasional flights of whimsy and rhetorical exaggeration to distract them from the wholly serious main line of argumentation.

Journal of Consciousness Studies, **7**, No. 8–9, 2000, pp. 37–42

As a case in point, let us consider 'The Science of Art' (Ramachandran and Hirstein, 1999). As its title suggests, this piece is written in the grand manner, having the form of a survey of established empirical results, embellished with illustrations of a popular nature. However, this familiar scientific-literary form creates an exceedingly misleading impression, because the authors have neither conducted nor reported *any* serious empirical tests of their purported principles of art, and the leap from the principles to the illustrations is usually tenuous, often dubious, and always misleading. What might charitably be said to lie behind the grand facade is a kind of manifesto, describing a programme of research, with some initial hypotheses, some plausibility arguments for their validity, some vague suggestions for experiments, and some examples and general discussion that hint at how the whole thing might eventually tie together. If the authors had expressed their hopes and plans in such a modest language, one might with some justification call (aspects of) the result promising, interesting, perhaps even exciting; but given how this paper is actually written, one must condemn it as reductive megalomania, an arrogant and unwarranted extrapolation from an almost completely inadequate empirical base, to broad assertions having (as we shall see) some unpleasant social and political overtones.

Insight

Despite centuries of Western mind–body separation, and despite the elevation of mind, intellect, intelligence, etc. at the expense of body (the corporeal, sensual, mortal, etc.), it is now becoming obvious that human physiology, including neurophysiology and the sense organs, should play a role in aesthetics. For this reason it would certainly be interesting to see this topic explored with appropriate care and modesty. In this regard the proposals of R&H are original and provocative, and make a good case that a careful empirical approach could uncover some fascinating details. In particular, it does seem plausible that the peak shift effect should be significant for a better understanding of certain technical aspects of art.

Confusion and Precision

This section, with the subsequent section of textual analysis, will be the most content-laden of this essay. Before turning to more contentious issues, I wish to make it clear that I have nothing against scientists having a go at art. Learning more about the human perception of beauty could be useful and healthy. It's the 'nothing but' face of reductionism that I find ugly, as in Francis Crick's infamous claim (paraphrasing Lewis Carroll) to the readers of his book that they are 'nothing but a pack of neurons' (Crick, 1994, p. 3). For example, the scientific study of the ear has recently produced impressive medical advances, so that many who would once have been irretrievably deaf can now expect to have almost normal hearing. But how many doctors would say to a patient that hearing is 'nothing but' some levers, membranes and nerves? Any decent physician knows how much hearing means to a patient, in terms of contact with the world, such as music,

conversation with loved ones, business phone calls, movies, and much more. In a similar way, there is much more to art than that which can be reduced to psycho-physiological measurements.

Today's psychology is the result of a long struggle to achieve scientific respectability. In the process, much of what is interesting and important to human beings has been sacrificed for that which can be measured in repeatable laboratory experiments. It is typical that topics like beauty are avoided, with attention instead focused on more technical constructs like arousal. Robert Sternberg's well-regarded recent textbook on cognitive psychology defines *arousal* as 'representing alertness, wakefulness and activation' (Sternberg, 1998). Though I must say that I find this definition still rather vague, it is certainly more precise than our commonsense notion of beauty, and it has the advantage that one can relatively easily devise ways to measure it in suitable experimental situations.

In this spirit, it would make sense to ask how, in suitable experimental situations, measurements of arousal (such as galvanic skin response, also known as skin conductance response, or SCR, which is familiar from so-called lie detectors and is suggested by R&H for use in their possible future experiments) correlate with suitably elicited subjective evaluations of beauty. But it does *not* make sense to simply *identify* arousal with beauty, as R&H have done. In fact, their paper can be seen as a *reductio ad absurdum* argument against their unstated, unjustified, and in fact unjustifiable presupposition that the quality of art can be determined by measurements of arousal, since this leads to the preposterous and disastrous conclusion that the best art is pornography. This is because, under normal conditions,[2] it is precisely such stimuli that produce maximum arousal in normal male subjects.

It is also important to note that the average female subject is much less aroused (again, in the technical sense) by the nude female form than the average male subject, because it is this observation that reveals the distasteful male voyeurism implicit in many examples that are presented.[3] I would finally note that the experiments proposed in this text, though undoubtedly interesting and valuable, would, because of their specificity, be unable to establish the overly general and grandiloquently named 'laws of aesthetic experience' proposed by R&H, even if carried out with complete rigour and success.

If we were highly evolved ants, our art would certainly be exceedingly different than it is. It's hard for us to imagine what might appear in the centrefold of the *Insect Trust Gazette*,[4] but no doubt the mode of reproduction, the caste-based social system, the large compound eyes, and the sensitive chemical sensors, would all be significant sources of that difference. An extrapolation from their paper suggests that in undertaking such an exercise, R&H would focus almost exclusively on a single sense modality (perhaps olfactory) and its associated

[2] We should exclude as 'abnormal' stimuli such as intense pain, and subjects suffering such conditions as great hunger or thirst.

[3] And many readers will no doubt consider the example of Nixon's face to be scarcely less offensive than the nudes.

[4] With apologies to William S. Burroughs.

neural systems, using examples that reeked of reproduction without explicitly mentioning it, and almost completely ignored social factors. They might make a good start on a science of insect centrefolds. But would this help us to understand art? Or would it just be insect pornography?

Textual analysis

It is of the nature of textual analysis to work in a precise and detailed way with a specific text. R&H's 'The Science of Art' is an appropriate text for this treatment because it is representative of its genre, is of relatively high quality within its class, and illustrates certain difficulties with a particular clarity.

No one who reads the R&H text, or even casually glances at its illustrations, can fail to notice an inordinate focus on the nude human female form. It should take little effort to see that this is offensively sexist and exploitative: the text treats the female form as an object that is subjected to scientific examination, with no connection to actual human beings or their actual life situations. Furthermore, illustrating technical points with the nude female form, again and again and again, may have the result of amplifying interest in the text at a subconscious level, attracting attention from the popular press, augmenting sales and, most importantly, reinforcing the cycle of sexist exploitation.[5]

It may take a little more thought to see that there are deeper problems with this text than sexism and exploitation. Let us start by noticing that the word 'pretty' is used to describe various 'artistic' results of exploiting the peak shift effect (p. 32).[6] But this word is never used by serious artists or art critics as a synonym for beauty; on the contrary, it would most often be considered an insult, because the art community is acutely aware that art which strives for immediate appeal is almost certainly shallow.

What then is it that makes art profound? Needless to say, opinions vary widely, despite the strong consensus that the merely 'pretty' cannot be profound. Certainly no serious artist or art critic would argue that short term arousal has any deep value. Many would argue that profound art should somehow illuminate deep aspects of the human condition, for example, exposing conflicts, ambiguities, sorrows, joys, their transitory nature, the inevitability of change, and ultimately of death. And many others would argue that good art uplifts the human spirit,

[5] Note that the method of textual analysis, after identifying certain patterns and their effects, calls for attributing the corresponding intentionality to the text itself, and only by metaphorical extension to its authors, without any implication that the authors ever explicitly had such an intention. Hence the above must not be considered an *ad hominem* argument; instead, it is an analysis of the *text itself* that takes account of its social context in a broad sense. It is in the nature of textual analysis to focus on a text and its context, rather than on its author, in much the same way that science focuses on an object and experiment, rather than on the experimenter. Thus, to be quite explicit, it is my claim that this text is by its nature sexist and exploitative, because of the signs that it uses, the way that it uses them, and the probable social effects of this use. This is not to claim that the authors in their private lives are either sexist or exploitative.

[6] Although this is the only instance of the word 'pretty' in R&H's published text, in an earlier draft, which was circulated to potential commentators, it was used repeatedly (see Wallen, 1999). Moreover, the use of this word captures very well the spirit of the R&H enterprise.

suggesting or revealing what is best in our species and our world. In comparison with such values, the approach proposed in this text can only be called superficial, tawdry, reductive, debasing, offensive, and ultimately anti-human.

The appeal to higher values made in the previous paragraph (which could easily be supported by numerous quotations from artists, critics, historians, philosophers, and even some experiments) should by no means be considered a denial of the importance of the low level visual processing that occurs in V1 and related regions of the brain, as explored for example (with greater modesty, as well as greater precision and detail) in the work of Semir Zeki (1999). However, it *should* be taken as evidence that such low-level processes are only the *beginning* of a much more complex and interesting story, presumably involving further 'high level' processing in areas of the brain that are more attuned to the emotions and to prior experience of the world, including culture. It is remarkable that R&H ignore both the prior experience of their subjects (such as their artistic sensitivity) and all aspects relating to culture (e.g. preferences for or against bright colours). Their use of Indian art is *not* cross-cultural, but rather based on the absurd assumption that culture just does not matter. How can we possibly take seriously experiments based upon such presuppositions, when it is well known that they are false in a wide variety of similar situations?

Just because science is beginning to understand low-level visual processing does *not* mean that that is all that is involved in art; exactly this kind of reductive error is characteristic of the arrogance of science, and can be seen again and again throughout its history. I have little doubt that future research will uncover neurobiological, evolutionary and psychological bases for emotional responses to art, and to the strong role played by prior experience, thus undercutting the crude reductionism proposed in this text. Research of this kind, however brilliant, can never reduce human experience and human values to impersonal scientific principles, because these belong to completely different epistemological categories (Oakeshott, 1933/1966). It is a common and tragic error of Western culture (though not of science as such) to fail to distinguish third person objective knowledge about things from direct first person experience of things.

The attentive reader will also notice a rather strong Indo-centric bias in the text. For example, the third paragraph criticizes Western artistic sensibility, and argues that Indian art is centuries more advanced in some respects; moreover, most of the art that is most praised in the text is Indian. It is delightful to find a serious scientific text that goes outside the Western tradition for examples, and even its bias is a welcome corrective to the far more usual Eurocentric bias of the scientific and art critical literatures. But these authors have not provided careful arguments for their assertions about Indian art, and it is doubtful that they have an adequate appreciation of the cultural background of the Indian images that they exploit, many of which come from temples, and hence undoubtedly have a religious dimension that they have studiously ignored. Classical Indian culture was deeply aware that there is more to human life than the enjoyment of the senses; indeed, several important streams of Indian religious thought consider such pleasures as merely one possible gateway to wisdom, provided of course that it is

practised with an appropriate discipline. Hence it is very likely that the Indian artifacts exploited in this text are neither art in the traditional western sense, nor in the reductive R&H sense, but instead are religio-cultural icons, that have deep multi-faceted resonances within their original contexts.

Conclusions

Reductionist approaches like that proposed by Ramachandran and Hirstein have little to offer art, artists, or lovers of art, and moreover serve to perpetuate a number of serious misconceptions about the nature of art, as well as a pernicious and offensive value system. However, work of this kind could be of significant practical value to professional pornographers.

Based on the relatively careful textual analysis conducted above, I nominate this paper for inclusion among the most clear-cut examples of late twentieth century sexist scientific and reductive megalomania. This text also illustrates the deep misunderstanding of the humanities found among many of today's scientists, unfortunately without their being in the least conscious of their ignorance of vast areas that lie outside science in the narrower sense, or of the dangers and malignant consequences of this ignorance. In summary, this paper has argued that, contrary to R&H, most art is more than caricature, whereas their paper demonstrates that some science is less than caricature.

References

Crick, F. (1994), *The Astonishing Hypothesis: The Scientific Search for the Soul* (London: Simon & Schuster).

Oakeshott, M. (1933/1966), *Experience and Its Modes* (Cambridge: Cambridge University Press).

Ramachandran, V.S. and Hirstein, W. (1999), 'The science of art: A neurological theory of aesthetic experience', *Journal of Consciousness Studies*, **6** (6–7), pp. 15–51 (Special Issue on *Art and the Brain*).

Sternberg, R.J. (1998), *Cognitive Psychology*, 2nd edition (Orlando, FL: Harcourt Brace College Publishers).

Wallen, R. (1999), 'Response to Ramachandran and Hirstein', *Journal of Consciousness Studies*, **6** (6–7), pp. 68–72.

Zeki, S. (1999), 'Art and the brain', *Journal of Consciousness Studies*, **6** (6–7), pp. 76–96.

Erik Myin

Two Sciences of Perception and Visual Art

Editorial Introduction to the Brussels Papers

Two kinds of vision science are distinguished: a representational versus a nonrepresentational one. Seeing in the former is conceived of as creating an internal replica of the external world, while in the latter seeing is taken to be a process of active engagement with the environment. The potential of each theory for elucidating artistic creation and aesthetic appreciation is considered, necessarily involving some comments on visual consciousness. This discussion is intended as a background against which various themes of the papers light up.

Representational Science of Vision

In May 1999 a 'Cognitive Science Conference on Perception, Consciousness and Art' was organized at the Free University of Brussels (VUB). It consisted of two thematically overlapping parts, one on 'Perception and Consciousness' (see Myin (in press, b) and the other on 'Perception and Art'.

The rationale for the conference was the enormous expansion in the science of perception in the last decades. As readers of this journal are well aware of, the study of visual perception is a blossoming field. Ever finer methods of directly observing the brain, and the use of these in contexts borrowed from experimental psychology, allow researchers to render transparent and peer into what used to be the black box of the brain. Indeed, the cognitive neuroscience of visual perception does not lack triumphant claims. It is widely believed that the overall architecture of the visual system is known, as a result of a kind of grand synthesis of research in computational vision, anatomy, physiology and empirical psychology. Two concepts dominate this research: the notion of *pathways* or *modules*, and the notion of *representation*. These two concepts ground the hope for a deep connection between the representational science of vision and the art of visually representing. Therefore, it seems good to probe a bit deeper into the motivation for each of them.

Journal of Consciousness Studies, **7**, No. 8–9, 2000, pp. 43–55

Both notions flow from the basic assumption that the visual stimulus is *ambiguous* and *fragmented*. It is *ambiguous* because, in principle, multiple and different distal stimuli can give rise to the same proximal stimulus. For example, a large square at a distance can project exactly the same image on the retina as a small square nearby. According to representationalists, this failure of one-to-one mapping between the distal and the proximal shows that vision requires internal computational processes, whereby additional knowledge, often considered to be 'inborn', is used to disambiguate the stimulus. The output of such a process is a re-representation of the proximal stimulus in a unequivocal format that truly codes for the distal stimulus (in the example given, it represents the square truly as either large or small). According to the classical view, perceptual input information is also *fragmented*. Fragmentation applies at a variety of levels. Input is not only fragmented over different sensory organs, the organs in one modality also come in pairs (think of the nose as two nostrils). Moreover, within every sensory organ, the input is spread out over thousands, if not millions of receptors.[1]

The representational solution for the problem of fragmentation lies in the notion of representation itself. It is assumed that the brain casts its representations in a certain code or form. It is at the level of this code that brain processes communicate and understand each other's computational products. Naturally then, it is at this level that the perceptual scientist must aim, rather than at the underlying processes that (merely) instantiate this code. This basic idea of a code underlies various representationalist alternatives: for 'symbolists' it is the level of structured items such as recursive lists; for connectionists, the code is constituted by the activation vector of a relevant set of neurons; for at least some neurophysiologists, the code is constituted by the receptive field properties or feature detecting propensities of the neurons that are activated at any moment in the brain.[2]

The representationalist account of the enormous and rapidly growing empirical evidence about the visual brain has stabilized into a fairly standard picture. The basic tenets of it are that the visual system is organized along what could be called a horizontal and a vertical dimension. In the vertical dimension, different stimulus attributes such as form, colour, motion and depth are computed, with some degree of independence or at least segregation (cf. for example, Zeki, 1993). The organization along the horizontal dimension is postulated because it is believed computations within every vertical module are carried out in stages. Early processes compute 'intermediate representations' which are then sent as output to further processes, with iteration. Representations are believed ever to become more powerful: while at early stages they code for simple stimulus features such as orientation or direction of movement, at later stages they code for three dimensional layout, or conceptual category.

[1] For some reason or other, even deeper levels of subcellular fragmentation are never considered. For a recent theory of perception without any fragmentation, see Stoffregen and Bardy (in press). Some of the points made later in this introduction are borrowed from my commentary on that paper (Myin, in press, a).

[2] See Shanon (1993) for more on the idea of a code, its crucial role in the representationalist tradition and a penetrating criticism of that tradition.

Of course, the actual theories presented, or, as is often the case, implicitly assumed, have various additional features. For one thing, information stream and influence between horizontal modules is assumed to occur in both an upward and a downward direction (a point stressed heavily, for example by Churchland, 1995). Moreover, there is mostly assumed to be a higher level of vertical organization, in which groups of modules cooperate. For example, there's the idea of basically two vertical streams, one dedicated to spatial aspects of visual perception, the other aimed at more abstract conceptual classification and recognition (Ungerleider and Mishkin, 1982). For a more recent and somewhat divergent version, cf. Milner and Goodale (1995).

It is quite natural that such a grand picture of what has become to be called 'the visual brain' (Milner and Goodale, 1995) is taken to have tremendous potential for understanding visual art. Many possibilities open up. An initial one flows from the notion of representation: given that both the brain and the artist are in the same business of representation, perhaps the overt representing of the artist is highly constrained by how the brain represents the visual world internally. Art could be classified in respect to how successful it is in manipulating the brain's representational schemes. The artist can then be portrayed as a kind of experimental psychologist who probes the visual system with pictures (Latto, 1995; Solso, 1994; Zeki, 1999). The modularity of vision leads to the related idea that different art styles could be correlated with different stages in there presentational cascade (Latto, 1995; Willats, 1997; Zeki, 1999). Their differences and specific characteristics could be accounted for in terms of their latching on exactly to any of the representational formats the brain is intrinsically using to represent visual scenes. 'Isolating' and uniquely stimulating one module by carefully selecting what she puts on the canvas, might in itself be a way for an artist to create unusual experiences of heightened intensity (Latto, 1995, p. 88; Ramachandran and Hirstein, 1999; Zeki, 1999). Relatedly, the artist might aim for and achieve her aesthetic goals by over-stimulating along a certain dimension of representation (Latto, 1995, p. 88; Ramachandran and Hirstein, 1999).

Alternatively, artists might not only be exploiting the visual system positively, but also taking advantage of some of its 'shortcomings' in order to obtain some effect or other. For example, Margaret Livingstone has argued that the dynamic impression of Mondrian's *Broadway Boogie Woogie* might be an effect skilfully obtained by casting yellow borders in low luminance contrast on a white background (Livingstone, 1988, p. 73). As the vertical spatial module is supposed to be fairly insensitive to such type of contrast, this creates the impression of uncertain and thus jumping borders (Livingstone, 1988).

Despite the almost universal acceptance of the representationalist paradigm as a framework for understanding visual perception, it faces many unsolved problems.

At the conceptual level, representationalism is vulnerable to a double-edged criticism: there seem both to be too *many* persons in the representationalist's brain, while at the same time, the most important person *seems to be missing*. The first aspect concerns the question whether it is really legitimate to explain the

end-product of perception, a person's representation of the world, in terms of sub-personal processes of the same kind, thus concerns the legitimacy of the very notion of internal representation itself (Ryle, 1949; Wittgenstein, 1953; Shanon, 1993). Simply stated, this objection goes as follows: we understand how whole persons interact with, look at or understand scenes or pictures, but how can we postulate that a somewhat downscaled version of this process goes on in the brain — when one functional unit handles the representational output of another one — without introducing the dreaded homunculus, or whole teams of them? The reverse side of the problem is that there seems to be a person *missing* too. In the computational interplay of these myriad representations, where is the conscious perceiver? A general tenet of the reprentationalist's theory is that only some representations are 'selected' for consciousness, while the others perform their jobs in the experienceless caves of the unconscious. Various answers have been proposed from within the representationalist tradition to the question of what this 'selection for consciousness' comes down to, from an avowed mysterious notion of 'projection' into consciousness of selected representations (see Jackendoff, 1987; for a neurobiological version, see Zeki, 1993) to a notion of a distinctive functional role played only by those representations that become conscious (see, for a philosophical version, Rey, 1993; for a psychological version, Baars, 1988).

Another family of problems that the representationalist faces could be called problems of *representational explosion.* Even if we forget for a moment about unconscious processes, and only assume that the contents of consciousness need to be built up out of underlying representations, we already encounter this problem in an acute version. For any focal content of consciousness seems to be possible only against a 'background' of memories, expectations, affections, etc., that give a precise and distinctive meaning to the focal content. If this background is to be modelled in representationalist terms we seem to open the door for a regress. On the other hand, if it doesn't, this shows there is a level of representation or intelligence that can be modelled *without* invoking representations, and then the question arises whether this kind of analysis could not be applied to the original problem of focal consciousness itself. A problem related to this representational explosion is the famous 'binding problem', how to account for the synchronic integration of all the fragmented modular contents (cf. Crick and Koch, 1990, in which it is suggested that synchronization of neural spiking frequencies in the 40 Hertz range is the solution). Moreover, though this seems less often noticed, the 'binding problem' has a diachronic aspect also. The contents of consciousness are not only bound in the synchronous dimension, but certainly also in the diachronous dimension. Consciousness is a *stream*, not a series of unconnected snapshots.

Because these problems potentially invalidate the whole representationalist framework, they are obviously indirectly relevant for its applicability to artistic phenomena. For one thing, if the representationalist framework is unfit to account for consciousness, it seems definitively the wrong choice to account for aesthetic perception, one of whose marks is an *intensification* of consciousness (cf. Mangan, 1999; Church, 2000). However, there are more direct challenges that

arise from considering how the representational framework can be and has been used to illuminate art.

One potentially problematic aspect of the explanation of art phenomena, as they have been offered from within the representationalist tradition, is that they typically concern fairly low level perception. Instead of being a deep problem, this might just be a reflection of the youthfulness of the cognitive neuroscience of vision. On the other hand, it might also be a diagnostic sign that the explanatory potential of the cognitive neuroscience of vision becomes increasingly less powerful when things get more complicated and, arguably, more interesting.

A probably more important and deeper problem is that there is a difference between 'goodness' for perception and 'goodness' for art and aesthetics. The ability of a stimulus to create a peak response in whatever area of the visual system might be an entirely different property from its capacity to create aesthetic appreciation. Indeed the former might neither be a necessary nor even a sufficient condition for the latter (a point recurring in the commentaries on Ramachandran and Hirstein, 1999, in *Journal of Consciousness Studies*, **6** (6–7) and in the current issue).

The difference between the areas of perception and aesthetics might also show up in the fact that the two areas face different 'binding problems': the binding problem of perceptual integration (seeing the world as not disintegrated) might be only a very low level aspect of — or even independent of — the 'structured unity' which we experience when perceiving art. Even if 'synchronization' in the brain were to supply a solution for the former problem, it might still not provide an answer to the latter question.

Nevertheless, either the representationalist tradition could find satisfactory answers to such criticisms, or, alternatively, it could find different ways to play an important role in the elucidation of art and aesthetics. Perhaps it could point out how some aspects of ordinary perception are crucially involved in aesthetic appreciation, perhaps in a transfigured form, or just as an aspect of a more complicated process created by the novel context of aesthetics. For example, perceptual 'binding' might play a crucial though somewhat different role in both perception and aesthetics.

Also, it should be borne in mind that at least some variants of the representational theory of mind are *very* ambitious. Building on the basic assumption that everything mental is to be accounted for in terms of brain-based representations, a tough-minded representationalist might hope for the discovery of the appropriate modular representational systems for art and aesthetics. Why not hope for an 'aesthetic representational module'? Art could then be elucidated by showing how this module interacted with different lower level modules and, perhaps, how the form of its representations — or of its representational primitives — constrain aesthetics. Of course, this might seem a non-starter because, if anything, aesthetic appreciation seems to lie at the extreme end of non-modularity. Everything one knows can affect one's aesthetic appreciation (Fodor, 1983). To give a rather

trivial example: a work might be considered mediocre until it gets looked at with different eyes because it is found out it is painted by an Old Master.[3]

In sum, the hope of applying the representational theory of vision in a fruitful way to art and aesthetics faces problems of two kinds. First, it might be questioned whether it will be applicable at all, and secondly, it seems that, if its applicability is granted, it cannot play the exclusive role some people want it to play. It seems clear it can only form part of an explanation. Extra explanatory force needs to come from other directions.

A Nonrepresentational Alternative

Though the representationalist framework has been and still is the dominant tradition in visual science, it has not been without contenders. In the latter part of the twentieth century, it has been subjected to vigorous philosophical criticism by philosophers such as Gilbert Ryle (1949) and Ludwig Wittgenstein (1953), and also by several philosophers in the phenomenological tradition, such as Maurice Merleau-Ponty (1945). In the field of visual science proper, the name associated most strongly with resistance to representationalism is that of James Gibson (1979). Gibson takes a fundamentally different approach towards visual perception by rejecting the — for the representationalist — fundamental notions of ambiguity and fragmentation. According to Gibson, the stimulus has these properties only when it is considered from the limited *spatial* perspective of the receptor's point of view, or from the limited *temporal* perspective of a single glimpse of a scene in an immobile posture.

The characteristic Gibsonian 'ecological' move is instead to consider vision and perception in general from the point of the whole perceiving organism, moving around in its environment. This nips the problem of fragmentation in the bud, because from the perspective of the whole organism, the stimulus is not fragmented. The problem of ambiguity is solved by bringing additional movements into play. The retinal projection of a large square at a distance and a small square nearby, after all, is no longer the same once the head is moved. External movements of the animal with respect to the perceived object replace internal inferential processes.

Having undercut their foundation, this view thus radically says goodbye to internal representations. Vision is not seen as building up an internal replica of the external, but as a process of resonating directly with the environment. Representations are replaced by 'invariants': robust patterns in the physical world that become accessible to the creature by actively exploring the world. For example, the distance of objects to the creature is grasped through patterns of 'optic flow', the patterns of expansion projected on the visual apparatus when objects are approached. Internal inferential processes and intricate learning are replaced by gradually becoming more sensitive to, by 'learning to pick up', those invariants (Gibson, 1979).

[3] This happened very recently in a small town near Brussels. A work in the local church, not considered particularly interesting, got reappraised after maintainance work uncovered Poussin's signature.

Gibsonian visual science has flourished ever since its inception as somewhat the official 'alternative'. Despite efforts to incorporate it into a representationalist perspective (Marr, 1982), it has remained a somewhat isolated strand of research with its dedicated set of followers, and its own journals, symposia, etc. Perhaps this picture is changing, as there is definitively a renewed and unprecedented surge of interest, if not in 'pure Gibsonianism', then certainly in the kind of approach advocated by Gibson. Partly arising out of intellectual dissatisfaction or the experienced inapplicability of the representationalist framework, researchers are stressing the importance for perception of 'embodied' activity in the real world, dynamical loops orbiting from the organism through the environment and back again (Hurley, 1998), 'active vision' in robotics (Blake and Yuille, 1992), or the importance of 'dwelling in the world' (Ingold, 1993).

A detailed theory of visual perception along these lines has recently been worked out by Kevin O'Regan and Alva Noë (in press a & b).[4] One of the cornerstones of this theory is formed by experiments in 'change blindness'. Typically, subjects in such experiments are shown successive pictures of scenes in which large changes have occurred. Much to their own surprise when later confronted with it, subjects seem unable to notice these changes, even when they are very big, sometimes making up more than thirty per cent of the presented scene. From such and other evidence, O'Regan and Noë conclude that the representationalist picture is false. Instead, they propose a conception of vision in which vision is more or less like *touch* (this metaphor is also used by Church, 2000). The eye is seen as 'a giant hand that palpates the environment' (O'Regan and Noë, in press b). Just as the haptically perceived object extends beyond the points where the fingers are in direct contact with it, so the visual world extends far beyond those few points where change blindness experiments have shown we are in direct visual contact with it.

The experience of a unified visual world 'out there', is thus not coming from a unified internal representation of it, but arises out of the implicitly mastered knowledge of what O'Regan and Noë call *sensorimotor contingencies*. Avowedly akin to Gibsonian invariants, these are regularities that pertain to the lawful interaction between light and objects, and objects and the moving perceiver. According to the theory, an organism sees an object as spherical, if it finds out that the stimulation by the object changes in certain lawful ways when either the object moves, the light changes, etc., or when the animal itself moves.

This approach to vision redefines the field in such a way that some of the pressing problems of the traditional approach either no longer arise or else have an obvious solution. Consider for example binding (cf. O'Regan and Noë, in press b, and Myin, in press a). On the one hand, there is no longer conceptual space to formulate the problem in its original form, because vision is no longer seen as the result of an interplay of internal representations. The problem of the unity of the subjective experience of the visual world becomes the problem of integrating

[4] Kevin O'Regan and Alva Noë were both speakers at the 'Perception and Consciousness' part of our conference (cf O'Regan and Noë, in press a; Noë, in press). Through a somewhat lucky coincidence, this journal does contain a paper by Alva Noë on art (Noë, 2000).

one's capacities to interact with the world when guided by one's visual apparatus. It is concerted activity, rather than an internal process like sychronization, that unifies experience. This seems to be borne out by evidence from psychopathology and experimental psychology. As an example of the former, hemineglect can be considered. According to one well-established theory of hemineglect (the condition in which patients neglect the existence of everything on one side in their world, including their body), the problem is due to an attentional deficit, rather than an inability to represent the world (Kinsbourne, 1995). Patients with hemineglect are simply no longer motivated to interact with anything on (usually) the left side of their world, because they are over-attentive to what happens on the other side. Additional evidence comes from famous experiments with distorting goggles (cf. O'Regan and Noë, in press b, and Hurley, 1998, for references and discussion). It appeared that when wearing goggles that distort the retinal image, by turning it upside down or mirror reversing it, people first experienced the visual world as distorted. But after a while, as they relearned how to carry out their normal everyday activities, their visual world returned to normal. This in itself shows the decisive role of action in subjective experience. What is particularly telling, however, is that, before complete adaptation was achieved, there sometimes was disunity in consciousness. A car, for example, was seen in its normal position, but the letters on its licence plate were distorted. The occurrence of disunity in experience was correlated with the different degree to which different capacities had returned to their normal level of functioning — thereby proving directly that behavioural integration is the key to experiential unity. For discussion, see Hurley (1998), pp. 347–8; O'Regan and Noë (in press b).

What about consciousness? Consciousness can be seen as a particular capacity for interacting with the world, with features such as flexibility, integratedness and goal-orientation, in humans certainly partly due to language. Being a capacity of the whole person, or whole organism, the double problem of the missing person and the homunculus is evaded. The experiencing person is there, not in the brain, but 'out in the open', as an embodied mind interacting with its environment (cf. Hurley, 1998). Because no attempt is made to reduce experience to computational processes in the brain, no homunculi are posited. Of course, much more needs to be said, but at least there seems to be potential here.

Is there potential to illuminate art also within this tradition? A first aspect to notice is that this approach in any case appears to be able to do justice to an aspect of art that is quite out of reach for the representationalist: the 'material aspects' of art, which are of extreme importance to both the artist (cf. Ione, 2000) and the spectator (cf. Kindy, 1999). If perception is seen as a process of actual interaction between a perceiver and the object of perception, rather than as an internal process in the perceiver's brain, all the aspects that shape this interaction might become important. Artists recorded self-reflections often testify of an extreme sensitivity to very subtle effects of light, reflection and texture. Monet, Cézanne and Van Gogh's repetitive depictions of the same scenes in different lighting conditions show how strong this preoccupation can become (see Hardin, 2000, on Monet; Ione, 2000, on Cézanne).

The materiality of art matters also to the spectator. It is what confers individuality on the exposed work, tying it to the specific viewing conditions of the place and time of exposition (cf. Noë, 2000). These 'external' conditions might, either by deliberate anticipation by the artist, or by historic contingency, become part of the art work itself.[5] Reflecting on these aspects, Julia Kindy (1999) remarked:

> Painting and sculpture must be experienced in their actual form and not in reproduction. One can never understand the all-encompassing, radiant atmosphere of a Mark Rothko painting, for example, unless standing in front of it. The scale alone of a Rothko canvas is meant to relate directly to the body, so that the painting can be 'absorbed' by more than the eyes. It is a direct physical experience. Looking at a reproduction is meaningless (p. 63).

Kindy's observations concern not only the materiality of the product of the artistic creation, but the full concreteness of the viewing situation. It seem natural to approach the process of creation from this more encompassing perspective too, and the nonrepresentational approach seems to invite us to do so. For if vision is not a phenomenon just going on 'inside' the artist's head, but rather is a process of give and take with the environment 'out there', and if the precise form of the interaction shapes the experience, this might give an unprecendented role of importance to the tools the artist uses in forging this interaction. The pencil, the palette, the canvas and its texture, sketches, even the record of preceding works, might all be seen to play an essential and irreplacable role in the very seeing and creation of something seeable. Indeed, once vision is brought back into the world, the process of creating might be brought back into the world with it. Laying out his general nonrepresentational theory of perception and cognition, Timo Järvilehto offers us the following description, eminently applicable in the present context:

> Let's look at the action of an artist when he is preparing a piece of art. Where is 'painting' located when the fine movements of the hand and fingers create a picture on the canvas? In the brain, in the hands, in the paintbrush, or on the canvas? If we destroy some of these elements it becomes more difficult to create this piece of art. Some of the elements may be more easily substituted than some other, but in the act of painting they are all necessary. Can we say that the process of painting is located in the part which seems to be most active or important?
>
> No, of course not, because painting is a process which is realized as a whole organization of elements which are located in different parts of the world. This organization is realized as a totality in the painting. If some element, even a very tiny one, was missing the painting would not be the same or it would not be ready at all. Therefore, all elements are active in relation to the result of action; none of them is passively participating in the result (Järvilehto, 1998, p. 331).

[5] Both the sensitivity for the material aspects andfor the viewing conditions under which works would be exposed was present to an extreme degree in the work of Jan Van Eyck. At the conference, this was shown in a visually compelling way by Marc De Mey and Erwin De Nil (De Mey & De Nil, 1999). Unfortunately, the dependence on computer-created illustrations and 3-D animations made it impossible to consider their presentation for inclusion in this issue. The self-consciously anticipated merging of artwork and environment is also discussed in this issue by Alva Noë in the contemporary context of Richard Serra's sculptures (Noë, 2000).

Most of the papers in the original issue of *Art and the Brain* (see *Journal of Consciousness Studies*, **6** (6–7), 1999) show that most people who have reflected on art and aesthetics feel a strong repulsiveness towards reductionism and fear that any approach to art from the perspective of visual science easily falls into reductionist traps. As is indicated by the quote from Järvilehto just given, the nonrepresentationalist approach towards vision, is inherently nonreductionistic. It is already so from the start, by conceiving of perception as the activity of the whole person. Some aspects of perception, including some aspects of aesthetic perception, might be explainable in terms of low-level organizational features of the visual system (think of Livingstone's explanation of Mondrian's creation of an impression of movement), but within the nonrepresentational framework such explanations remain incomplete when they are not related to the experience of the person. The artist experiments, observes certain effects and brings her judgment to pass on whether the technique that creates the effect is suitable for application. The visual system, rather than being a source of rigid constraints, becomes itself an exploratory tool, directed towards the goals the artist sets for herself. The plasticity of the visual system which is apparent in the experiments with distorting goggles, suggests that in the process of artistic creation and development, the artist might even recreate his tool and literally begin to see differently (as also suggested by the experiment described by Robert Solso's paper in this issue). In the end, the self-conscious perception and creation of the artist appear as ever more flexible capacities to modify lower level capacities.

A somewhat similar account might be true for aesthetic appreciation. Aesthetic value and the capacity to create and sense it, might be a self-standing capacity, a distinct way of interacting with an environment, arising out of, and deeply interconnected with other ways of interacting. The science of perception might elucidate it, but not in an hegemonic bottom-up way. Again, the science of perception might itself be elucidated by it. For if what was said above makes sense at all, our conceptions of aesthetic value might, in the intertwined process of organismic maturation and cultural assimilation, shape our perceptual apparatus itself.

The Papers

In her paper on Cézanne, Amy Ione highlights several of the themes discussed above in the light of the 'active' conception of vision. Approaching Cézanne both through his paintings and his writings, she unveils the delicate process in which, in her own words, 'seeing changes over time and the practice of art informs the entire brain over time'. The artist is both the subject and the object of this development. Ione's discussion establishes and vividly illustrates, among other themes, the importance of the body and in particular of touch for vision, and the role of experimenting and of finding novel ways of representing and of seeing itself.

Robert Solso invokes some highly interesting lines of experimental work in the neuroscience of art. Standard fMRI methods were used to observe an artist's brain while creating. Though, admittedly, the results obtained are not conclusive

at this stage, they do suggest that an experienced painter uses his 'visual brain' in a different way from the layman (an interesting extension would be perhaps to investigate whether the experienced art *consumer* would also show differences in brain response!).

Raf De Clercq approaches the question of the 'ineffable' character of art. Ineffability is almost universally agreed to exist, but notoriously resistant to explanation. De Clercq takes issue with a particular attempt at explaining ineffability, coming from cognitive science. The suggestion, made by Diane Raffman, roughly is that ineffability in art can be explained as the difference in 'grain' between pure and conceptualized perceptual experience. De Clercq shows that this move isn't valid, because it bypasses some of the characteristics which are present in aesthetic, but not in ordinary perception. He then suggests a way out, by applying Michael Polanyi's ideas on the structure of consciousness as having a dual focal/background structure.

Also writing from a philosopher's perspective, Jennifer Church analyses the phenomenon of 'seeing as'. She discerns a tension within the phenomenon of seeing as, because it requires both a conflict (something is seen both as what it is and as what it is seen as), and a convergence (nonetheless the perception is unified in space and time and in consciousness). Developing Kant's ideas on these matters, she gives an account of consciousness as emerging from the resolution of the two requirements of conflict and convergence. She discusses various solutions to the binding problem in the light of it. Finally, it leads her to an interpretation of aesthetic experience as a particular *intensification of consciousness*, thus both highlighting the particular nature of aesthetic experience and its relation to consciousness.

In his paper on colour, Larry Hardin shows how a particular scientifically successful theory of colour perception, opponent process theory, can explain aspects of artist's practice and viewer's reaction. He shows how painters often implicitly master regularities operative in perception and how they find delicate compromises between their goals and constraints set by their medium. For example, he shows how chromatic contrast sometimes is heightened to compensate for the material impossibility to achieve enough lightness contrast. He ends his paper with a speculation about the well-known 'warm–cool' contrast in colour perception. Building on recent experimental and theoretical work, he puts forward a speculation as to how this contrast might have a ground in hard-wired and phylogenetically old circuitry in the brain.

Acknowledgments

The conference could not have taken place without the financial support of the Ministry of the Flemish Community, Department of Science, Innovation and Media (agreement Caw 96/29b), the Flemish Fund for Scientific Research (FWO — Vlaanderen), the Free University of Brussels (Vrije Universiteit Brussel) and Professor Gosselin's Center for Empirical Epistemology, the Belgian National Center for Research in Logic (CNRL-NCNL), in particular Professor Jean Paul Van Bendegem, and the FWO Contact Group *History of Science*, in particular

Professors Marc De Mey and Fernand Hallyn. Finally, I am obliged to Kevin O'Regan for some very helpful last-minute advice.

Many thanks also to my co-editor Joseph Goguen and to Anthony Freeman for the very smooth and enjoyable cooperation during the preparation of this issue.

References

Baars, Bernard J. (1988), *A Cognitive Theory of Consciousness* (Cambridge: Cambridge University Press).

Blake, A and Yuille, A. (ed. 1992), *Active Vision* (Cambridge: Cambridge University Press).

Church, Jennifer (2000), '"Seeing as" and the double bind of consciousness', *Journal of Consciousness Studies*, **7** (8–9), pp. 99–111 (this issue).

Churchland, Paul. M. (1995), *The Engine of Reason, the Seat of the Soul: A Philosophical Journey into the Brain* (Cambridge, MA: MIT Press)

Crick, F., & Koch, C. (1990), 'Toward a neurobiological theory of consciousness', *Seminars in the Neurosciences*, **2**, pp. 263–75.

De Mey, Marc & De Nil, Erwin (1999), 'Representation and reflection in Van Eyck: Varying sensibility to optics in early renaissance art'. Paper presented at the *Cognitive Science Conference on Perception, Consciousness and Art,* Centrum voor Empirische Epistemologie, Vrije Universiteit Brussel, 17–19 May 1999.

Fodor, Jerry A. (1983), *The Modularity of Mind: An Essay in Faculty Psychology* (Cambridge, MA: MIT Press)

Gibson, James J. (1979) *The Ecological Approach to Visual Perception* (Boston, MA: Houghton Mifflin)

Hardin, C. Larry (2000), 'Red and yellow, green and blue, warm and cool: explaining colour appearance', *Journal of Consciousness Studies*, **7** (8–9), pp. 113–22 (this issue).

Hurley, Susan (1998). *Consciousness in Action.* (Harvard: Harvard University Press).

Ione, Amy (2000), 'An enquiry into Paul Cézanne: The role of the artist in studies of perception and consciousness', *Journal of Consciousness Studies*, **7** (8–9), pp. 57–74 (this issue).

Ingold, Tim (1993), 'Technology, language, intelligence: A reconsideration of basic concepts', in *Tools, language and cognition in human evolution*, ed. Kathleen R. Gibson and Tim Ingold (Cambridge: Cambridge University Press).

Jackendoff, Raymond (1987), *Consciousness and the Computational Mind* (Cambridge, MA: MIT Press).

Järvilehto, Timo (1998), 'The theory of the organism-environment system: II. Significance of nervous activity in the organism-environment system', *Integrative Physiological and Behavioral Science*, **33**, pp. 331–8.

Kindy, Julia (1999), 'Of time and beauty', *Journal of Consciousness Studies* **6** (6–7), pp. 61–3.

Kinsbourne, Marcel (1995), 'Awareness of one's own body: An attentional theory of its nature, development and brain basis' in *The Body and the Self*, ed. José L. Bermúdez, Anthony Marcel and Naomi Eilan (Cambridge, MA: MIT Press).

Latto, Richard (1995), 'The brain of the beholder', in *The Artful Eye*, ed. Richard L. Gregory and S. Harris (Oxford: Oxford University Press).

Livingstone, Margaret S. (1988), 'Art, illusion and the visual system', *Scientific American*, **256**, pp. 78–85.

Mangan, Bruce (1999), 'It don't mean a thing if it ain't got that swing', *Journal of Consciousness Studies*, **6** (6–7), pp. 56–8.

Marr, David (1982), *Vision: A Computational Investigation Into the Human Representation and Processing of Visual Information* (New York: Freeman).

Merleau-Ponty, Maurice (1945), *Phénoménologie de la Perception* (Paris: Gallimard).

Milner, David A. and Goodale, Melvyn A. (1995) *The Visual Brain in Action* (Oxford: Oxford University Press)

Myin, Erik (in press, a), 'Fragmentation, coherence and the perception/action divide', *Behavioral and Brain Sciences*, **24** (1).

Myin, Erik, ed. (in press, b), *Perception, Action and Self-Consciousness*, Special Issue of *Synthèse*.

Noë, Alva (2000), 'Experience and experiment in art', *Journal of Consciousness Studies*, **7** (8–9), pp. 123–35 (this issue).

Noë, Alva (in press), 'Experience and the active mind', *Synthèse*.

O'Regan, J. Kevin & Noë, Alva (in press a),'What it is like to see: A sensorimotor theory of visual experience', *Synthèse*.

O'Regan, J. Kevin & Noë, Alva (in press b), 'A Sensorimotor Account of Vision and Visual Consciousness', *Behavioral and Brain Sciences*.

Ramachandran, V.S. and Hirstein, William (1999), 'The science of art: a neurological theory of aesthetic experience', *Journal of Consciousness Studies*, **6** (6–7), pp. 15–51.

Rey, Georges (1993), 'Sensational sentences', in *Consciousness*, ed. Martin Davies and Glynn E. Humphreys (Oxford: Blackwell).

Ryle, Gilbert (1949), *The Concept of Mind* (London: Hutchinson)

Shanon, Benny (1993), *The Representational and the Presentational: An Essay on Cognition and the Study of the Mind* (New York: Harvester Wheatsheaf).

Solso, Robert L. (1994), *Cognition and the Visual Arts* (Cambridge, MA: MIT Press).

Solso, Robert L. (2000), 'The cognitive neuroscience of art: A preliminary fMRI observation', *Journal of Consciousness Studies*, **7** (8–9), pp. 75–85 (this issue).

Stoffregen, T.A. & Bardy, B.G. (in press), 'On specification and the senses', *Behavioral and Brain Sciences*, **24** (1).

Ungerleider L.G. and Mishkin, M. (1982), 'Two visual systems' , in *Analysis of Visual Behavior*, ed. D.J. Ingle, M.A. Goodale and R.J.W. Mansfield (Cambridge, MA: MIT Press)

Wittgenstein, Ludwig (1953), *Philosophical Investigations* (Oxford: Basil Blackwell)

Willats, John (1997), *Art and Representation* (Princeton: Princeton University Press)

Zeki, Semir (1993), *A Vision of the Brain* (Oxford: Blackwell).

Zeki, Semir (1999), 'Art and the brain', *Journal of Consciousness Studies*, **6** (6–7), pp. 76–96.

LEFT HEMISFOOT RIGHT HEMISFOOT

Genie Shenk *Hemisfeet: A Study in Dominance*

Amy Ione[1]

An Inquiry into Paul Cézanne

The Role of the Artist in
Studies of Perception and Consciousness

Introduction

An intriguing element of Paul Cézanne's legacy is that while he aligned his paint-
ings with the classical Renaissance tradition of Western art, his innovative body
of work ushered in a decisive break with the standards of that tradition in the
twentieth century. The many ways in which Cézanne's representational system
deviates from the pluralistic art of the twentieth century suggests that probing his
allegiance to classicism offers a unique vantage point for studying visual art, per-
ception, and consciousness. It is for this reason that this paper examines
Cézanne's contributions from both the painterly and the cognitive science per-
spectives, asking what artists in fact contribute to our studies in these areas.

What must be stressed in approaching the bridge Cézanne was so instrumental
in building is that Cézanne considered any artistic style governed by fundamental
principles of communicative expression as classical. Thus, from his perspective,
his turn toward the classical masters was not one that emphasized blind imitation
or simply copying their work.[2] To the contrary, Cézanne believed that the artist's
success in solving technical problems should guide the artist in rendering his or
her personal sensation[3] (Rewald, 1995; Shiff, 1984).

[1] Presented at the *Cognitive Science Conference on Perception, Consciousness, and Art.* Vrije
Universiteit Brussel, Centrum voor Empirische Epistemologie, 17–19 May, 1999. Special thanks to
Christopher W. Tyler, Glenn English, Kevin Flanagan, and Joseph Goguen for their input.

[2] Cézanne expressed his allegiance to classicism when he wrote to the art critic Roger Marx, 'one does not
put oneself in place of the past, one only adds a new link' (Rewald, 1995, p. 275). He also spoke of his dis-
taste for strictly imitating the classical masters in a 1905 letter to Emile Bernard, saying: 'The Louvre is the
book in which we learn to read. We must not, however, be satisfied with retaining the beautiful formulas of
our illustrious predecessors. Let us go forth to study beautiful nature, let us try to free our minds from them,
let us strive to express ourselves according to our personal temperament. Time and reflection, moreover,
modify little by little our vision, and at last comprehension comes to us' (Rewald, 1995, p. 315).

[3] It is important to recognize that Cézanne had a tremendous respect for the way old masters looked for
new problems to solve and for how they solved problems as they worked. This explains Cézanne's
stress on the need to respect previous masters' skills while bringing one's own eye to one's efforts.
Richard Shiff has an illuminating discussion on this (Shiff, 1984).

Journal of Consciousness Studies, **7**, No. 8–9, 2000, pp. 57–74

Paul Cézanne and his art are examined in this paper by adapting, rather than adopting, Semir Zeki's idea that 'artists are neurologists, studying the brain with techniques that are unique to them . . .'[4] (Zeki, 1998, p. 80). Before outlining where this discussion diverges from Zeki it should be emphasized that there is no dispute that what is generally referred to as the visual brain is V1 plus the specialized visual areas with which it connects directly and indirectly (Zeki, 1998). Rather, I would propose that how a painter 'sees' cannot be captured in terms of a localized picture of processing in the visual brain. In other words, as Paul Cézanne's work clearly demonstrates, an artist does not passively 'see', so much as the artist relates to what he or she sees while painting — and thus actively coordinates various areas of the brain while seeing and creating.

This element of 'active seeing' will be used to explain the three areas in which this discussion diverges from Zeki's premises, as outlined in his article *Art and the Brain*.[5] First, while Zeki suggests that the question art can illuminate is 'why do we see?',[6] I will emphasize that if this question is narrowly approached it can fail to include key elements related to artistic perception, artistic practice, and artistic products — elements that are essential to any comprehensive study relating art to vision, perception, and consciousness.[7] Second, while Zeki claims that 'many [artists] still hold the common but erroneous belief that one sees with the eye rather than with the cerebral cortex' (Zeki, 1998, p. 80), this paper will

[4] Zeki writes: 'I hold the somewhat unusual view that artists are neurologists, studying the brain with techniques that are unique to them and reaching interesting but unspecified conclusions about the organization of the brain. Or, rather, that they are exploiting the characteristics of the parallel processing-perceptual systems of the brain to create their works' (Zeki, 1998, p. 80).

[5] The *Art in the Brain* essay was first published in *Daedalus, Proceedings of the American Academy of Arts and Sciences* and then reprinted in the *Journal of Consciousness Studies*. Page numbers noted in this paper are from the JCS version of the paper. It should be noted that Zeki's book *Inner Vision: An Exploration of Art and the Brain* was published in 1999, shortly after this paper was written. The book reiterates the arguments in the essay and likewise fails to address the weaknesses inherent within the neuro-reductionistic approach Zeki's theory uses (Zeki, 1998; 1999a; 1999b).

[6] According to Zeki, the reason connections between the functions of art and the functions of the visual brain have not yet been made is that our conception of vision and the visual process has been dictated by simple but powerful facts derived from anatomy and pathology. He writes: 'These facts spoke in favour of one conclusion to which neurologists were ineluctably driven, and that conclusion inhibited them, as well as art historians and critics, from asking the single most important question about vision that one can ask: Why do we see at all?' Zeki then goes on to claim that it is the answer to that question that immediately reveals a parallel between the functions of art and the functions of the brain, and indeed ineluctably drives us to another conclusion — that the overall function of art is an extension of the function of the brain (Zeki, 1998, p. 78). I am asserting that Zeki has not brought enough emphasis to how seeing changes over time and how the practice of art informs the entire brain over time.

[7] In Joachim Gasquet's *Cézanne*, Gasquet recalls Cézanne's view on what artists do and reports that Cézanne saw seeing as a complex activity: 'One has to go beyond feeling, get past it, have the nerve to give it objective shape and be willing to put down squarely what one sees by sacrificing what one feels — by having already sacrificed what one feels You see, it's enough to feel . . . feeling never gets lost . . . I'm not against it. On the contrary, I often say . . . An art which does not have emotion as its principle is not an art . . . Emotion is the principle, the beginning and the end; the craft, the objective, the execution is in the middle . . . That's where the slightest misplaced brush stroke upsets everything. If there's nothing but emotion for me in it, I send your eye crooked . . . If I weave around your expression the whole infinite network of little bits of blue and brown that are there, that combine there, I'll get your authentic look on my canvas' (Gasquet, 1927; Gasquet, 1927/1991, p. 213).

explain that this absurd simplification does not address how the artist uses the term 'eye' as a metaphor for the intuitive process of visual apprehension. Finally, this paper will question whether Zeki's definition of the function of art extends far enough to include the actual 'seeing' the artist brings to artmaking. According to Zeki, the general function of art is:

> [A] search for the constant, lasting, essential, and enduring features of objects and surfaces, faces, situations, and so on, which allows us not only to acquire knowledge about the particular object, or face, or condition represented on the canvas but to generalize, based on that, about many other objects and thus acquire knowledge about a wide category of objects or faces (Zeki, 1998, p. 79).

As will be shown, this conclusion fails to acknowledge the degree to which an artist informs art. For a painter, for example, touching paint to canvas is very much connected to seeing. This means the art that *we* see includes *many* faculties and, *for the artist*, its success is based on the kind of seeing that Richard Gregory introduces when he speaks of the importance of touch to vision[8] (Gregory, 1997). As Gregory points out, the essential problem the brain needs to solve visually is that any given retinal image could be produced by an infinity of sizes and shapes and distances of objects, yet normally we see just one stable object (Gregory, 1997).

In sum, artists face the problems of seeing directly in their projects and, as will be shown, artists face the problems of seeing regardless of whether the representational system of choice is totally abstract or one that attempts to render objects we see in the physical world. Moreover, since retinal images can be interpreted in multiple ways, and since artists could be said to specialize in wrestling with the problems of seeing that concern all of us, it is essential that when we evaluate art in cognitive terms we clearly recognize that the artist, too, evaluates hypotheses. When the artist does so the artist's eye and the artist's brain work together. More important, when ascertaining how the artist functions as a neurologist, one must not lose sight of the degree to which an artist is involved with what is going on when making art on many levels. The creation is not comprehensively defined using terms like abstract, formal, or objective. Nor can we say that it is a totally subjective endeavour in which one relates to essential and enduring features. Rather the applied research the artist is doing is an activity that brings a concrete — and a very relational form — to his or her consciousness. The artist — in this case Paul Cézanne — also presents this form to the consciousness of others.

The Eye

Paul Cézanne's (1839–1906) body of work shows how an individual's perceptual knowledge can deviate from the weight of history, learned formulae, and conventional ideas and can nonetheless still be informed by the context of his time. Among the radical changes of the nineteenth century that informed his

[8] Gregory writes: 'The brain's task is not to see retinal images, but to relate signals from the eyes to objects of the external world, as essentially known by touch. Exploratory touch is very important to vision' (Gregory, 1997, p. 6).

development are (1) scientific ideas related to vision and colour, (2) radical social changes, and (3) discussions on the value of bringing an 'innocent eye' to one's painting process. While the importance of these complex influences on Cézanne's work is beyond the scope of this paper, the impact of societal changes, new technologies, and the revisions we find in both nineteenth-century art practice and the empirical knowledge base of that time should not be underestimated.[9]

The area I want to emphasize here is that while Cézanne asserted 'the eye educates itself by contact with nature' (Gasquet, 1927, p. 163; 1927/1991), the idea of the 'innocent eye' tended to be understood in terms that are somewhat less active and developmental. John Ruskin's 1857 book, The Elements of Drawing, conveys how this idea was frequently presented. Ruskin writes:

> The whole technical power of painting depends on our recovery of what may be called the *innocence of the eye*; that is to say, of a childish perception of [these] flat stains of colour; merely as such, without consciousness of what they signify — as a blind man would see them if suddenly gifted with sight (in Smith, 1995, p. 28).

Ruskin's view of the 'innocent eye' has increasingly permeated theories of art and has diffused the complexity of seeing in painting since the nineteenth century. Given that the value of the 'innocent eye' is often implicitly valued at this point in time, it is important to explore this idea in light of recent scientific information about seeing and vision before looking at Cézanne's oeuvre and working process.

An excellent starting point is an essay by the neurologist Oliver Sacks, 'To See and Not See', in which he compares the experience of a fifty-year-old man, Virgil, who had his sight restored after being almost totally blind since the age of six with the seeing of the artist, Paul Cézanne, writing:[10]

> As Virgil explored the rooms of his house, investigating so to speak, the visual construction of the world, I was reminded of an infant moving his hand to and fro before his eyes, waggling his head, turning it this way and that, in his primal construction of the world. Most of us have no sense of the immensity of this construction, for we perform it seamlessly, unconsciously, thousands of times every day, at a glance. But this is not so for a baby, it was not so for Virgil, and it is not so for, say, an artist who wants to experience his elemental perceptions afresh and anew. Cézanne once wrote, 'The same subject seen from a different angle gives a subject for study of the highest interest and so varied that I think I could be occupied for months without

[9] There are many references that speak of innovation and concerns related to nineteenth-century art and science (Helmholtz, 1995; Ione, in press; Ruskin, 1843; Smith, 1995; Wade, 1983).

[10] There are limited studies documenting how a blind person sees when given sight. To the best of my knowledge, the oldest reported case of a blind man being given sight was recorded in AD 1020 (Gregory, 1997). The first noteworthy recorded discussion is generally agreed to have resulted when the English philosopher John Locke (1632–1704) received a letter from his friend William Molyneux that concluded a formerly blind man would need experience with seeing to distinguish the shapes of a cube and a sphere if he had formerly only known them by touch. Locke, in his *Essay Concerning Human Understanding* (1690) agrees with Molyneux's conclusion. Additional well-known studies include: (1) a 1728 study by William Cheselden, where a thirteen-year-old boy was given sight (Senden, 1960), (2) *Space and Sight* by M. von Senden, which traces cases involving operations for the removal of lenses for blindness due to cataracts (Senden, 1960), and (3) Richard Gregory and Jean Wallace's research on S.B., who was successfully given corneal transplants at the age of 52 (Gregory & Wallace, 1963).

changing my place, simply bending more to the right or left' (Sacks, 1995, pp. 127–8).[11]

Sacks, of course, is attempting to explain that we achieve perceptual constancy — the correlation of all the different appearances, the transforms of objects — very early, in the first months of life.[12] (Sacks, 1995). When thinking about this in terms of an artist as a neurologist it is particularly important to consider Sacks' words in light of (1) how painting relates to seeing in general and (2) how achieving perceptual constancy is defined in Zeki's view of art and the brain.

Turning first to Zeki we find he acknowledges that the organism must be exposed to visual stimuli after birth and theorizes that in time a stored record is acquired through learning about the world. This idea of a stored memory, however, fails to address how (and why) visual artists optically engage with their products as they move them toward completion. Moreover, while Zeki correctly asserts that we 'see' with the brain, his static analysis does not address the degree of interactive 'looking' that artists use when they develop their ever-expanding pictorial vocabularies. The ongoing trials, experiments, and the innovations that are a part of the artist's evolving process speak directly to factors we must weigh when we ask how painting relates to seeing in general and how people who were once blind and then given sight differ from artists.

The primary issue from an artist's standpoint is not that the formerly blind do not have access to a stored record. Rather, visual artists spend years evaluating how to manipulate their tools so that they can convey what is of interest to them effectively — and then more effectively. For painters this exploration is one that constantly brings sight, touch, cognition, and emotions together as novel solutions are actively developed to encode information. Indeed, what makes powerful art exciting is that the solutions are not memorized models that have settled into our brains.

To the contrary, history shows that the creative work artists produce includes an experientially created record that, among other things, precisely shows how artists have learned to expand their means of expression over and over and over again. Frequently and repeatedly we find examples of perceptual and technical growth in a single artist when we examine the artist's oeuvre over the course of a productive lifetime. We also encounter evidence demonstrating how innovative artists break with learned conventions for seeing and representation. Perhaps of

[11] About a month before Cézanne died in September 1906, Cézanne expressed this thought in a letter to his son, writing: 'I must tell you that as a painter I am becoming more clear-sighted before nature . . . Here on the bank of the river the motifs multiply, the same subject seen from a different angle offers subject for study for the most powerful interest for months without changing place, by turning now more to the right, now more to the left' (Rewald, 1995, p. 327).

[12] 'By about the age of one month, kids blink if something moves toward their eyes on a collision course. By three months they use visual motion to construct boundaries of objects. By seven months they also use shading, perspective, interposition (in which one object partially occludes another), and prior familiarity with objects to construct depth and shape. By one year they . . . proceed to learn names for the objects, actions, and relations they construct. . . . Kids aren't taught how to see . . . Every normal child, without being taught, reinvents the visual world; and all do it much the same way' (Hoffman, 1998, pp. 12–13).

greatest importance is that when artists break with conventions and develop new tools to enable them to be better communicators they often bring new ways of perceiving the world to the attention of others.

The larger point here is that the eye of a painter, like Paul Cézanne, who continues to deepen his visual knowledge base as he continues to look anew, is contextually different from the eye of a blind person as well as from that of the innocent child's eye. Relating the artist's eye to the perceptual constancy Sacks mentions and the so-called 'stains' on the canvas Ruskin referred to above leads me to suggest that when we look closely at Cézanne's 'stains' we can quickly perceive that they are more than just stains on the canvases. Cézanne's stains, if we call them that, show how he first reaches out to capture something vital and vibrant and then finds a means of expression that translates this vitality to those who view his markings. Thus Cézanne's so-called innocent eye is more aptly defined as an 'open' but yet 'practiced' eye. He used it to aid him as he developed the techniques he needed to solve the problems that arose in encoding his vision and sensation onto the flat surface the canvas provided.

What must be stressed here is that the logic of Cézanne's visual decision-making process, often referred to in his letters (Rewald, 1995), was both deliberate and exploratory. We only need look at canvases at various stages of completion and at different periods of his life to see his active approach and the visual logic he employed.[13] Moreover, his open yet guided process suggests the word intuitive is appropriate — and also suggests we should use this word with great care. Carefully examining his canvases is the most effective way to conceptualize how Cézanne proceeded and what he meant when he said:

> There are two things in a painter: the eye and the brain, and they need to help each other, you have to work on their mutual development, but in a painter's way: on the eye by looking at things through nature; on the brain, by the logic of organized sensations which provides the means of expression . . . The eye must concentrate, grasp the subject, and the brain will find a means to express it (Gasquet, 1927/1991, p. 222).

Cézanne's many unfinished compositions offer the best reference points for perceiving his process and how his eyes and brain worked in tandem. First of all, it is well documented that Cézanne slowly built up the paint and the colour relationships on the canvas overall and the partially worked canvases effectively illustrate how he perceived the canvas as a whole when he worked. In addition, when we compare canvases from different periods of his life we see the early stages of several innovations that were not fully realized until late in his career. In sum, the work itself clearly articulates that Cézanne never stopped using his eyes to see his paintings and he never stopped using his brain to adjust how he painted. Over time, and through much trial and error, he was able to develop the innovative visual syntax that led his peers to see him as radical in his time. In fact his various experiments brought about the unique qualities that made the work revolutionary

[13] Reproduction of Cézanne's paintings can be found at several web sites. Some good ones include: http://metalab.unc.edu/wm/paint/auth/Cézanne/, http://sunsite.auc.dk/cgfa/Cézanne/index.html and http://www.artchive.com/artchive/C/Cézanne.html#images.

and now allows us to perceive how *he* used paint to denote his perceptions and sensations over the course of his life.

For example, looking at the techniques Cézanne invented and then refined over time, we see how he developed the technical solutions that no one had pre-defined for him. We also discover that he never settled into a fixed technical method that would lead him to characterize qualities in a singular fashion. To the contrary, he constantly experimented with possibilities. The deeply studied oil compositions, for instance, offer a stark contrast to the spontaneous simplicity of Cézanne's watercolours. Yet with each medium Cézanne shows that his 'open' eye slowly comprehended — i.e., learned — how to coordinate seeing with touching. It is not just that he was looking at what was in nature, which was important to the way he approached his work. Rather, Cézanne, like painters in general, was also looking at what he was building on the canvas. His process of decoding what he wanted to communicate and then encoding it in paint was an activity that depended on his deepening of the eye/brain combination. As noted, there were areas of consistency within this. For example, when we look at the unfinished works we see he always worked on the canvas as a whole as he visualized the path toward the overall 'look' of the finished painting.

In summary, as a painter Cézanne repeatedly combined his hands and his sensations with his eyes, brain, and mind to bring his unique vision onto the flat picture plane. This paper will turn to specific works later in this discussion. At this point two ideas are important to keep in mind. First, since no one had ever painted his way before him, the complex painting techniques he developed to convey what he 'saw' were not prescribed methods others could teach him. Second, his paintings are concrete forms and were formed as a part of a dynamic, experiential, and embodied activity. His canvases did not serve as a means to translate abstract ideas into an aesthetic form. Instead they recorded a process through which he (1) systemized the particular elements that came to define his style, (2) learned to coordinate what he saw with what his materials could do, (3) learned to push the materials to their limits and, finally, (4) continually found ways to perceptually deepen all he wanted to express with paint. Thus, Cézanne's paintings record his way of combining constancy with a complex and vitally informed visual expression and this relationship cannot be underplayed when reviewing his work. For example, despite the fact that he painted *Mont Sainte Victoire* over forty times (Figure 2 is a relatively late rendition), the constancy of the subject does not connote a fixed quality of expression. It is never visually repetitive. Instead the freshness of each piece shows the degree to which he carefully studied his goals, brought a 'new' eye to each day of painting, and also brought particular intentions to his painting process.[14]

[14] Richard Wollheim and Paul Smith have both cogently argued that artists fulfill two roles in painting. On the one hand, an artist is involved with the task of making the painting and, as such, is the agent of production. On the other hand, the artist is also a spectator, being among those who view the painting. This gives the painter an active role in formulating what the spectators (including the painter) see. The consequence of this, as both Wollheim and Smith assert, is that an artist's style matures as he or she develops modes that aid his or her expression (Wollheim, 1987; Smith 1995). Cézanne himself said that the means of expression are acquired through long experience (Rewald, 1995).

Figure 1

An illustration of the principle of organization Loran applies to *Mont Sainte Victoire Seen from the Bibemus Quarry* (Figure 2 is a reproduction of this painting).

The diagram shows planes and volumes moving around an imaginary central axis. The axis is indicated with dotted lines. The heavy arrows represent the circular path moving from the foreground into the distance and returning again. The small arrows indicate the endless movements and counter-movements from one overlapping plane to another. The essential planes have been indicated in the diagram without departing too much from the overall appearance of the painting.

Reproduced courtesy of The Regents of the University of California Press. The diagram is reprinted from Erle Loran's *Cézanne's Composition* (1943) and the arrows were drawn as three-dimensional solids at the suggestion of Edgar Taylor.

We can optimally appreciate the visual richness and carefully developed complexity within Cézanne's body of work when we look at his style as it developed over time. Many paintings completed in the mid 1860s, for example, were characterized as palette knife pictures and offer an extraordinary testimony to Cézanne's early abilities (Gowing, 1988). Each of these portraits is said to have been finished in an afternoon and their roughness is said to show the force of his temperament at this time.[15] Lawrence Gowing claims the group marks the invention of modern expressionism — and more, saying that

[15] These pieces include a *Self-Portrait* (V. 18), *Portrait of Anthony Valabrèque* (V. 126), *Portraits of Uncle Dominique* (V. 76, V. 80, V. 82), *Portrait of Louis-Auguste Cézanne, Father of the Artist reading l' Evénement* (V. 91), *The Man with the Cotton Cap (Uncle Dominique)* (V. 73), *The Lawyer (Uncle Dominque)* (V. 74), *and the Portrait of Marie Cézanne, Sister of the Artist* (V. 89) [V. = L. Venturi, a standard catalogue of Cézanne's work] (Gowing, 1988).

Figure 2

Paul Cézanne (French, 1839–1906), *Mont Sainte Victoire Seen from the Bibemus Quarry* (c. 1897), oil on canvas, 65.1 x 80 cm.

Reproduced courtesy of The Baltimore Museum of Art: The Cone Collection, formed by Dr. Claribel Cone and Miss Etta Cone of Baltimore, Maryland. BMA 1950.196.

> This phase was not only the invention of modern expressionism, . . . [it included] the invention of *forme* in the French modernist sense — meaning the condition of paint that constitutes a pictorial structure. It is the discovery of an intrinsic structure inherent in the medium and the material Underneath the rudeness of Cézanne's way with paint in 1866 there was the idea of an order of structure that would be inherent in the paint-stuff (Gowing, 1988, p. 10).

Comparing compositional layout and paint application in these early works with what is conveyed in later canvases, we can also see how deliberately Cézanne wrestled with how to use paint to bring forms to life. For example, paintings of the later seventies and early eighties show that Cézanne had arrived at a consistent method by this time (Fry, 1966, p. 64). It was in the work during this interval that his pigment attains a particular density and resistance. We see an enamel or lacquer-like hardness and brilliance of surface. This is the result of his incessant repetitions and revisions of the form, particularly of the contours. Then, around 1885, a progressive change in how Cézanne handles paint begins to become

apparent. Hatched strokes are more loosely spaced and the impasto becomes thinner, having evidently been applied in a more liquid state.

Another noteworthy element is that Cézanne seemed to put off as long as possible covering the canvas. Even finished paintings are left with small interstices of white here and there. Additionally, the handwriting of the brush becomes looser and freer, perhaps due to his paintings in watercolour which became more numerous as he matured.[16] In sum, as we advance the chronology we find that Cézanne's materials become less and less pastose, his colours more and more liquid and transparent, more like watercolour. We also see that the change is gradual and that at times the thinner painting does not predominate, for there are returns to the old impasto (Fry, 1966).

The Eye, the Brain, and the Work

Cézanne's ability to break down form in a way that conveys a harmony and a brilliant radiance was a radical addition to art as a whole and it led many twentieth-century artists to further break down the painted form. The quite varied results of these later artists has led to much debate about Cézanne's contributions. For example, both the artist-turned-art-educator Erle Loran and the critic Clement Greenberg[17] open one door for beginning to approach the logic of Cézanne's expression and his view of the constancy of nature, which was an integral touchstone of his learning process. Greenberg speaks about the revelation Cézanne had at the age of forty as an attempt to 'save the key principles of Western painting — its concern for an ample and literal rendition of stereometric space — from the effects of Impressionistic colour'[18] (Greenberg, 1961, p. 50).

According to Greenberg, Cézanne did this because he sought

> [M]ore like the Florentines than like the Venetians he cherished — to achieve mass and volume first, and deep space as their by-product, which he thought he could do by connecting the Impressionistic method of registering variations of light into a way of indicating the variations in planar direction of solid surfaces. For traditional modelling in dark and light, he substituted modelling with the supposedly more natural — and Impressionistic — differences of warm and cool . . . The result was a kind of pictorial tension, the like of which had not been seen in the West since Late

[16] Writing about his watercolour, Roger Fry says: 'Cézanne felt so strongly of discovering always in the appearances of nature an underlying principle of geometric harmony. On his sheet of paper he noted only here and there, at scattered points in his composition, those sequences of plane which were most significant of structure; here, part of the contour of a mountain; there the relief of a wall, elsewhere part of the trunk of a tree or the general movement of a mass of foliage. He chose throughout the whole scene those pieces of modelling which became, as it were, the directing rhythmic phases of the total plasticity. One might compare the synthesis which Cézanne thus sought for to the phenomenon of crystallization in a saturated solution. He indicated, according to this comparison, the nuclei whence the crystallization was destined to radiate throughout the solution' (Fry, 1966, p. 64).

[17] Clement Greenberg is generally considered the critic who brought some measure of credibility to abstract painting. Given this, his opinion of Cézanne can be seen as a part of a larger story, one related to the kind of analysis he brings to the story of twentieth-century art.

[18] This frequently-quoted idea is related by Gasquet as follows: 'I wanted to make out of Impressionism something solid and lasting like the art of museums' (Gasquet, 1927, p. 164; 1927/1991).

Roman mosaic art. The overlapping little rectangles of pigment, laid on with no attempt to fuse their edges, brought depicted form toward the surface; at the same time the modelling and shaping performed by these same rectangles drew it back into illusionistic depth[19] (Greenberg, 1961, p. 52).

Loran likewise acknowledges the stereometric effect of Cézanne's compositions. Loran, however, stresses that Cézanne did not model form so much as light and further proposes that Cézanne's abandonment of traditional perspective was instrumental in developing the dynamic forms and unique techniques that resulted in the stereomorphic colouration we see. As a result, according to Loran, Cézanne

> [A]chieved light in the sense that modern painters give to the word, namely, the creation of an inner light that emanates from the colour relations in the picture itself, without regard for the mere copying of realistic effects of light and shade (Loran, 1943, p. 29).

Moreover, Loran's formal analysis of Cézanne's composition rests upon a dynamic analysis of how this painter developed compositional relationships (see Figures 1 and 2). The analysis, intended to illuminate how Cézanne saw the formal relationships on his canvases overall as he approached a painting, is not a universally accepted approach among art critics. In fact, many who reject Loran's approach do so for reasons that have nothing to do with Loran's deviation from classical linear perspective and classical themes. Rather, the concern is Loran's failure to address the inner psychology and the cultural context of the artist in this formal emphasis. For example, the art historian Rosalind E. Krauss writes:

> We all remember [Loran's diagrams] as something of a joke, . . . [Loran's] bizarre graphs of Cézanne's pictures, . . .the bodies of Madame Cézanne or the gardener sitting with folded arms, drained of everything but a set of their now brutishly definitive silhouettes, traced for them by Loran's own hand, each element notched in turn into the overall diagram of the picture plotted by means of the same myopic contour. The whole of this pictorial map was then vectored by a series of lines and arrows intended to reveal the hidden secrets of Cézanne's construction, the logic of a drawing that could create the experience of pyramid or cone while never dropping the ball in the smooth juggling act of maintaining the continuity of the surface planes (Krauss, 1994, p. 103).

Krauss concludes that Loran's approach, and its relationship to modernism, has been adopted in a way that does not give due credit to the optical unconscious, fantasy, and unexamined compulsions of the human involved. While I am not persuaded by her remarks, they do reveal that how we address paintings has a great

[19] Greenberg continues: 'The Old Masters always took into account the tension between surface and illusion, between the physical facts of the medium and its figurative content — but in their need to conceal art with art, the last thing they wanted was to make an explicit point of this tension. Cézanne, in spite of himself, had been forced to make the tension explicit in his desire to rescue the tradition from — and at the same time with — Impressionistic means' (Greenberg, 1961, p. 53).

deal to do with the kinds of assumptions we bring to our analyses of art and, by extension, how we bring the brain and art together.[20]

Let me therefore propose that it might be useful — and perhaps is essential — to ask how we can put artists, in this case Cézanne, into a larger context. This question needs to be addressed from both a painterly and a cognitive perspective. From a painterly perspective I will ask what, if anything, is to be gained from looking at art in an enlarged context. From a cognitive perspective the critical element to consider is whether an analysis of art and the brain can aid us in developing a larger context.

Cézanne and Cognitive Research

What is to be gained from a painterly perspective is a greater understanding of what artists do, how the 'eye' of an artist evaluating options differs from that of a general viewer looking at a finished product, and where the limitations are when bringing scientific information to our studies of art, an area I will address in the conclusion. Before looking at what could be gained, we must first return to Zeki's theory.

While Zeki is to be applauded for recognizing the value in probing the 'artist as a neurologist', his conclusions nonetheless reveal some of the dangers inherent in applying a neuro-reductionistic vantage point to our studies in this area. This is not to say studies of the brain cannot facilitate our understanding of art. They can. But the kind of argument Zeki presents fails to include what artists in fact do. The importance of including art practice in our theories about art and the brain cannot be underestimated, especially if the claim is that the theory is biologically-based and supposes, as Zeki does, that 'artists are neurologists, studying the brain with techniques that are unique to them . . .' (Zeki, 1999a, p. 80).

Probing Zeki's somewhat limited and objectified characterization of Cézanne's work helps bracket elements that would have advanced Zeki's analysis of neural processing in artists and in general. He describes Cézanne's work as a 'painted epistemology' on the evidence that Cézanne supposedly shared Kant's views. What Zeki's conclusion seems to miss, however, is that each developing painting is a dynamic visual experience. Cézanne is not providing narrative statements that can be reduced to his view on nature, knowledge, knowing, or experience. To the contrary, each dynamic statement records a subtle interplay of sensory, cognitive, perceptual and emotive processes. Describing

[20] Correlating Gasquet's characterization of Cézanne's beliefs with the views of later scholars, one often wonders whether what an artist does can ever be fully stated in a textual and/or theoretical analysis. Loran's diagrams, as Krauss notes, fail to capture the spirit of Cézanne's paintings. Krauss, on the other hand, seems to lose sight of how the intellectual element that is a part of her interpretive style would offend Cézanne, for, if Gasquet is to be believed, Cézanne himself remarked: 'The fact is one doesn't paint souls. One paints bodies; and when the bodies are well painted . . . the soul, if there is one, of every part of the body blazes out and shines through!' (Gasquet, 1927, p. 176; 1927/1991), and 'A picture doesn't represent anything, it doesn't need to represent anything in the first place but the colours . . . As for me, I hate that, all those stories, that psychology, that symbolism' (Gasquet, 1927, p. 185; 1927/1991).

this interactive process using words like a 'painted epistemology' suggests there is more of a fixed, static quality driving the activity than the range and the innovations within the work records.

The difficulty in grasping what the Kantian view misses is perhaps best explained by simply pointing out that Cézanne abhorred abstractions, especially in regard to art. As he explained in a 1905 letter to Emile Bernard, shortly before his death in 1906, he saw paintings as a concrete form of communication and as a form of education, writing:

> [P]ainters must devote themselves entirely to the study of nature and try to produce pictures which will be an education. Talking about art is almost useless . . . The man of letters expresses himself in abstractions whereas a painter, by means of drawing and colour, gives concrete form to his sensations and perceptions (Rewald, 1995, pp. 303–4).

Cézanne's clearly-stated preference for concrete painted statements is one reason to put Kantian abstractions aside and to use a non-epistemological approach when evaluating his work. Another is that he spoke better with paint than in words. This means that even his words must be read in terms of his work. Moreover, many, including Cézanne himself, have pointed out (Greenberg, 1961; Loran, 1943; Rewald, 1995) that Cézanne, like many artists, was more articulate with his brush than his words[21] (Gasquet, 1927/1991; Rewald, 1995). Even when the critic Greenberg wrote that 'Cézanne was one of the most intelligent painters about painting whose observations have been recorded' (Greenberg, 1961, p. 53), he quickly added that 'the master himself was more than a little confused in his theorizing about his art (Greenberg, 1961, p. 56).

This explains why I have emphasized looking at the work itself, and perhaps explains why Cézanne's story is often filled with contradictions. For example, on the one hand, Cézanne wrote to Emile Bernard: 'I believe in the logical development of everything we see and feel through the study of nature and turn my attention to technical questions later'. Yet, on the other hand, Cézanne's work illustrates that he was nonetheless very aware of the materiality of paint, particularly from a technical standpoint (Gasquet, 1927/1991; Rewald, 1995). His accomplishments offer a clear record of this, documenting the degree to which he focussed on expanding his capacity to express his sensation outwardly, ever seeking new painterly skills.

In summary, Cézanne's paintings illustrate how he coordinated his mind, brain, eyes, and hands. They demonstrate how he solved particular problems of interest to him over time — and detail the degree to which he changed his painting style as he did so. Configurations he returned to often — e.g. *Mont Sainte Victoire*, still life compositions and the bathers — are so fresh and yet so deliberately re-produced

[21] The ideas of the historian Lawrence Gowing offer some intriguing commentary. Gowing speaks of Cézanne's special vocabulary and how pictorial definitions took on a special importance in Cézanne's later years when he attempted to explain his work to others. Gowing writes: '"Harmony"' is evidently not merely the tonal accord which a painter like Manet might possess, but the structure of correspondences. "Temperament" meant the compulsive force with which real painters had to deploy such structures' (Gowing, 1988, p. 10).

that studying them individually, together, and visually allows us to see how Cézanne's exceptional body of work evolved over the course of his life as he developed ways to first decode what he wanted to communicate and then to encode these perceptions and sensations in paint.

Each series reflects the process of problem-solving and, of perhaps greater importance, shows how this painter engaged anew with each painterly challenge. We may not perceive this active process in any one piece, but each series provides us with multiple examples that serve as a kind of x-ray into the development of the percept and the nature of the problems. When looked at as a group the composite records how he developed the tools he needed to be an effective communicator. Indeed, his focus on conveying his own sensation in relation to the objective, physical world led him to pursue a particular kind of style. Still, as his painting progressed, it was with painterly techniques and ongoing exploration that he developed an understanding of how to vitally capture the particulars of interest to him. As a result, early paintings, like *The Railroad Cut*, show he was coarsely documenting the world, and a later painting, such as *Still Life with Apples and Peaches*, shows how far he has come. Comparing the works one can only be impressed by how his touch has gained facility and dynamically captures something vital and alive even when he is presenting a static still life scene on a canvas.

Conclusion

Overall Cézanne offers an example of how an artist actively 'sees' and suggests there are key modalities that Zeki's analysis of art and the brain fails to address. Cézanne, however, does not offer brain-based reference points we can point to directly since we have no direct neural data on Cézanne. Therefore, in closing, it is important to look beyond Cézanne and ask if brain studies can illuminate art at all. Can scientific research add to our understanding of how artists in general evaluate hypotheses, as Gregory puts it, and can the data gleaned from studying these activities somehow bring art and the brain together? Do brain studies combine with art to show the interplay of different sensory, cognitive, perceptive, and emotional components?

I would propose there is much we can learn from neural studies, but we need to draw conclusions carefully. Some of the elusive variables that must be weighed include (1) how to compare studies of non-artists with data on practicing artists and (2) how to incorporate our understandings of artists for whom we have no neural data. In Cézanne's case, for instance, we can easily see that the vision and craft brewing in the younger artist later emerged in the older and more practiced painter. Contemporary research studies, on the other hand, have looked at artists neurologically and thus offer evidential data that is connected to both art and the brain. For example, one recent study documented several differences between the seeing of non-artists and that of a practicing artist, concluding:

> The 'seeing' process for everyone takes place in the visual cortex at the back of the brain, which receives nerve signals representing light captured in the retina. At the same time, increased blood flows are evidence of increased brain activity. . . . thanks to photographs of scanned 'slices' of different brains, it is possible to see that, when

drawing a face, non-artists in the experiment used only the back of the brain, while Mr Ocean [an artist] used mainly the frontal part of his brain where you find emotion, previous faces, painting experience, intentions and so on . . . in essence, the control subjects were simply trying to copy what they saw. But [the artist] was creating an abstracted representation of each photograph. He was *thinking* the portraits (Riding, 1999, see also Solso, 1999).

Oliver Sacks' work on 'The Case of the Colour-blind Painter' is another study in this area, and a particularly important one in terms of Zeki's ideas because Zeki also studied this patient. In fact, when we look at the conclusions Zeki drew from his work with this artist we can see how Zeki's conclusion seem to miss important modalities related to artistic creation, artistic perception, and artistic vision — especially in relation to the brain. For example, Zeki describes the brain of this artist, Jonathan I., by explaining that

This particular patient was himself an artist and his drawings of a banana, a tomato, a cantaloupe and leaves, which he made from memory, show a nearly perfect ability to reproduce forms coupled to a highly defective colour system . . . Before his attack, the patient had a passion for Impressionist art and the paintings of Vermeer. After the attack, he ceased going to the galleries — the aesthetic quality of the works had become completely different (Zeki, 1999b, pp. 82–3).

Zeki also tells us that 'when area V4, the colour centre, is damaged the consequence is an inability to see the world in colour' and therefore 'It does no good to ask a patient with a V4 lesion to appreciate the complexities of fauvist art These are aesthetic experiences of which such patients are not capable.' Yet these descriptions, while accurate, do not capture the qualities that brought the art into existence in the first place. In Jonathan I.'s case, for example, Zeki's statements would have been more convincing (and seemed more relevant to art) if he had attempted to neurologically consider how Mr I.'s art changed in relation to his brain. Yet Zeki says nothing about this. Nor does he consider why this artist, who had long painted in a colour-filled, non-representational style did not lose his appreciation of art. He not only *remained a painter after losing his ability to see colour*, the neurological evidence shows that Jonathan I. was able to substantially remap his brain after the tragic accident that deprived him of colour vision.

Several elements are important if we are to conceptualize Mr I.'s experience in relation to visual art in general. First, he continued to paint although he did not lose just his perception of colour, he also lost his sense of colour imagery, the ability to dream in colour and even his memory of colour. He continued to paint although colour ceased to be a part of his mental knowledge and his mind. More important, after a year or more of experiment and uncertainty, Mr I. moved into a strong and productive phase, as strong and productive as anything in his long artistic career. People applauded the black-and-white paintings he now produced and commented on what they characterized as a creative renewal. Perhaps of primary importance in terms of aesthetics is that very few people knew that this new phase was anything other than an expression of his artistic development. They failed to recognize that it was brought about by a calamitous loss (Sacks, 1995).

In summary, Zeki's approach is incomplete and perhaps misleading because he fails to explore the active relationship an artist forges with art, which includes something more complex and multifaceted than a Platonic Ideal suggests. In terms of this painter, who found new (and fulfilling) ways to communicate with paint, Zeki says that 'What is perhaps most interesting from the viewpoint of a Platonic Ideal, at least for colours, is that with V4 destroyed a patient can often not even imagine what colours "look" like; the stored memory record of the brain for colour is completely obliterated' (Zeki, 1999b, p. 83).

This conclusion neglects to factor in that the brain of the colour-blind artist changed as he derived a new world — with other ways of seeing, of imagination, and of sensibility. Had Zeki combined Mr I's artistic experience with the neurological evidence he might have perceived that Mr I. re-oriented his life and, as he continued to paint, his brain showed how plastic the cerebral cortex is. His colour-blind condition did not negate his creative practice. To the contrary,

> His initial sense of helplessness started to give way to a sense of resolution — he would paint in black and white, if he could not paint in colour; he would try to live in a black-and-white world as fully as he could. This resolution was strengthened by a singular experience about five weeks after his accident, as he was driving to the studio one morning. He saw the sunrise over the highway, the blazing reds all turned into black: 'The sun rose like a bomb, like some enormous nuclear explosion', he said later. 'Had anyone ever seen a sunrise in this way before?' Inspired by the sunrise, he started painting again — he started, indeed, with a black-and-white painting that he called Nuclear Sunrise, . . .'I felt if I couldn't go on painting,' he said later, 'I wouldn't want to go on at all' (Sacks, 1995, p. 14).

Clearly artists themselves give us insight into art and the brain. As they do so the work shows the open-ended process a visual artist uses. This open-ended process, in turn, explains that seeing is not simply about appreciating art and art is not simply an aesthetic object. Therefore, an adequate scientific explanation of art and the brain must go beyond an appreciation of aesthetic qualities and must also reflect on what a brain involved with the production of art reveals to us empirically. From this perspective neural studies can yield fruitful information. While more data is needed to form far-reaching conclusions, the data we now have has already indicated that (1) it is likely that artists and non-artists process differently when reproducing visual information (Solso, 1999) and that (2) cerebral 'mapping' may be drastically reorganized and revised 'not only following injuries or immobilizations, but in consequence of the special use or disuse of individual parts' (Sacks, 1995, p. 41).

What must be stressed in closing is that the open-ended nature of artistic discovery no doubt precludes reductive conclusions. Since discovery is at the heart of art practice it seems unlikely that we could ever reduce the experimental approach an artist uses to easily-definable brain functions and neural processes. There are too many variables we could never include in this kind of model. For example, we simply cannot predict how one's biological state may change — and be changed — by new forms of expression. Nor can we pretend to know what new tools will make possible. This does not mean we need to rest on philosophical

conclusions that will fill in the holes a reductive theory cannot address. Research continually shows we can broaden our understandings of all domains and, to date, researchers have shown that (1) our brains change as we use them, (2) art, too, changes over time, and (3) it appears that the brains of artists record the kind of work they do and how they do it. Undoubtedly, further studies can better connect the changes we see in art with neural functions and processes. Even still it is unlikely scientists will be able to establish hard-and-fast principles in this area given how artists work.

For example, it is unlikely hard-and-fast principles could decipher how to predict the 'laws of painting' Cézanne invented, particularly when we consider that ongoing painterly adjustments governed how he approached painting, and his approach shows that he never stopped inventing. What a study of Cézanne's brain might offer, if such a study were possible, is a better understanding of how our brains interpret the retinal images our eyes receive. Theoretical formulations that emphasize neural encoding in terms of Platonic Ideals, however, are likely to obscure the degree to which an artist's activity *is both active and cognitive*. Moreover, in the case of an innovative artist like Cézanne, interpreting his results in terms of 'stored memories' obscures the kind of seeing of interest to him. Cézanne was not attempting to transcribe what he had previously stored in his brain or what others had taught him. He was looking for ways to stretch beyond stored memories. His powerful canvases show this best, documenting a realization that deepened over time. In fact, almost two years before his death Cézanne summed up his work as an artist in a letter to his friend Louis Aurenche, writing:[22]

> You speak of my realization in art. I believe that I attain it more every day, although a bit laboriously. Because, if the strong feeling for nature — and certainly I have that vividly — is the necessary basis for all artistic conception on which rests the grandeur and beauty of all future work, the knowledge of the means of expressing our emotion is no less essential, and is only to be acquired through very long experience (Rewald, 1995, p. 299).

References

Fry, Roger (1966), *Cézanne: A Study of his Development* (New York: The Noonday Press).
Gasquet, Joachim (1927), *Cézanne* (Paris: F. Sant' Andrea).
Gasquet, Joachim (1927/1991), *Cézanne*, trans. C. Pemberton (London: Thames and Hudson Ltd.).
Gowing, Lawrence (1988), *Cézanne: The Early Years 1859–1872* (Washington, DC and New York: National Gallery of Art, Washington in association with Harry N. Abrams, Inc., Publishers, New York).
Greenberg, Clement (1961), *Art and Culture: Critical Essays* (Boston, MA: Beacon Press).
Gregory, Richard L (1997), *Eye and Brain* (fifth ed., Princeton, NJ: Princeton University Press).
Gregory, Richard L., & Wallace, Jean G. (1963), 'Recovery from early blindness: A case study', in *Concepts and Mechanisms of Perception*, ed. R.L. Gregory (London: Duckworth).
Helmholtz, Hermann von (1995), 'On the relation of optics to painting (1871)', in *Science and Culture: Popular and Philosophical Essays*, ed. D. Cahan (Chicago and London: The University of Chicago Press).

[22] The following year, in a letter to Emile Bernard, Cézanne adds some perspective to the painterly experience, writing: 'It is, however, very painful to have to state that the improvement produced in the comprehension of nature from the point of view of the picture and the development of the means of expression is accompanied by old age and a weakening of the body' (Rewald, 1995, p. 315).

Hoffman, Donald D. (1998), *Visual Intelligence: How We Create What We See* (New York: W.W. Norton & Company, Inc.).

Ione, Amy (in press), 'The gift of seeing: Nineteenth century views from the field', in *Art Technology Consciousness*, ed. R. Ascott (Exeter and Portland Oregon: Intellect Books).

Krauss, Rosalind E. (1994), *The Optical Unconscious* (Cambridge, MA and London: The MIT Press).

Loran, Erle (1943), *Cézanne's Composition* (3rd ed.) (Berkeley: University of California Press).

Rewald, John (ed. 1995), *Paul Cézanne, Letters* (New York: Da Capo Press).

Riding, Alan (1999, Tuesday, May 4, 1999). 'Hypothesis: the artist does see things differently', *The New York Times*.

Ruskin, John (1843), *Modern Painters* (London: George Allen).

Sacks, Oliver W. (1995), *An Anthropologist on Mars: 7 Paradoxical Tales* (1st ed., New York: Alfred A. Knopf).

Senden, M. von (1960), *Space and Sight: The Perception of Space and Shape in the Congenitally Blind Before and After Operation*, trans. P. Heath (Glencoe, IL: The Free Press).

Shiff, Richard (1984), *Cézanne and the End of Impressionism* (Chicago and London: The University of Chicago Press).

Smith, Paul (1995), *Impressionism: Beneath the Surface* (New York: Harry N. Abrams, Inc.).

Solso, Robert L. (1999), 'Brain activities in an expert versus a novice artist: An fMRI study', working paper.

Wade, Nicholas J. (ed.) (1983), *Brewster and Wheatstone on Vision* (London and New York: Academic Press, Inc.).

Wollheim, Richard (1987), *Painting as an Art* (Princeton: Princeton University Press).

Zeki, Semir (1998/1999), 'Art and the brain' *Daedalus: Proceedings of the American Academy of Arts and Sciences*, **127** (2), pp. 71–104. Reprinted in *Journal of Consciousness Studies*, **6** (6–7), pp. 76–96.

Zeki, Semir (1999), *Inner Visions: An Exploration of Art and the Brain* (Oxford: Oxford University Press).

Robert L. Solso[1]

The Cognitive Neuroscience of Art

A Preliminary fMRI Observation

The perception and cognition of art, a venture done effortlessly by all members of our species, is a complicated affair in which visual perception, brain structures, sensory reasoning, and aesthetic evaluation are made in less time that it takes to read this sentence. Only recently, through perceptual/brain studies, have we begun to understand the many neurological sub-routines involved in visual perception. The discoveries made in cognitive neuroscience laboratories have helped us better understand the perception of everyday visual phenomena, including the perception of art. In addition, cognitive neuroscientists have provided techniques and instruments which are valuable in the study of the psychology of art. In this paper I give an overview of the past research which has advanced our understanding of how people process visual art. In addition the results of a preliminary study of an accomplished artist as he drew a portrait while in an MRI machine are presented.

Art and Science

Recently, there has been an increased interest in closing the gap between the sciences and arts (see Goguen, 1999; Ramachandran & Histein, 1999; Solso, 1994a; Zeki, 1993; 1999). Such efforts are understandable given the new technology now available that reveal cognitive functions by means of brain imaging and other techniques such as measuring evoked potentials and EEG recordings. These new methods, coupled with our understanding of the neuro-processes which are engaged in visual perception, have expanded our knowledge of artistic perception. We begin by considering the elementary pathways engaged in visual perception.

[1] I wish to express my thanks to Michael A. Crognale, Jennifer Muskat and unknown reviewers whose comments enhanced this paper.

Journal of Consciousness Studies, **7**, No. 8–9, 2000, pp. 75–85

Basic Perception

Visual perception begins when electromagnetic signals within the visual spec-
trum are sensed by the eye. The eye, which contains about 150 million
light-sensitive rods and cones was once thought to be an entity conceptually sepa-
rate from the brain, to which it sent its electro-chemical signals. During fetal
development the retinas of eyes forms from outpouchings of the same tissue that
gives rise to the cerebral cortex and consequently the retina and cortex are struc-
turally quite similar. The eye (and other sensory organs) and brain are now
thought to be conceptually related. Many theorists suggest that the eye is an
extension of the primary visual cortex. Most visual signals follow a well known
neurological route — from the retina, to the lateral geniculate bodies, to the pri-
mary visual cortex in the occipital lobe. From that point the pathway becomes
more nebulous. From the initial structures, V1, signals proceed to an area called
V2 and separate into a series of higher processing areas each of which carries out
specialized analysis. These processing routes have generally been labeled the
'where is it' pathway in the more dorsal brain regions and the 'what is it' pathway
in the ventral portions (Haxby *et al.*, 1991) In the first instance, areas specialized
in depth processing, location and motion are found. Form, detail, colour, and
faces are found in the 'what' pathway. It is with the 'what' pathway and regions
beyond that we are mainly concerned in this paper and we shall return there
shortly. Of course, this simplified and sterile description of the stages of visual
perception lacks details and poignancy of real world experiences. We need to
paint a broader picture that has 'warts and all'.

The Viewing of Art

The viewing of art causes an immediate conscious experience in people. We see
colours, shapes, contours, objects, distances, and interactions (among other
things) and, when all of these impressions are sensed, the brain brings meaning
and comprehension to the art object. In some instances our conscious experience
may indicate that the object has three dimensions even though the retina, which
initially records the image, does so in two dimensions. Furthermore, our mind
supplies reasonable inferences to our consciousness about a visual scene which
may be, in fact, absent in the object. We 'see' behind occluded objects, feel
motion, and react emotionally to provocative themes even though these things
may not literally exist. In the cognition of art, our past knowledge supplies con-
sciousness with context. Experience colours art. We understand Picasso's
Guernica, Michelangelo's, *Sistine Chapel,* and Rembrandt's *Self-portrait* (1658)
better because we can feel the intensity of women and children being victimized
in the embittered Spanish Civil War, know the Biblical story of creation and
man's fall from grace, and comprehend the weathered features of an old man's
face. Our cognizance of art, which give mindful substance to visual signals, goes
well beyond V1 and V2. Yet, these early processing stages of visual signals are
relatively well known — the mysteries of the later stages are only beginning to be
untangled.

Representation of Visual Information

The processing of all visual signals and art raises the question of the nature of representation. It is suggested here, and elsewhere (see Crick & Koch, 1995) that conscious awareness of an object, such as a piece of art, is constructed by the brain at various locations but that one central locus is primarily implicated. Thus, for an observer viewing a portrait, such as one of van Gogh's self portraits, the primary visual cortex and the 'what' pathway, especially the fusiform area associated with facial perception (Kanwisher *et al.*, 1997), are directly involved while other areas, such as the frontal areas, may be also active. It should be pointed out that such speculation is subject to wide variations depending on instructions, attention, background of the observer, and intention. A person who views an abstract painting and is asked to count the number of right angles is likely to process the scene in his right hemisphere while another subject, viewing the same abstract painting but asked to make up a story about the painting, is likely to process the scene in his left hemisphere. Some support for this observation has been found in several laboratories (Solso, 1994b; Zaidel, 1994).

Representation of visual information, such as a face, seems to engage a limited number of neurons for a particular face, and a broader number to faces in general (Young & Yamane, 1992) Thus, a particular face might activate a series of neurons but, if some of those neurons in the series were destroyed one might see only components of a familiar face — a nose, an eye and the like. In our example of Rembrandt's face the meaning we attribute to it is explicitly represented centrally as well as in other parts of the brain. The emotions may be in one place; the interpretation of the person's age, in another; and yet the historical significance of the portrait, in another place.

From the vast experimental literature on priming it is clear that following even simple stimulation, the brain's neuro-circuitry begins on a relentless, parallel, and multifarious route. Furthermore, much of the neurological activity goes on without reaching the threshold of consciousness but, nevertheless, has profound importance in everyday cognition. In order for us to understand the world, and the world of art, many unconscious, subliminal, neural processes must take place. To illustrate this, consider an uncomplicated experiment Bruce Short and I conducted a few years ago (Solso & Short, 1979) in which a colour swatch (RED) was shown as a prime and then a verbal associate to the colour (BLOOD) was shown. The task was to identify the associate as related to the colour swatch. When the latency between the stimulus and the associate was delayed up to 1500 ms. subjects reaction time to the associate was approximately the same as their reaction time to matching the colour with a same colour. Thus, when one sees a stimulus, as simple and elementary as a colour chip, a whole range of neurological associates are excited, most at a level below consciousness. To further illustrate the spread of excitatory activation, in a follow up experiment we presented a very remote associate to the colour swatch (e.g., the colour RED was presented and the remote associate PLASMA then presented.) Presumable, RED elicits BLOOD and BLOOD elicits PLASMA. Even here, the reaction times were

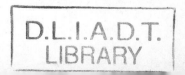

slightly faster than control conditions, yet, it is unlikely that any of the subjects were consciously aware of the word PLASMA when they saw the colour. Such remarkable demonstrations, repeated in numerous laboratories throughout the world, show the vast network of neurological activities which follow the perception of even simple stimuli. The brain bristles with synaptic activity following stimulation. It is the way we understand the world, how we 'get' jokes, and grasp the richer meaning of everyday events. Think of a red swatch. Is FIRE an associate? Is COMMUNISTIC a word? What colours are in the American flag? Even thinking about a red colour sets in motion countless neural connections which makes available a wide range of associated events.

In terms of how the brain forms a construction of more complex events, such as van Gogh's self portrait, it follows from simple priming experiments that there is a spread of associated activation effectuated by massively parallel processing. These myriad of excited patterns of spacial temporal neurological energy are the computations necessary for the brain to make meaning out of van Gogh's portrait, as well as a simple colour chip. The model of cerebral computation as a means of representing (and understanding) sensory events is beginning to come into focus. Although, perceiving complicated art is likely to engage different and more diverse sights than those visited by simple stimuli, the paradigm is the same. There are additional considerations in the way the brain goes about its business of making meaning out of visual stimuli including the intentionality of the observer and his or her personal history.

Intentionality and Viewing Art

A viewer's intention in viewing art and personal history strongly influences what he or she looks at in an object. This, in turn, determines which patterns of neural activity are aroused. (See our earlier discussion of instructions, attention and the representation of visual information.) In addition to situational demands, each person views art with a unique personal history which biases his or her attentional focus — a Nebraska farmer might attend to different features in Grant Wood's *American Gothic* than would a New York fashion designer. Each brings to art perception a largely undefinable[2] personal history which affects attention and interest. Furthermore, it has been demonstrated that selective perception of visual scenes may be artificially induced by an occupational schema (Beal & Solso, 1996). Here, subjects who developed a police officer schema tended to see more weapons in an art piece that was filled with violence than those who developed a nurse or architect schema. While the neurological rules and routing schedules may be entirely reliable, we humans bring extensive personal backgrounds and intentions to the viewing of art.

[2] While precise personal histories may be difficult to assess it is possible to estimate individual proclivities through personal statements of interests, occupation, and likes. In the work of Miall and Tchalenko (2001) and Solso (2001) with the artist HO we used occupation (artist) as an independent variable in examining his viewing patters and brain activity. See subsequent observations about HO.

The cognitive neuro-scientist is bedeviled with a hugely complicated labyrinth in which structural properties (for which he is searching) meander (sometimes slightly, sometimes profoundly) for each person who views art. Nevertheless, it is probable that reliable laws about 'higher order' processing of visual signals will be teased out through modern imaging technology, some of which will be considered next.

Neuro-imaging Techniques

Throughout the history of human brain studies, researchers were largely limited to observations based on disease and/or injured patients. During the nineteenth century these early neurological pioneers discovered important properties of the brain, such as the relationship between regions in the left hemisphere associated with language production, by Broca and language comprehension by Wernicke. Recently, brain functions have been evaluated by means of Positron Emission Topography (PET) and functional Magnetic Resonance Imaging (fMRI), in addition to other methods, which have greatly expanded our knowledge of the links between cerebral activities and mental events. Yet, because of the massive instrumentation involved in current imaging devices and other restrictive circumstances, the scope of experimental studies has been limited.

The fMRI technique measures micro-vasculature changes in active brain tissue, such as might be present in a subject performing a cognitive task. Such observations are secondary measures of active synaptic processing. We found that it was possible to use a MRI scanner, only slightly modified, as a suitable instrument for gathering information about the brain activity of a skilled artist as he drew a portrait.

Previous imaging research (both fMRI and PET) has show that specific cortical regions are implicated when a person views an object, attends to a stimulus (Kwong et al., 1992), processes words semantically (Gabrieli et al., 1996), or is engaged in motor activity. Thus, these methods of measuring the changes in regional cerebral blood flow (rCBF) are appropriate methods for assessing both structural sites and functional processes involved in cognitive tasks.

Cognitive research is a prime candidate for brain imaging studies as cognition involves neurological activity (and corresponding blood flow to specific regions) which may be detected by scanning techniques. However, MRI technology restricts subjects to limited experimental interactions such as squeezing a bulb or pressing a reaction time key in response to a stimulus. These strictures have been necessary because of the limited quarters of the MRI machine and the necessity of having the head held rigidly to get clean impressions. Yet, most cognition, thinking, and brain activities carried out by humans involve a wide range of interactive processes as in the perceptual-cognitive-motor activities of an artist as he views a model, cogitates and draws. In the experiment presented later in this paper, the magnetic resonance activity of an expert portrait artist was measured as he looked at a face, thought about it, and drew a portrait.

Facial Perception

Much of the cerebral research in the past several decades has dealt with the role of the right and left hemispheres in perceptual/cognitive tasks. These studies concentrated on semantic processing and were initiated by the seminal work of Sperry and others on 'split brain' subjects. Because facial perception is among the better understood cognitive perceptual tasks and because portrait artists specialize in facial perception, we concentrated our efforts in this area. More specific work has been devoted to facial perception and representation in humans (Courtney et al., 1997; Haxby et al.,1991; 1995; 1996; Kanwisher et al., 1997). The original work by Haxby and his colleagues (1991) used oxygen-labeled water and positron emission tomography (PET) to measure rCBF. It was thus possible to trace the object pathways activated in various tasks. The probes originally used were a dot-location matching task and a face-matching task. In the location task (where is it) the dorsal spatial location pathway was activated and in the face-matching task (what is it) the ventral object pathway was activated. These results have been confirmed by other experiments mentioned above and the consensus is that facial processing implicates the ventral occipitotemporal region. The activation has been observed bilaterally but with greater magnitude and spatial bounds in the right hemisphere — a finding consistent with many other observations of right hemisphere functioning. The specific area of facial activation is the fusiform gyrus, especially the right hemisphere fusiform gyrus (see Kanwisher et al., 1996; 1997; Puce et al., 1995; Sergent and Signoret, 1992, for specific areas of facial processing). It is because of these very specific patterns of brain activation brought about by facial perception and processing that we chose a portrait artist to study in some detail.

Other studies of facial processing have been based, in part, on a type of visual agnosia, called prosopagnosia, in which patients exhibit the inability to recognize or differentiate among faces even though other visual objects may be correctly identified (Sergent & Signoret, 1992). As mentioned above, facial perception seems to be concentrated in the right hemisphere and case reports suggest that damage in the occipital regions and posterior parts of the medial temporal cortex is involved in facial recognition but not object recognition.

Although much of the medical research has focused on the pathological studies of visual agnosia there is a broader implication for the interest in facial recognition. The ability to recognize faces and comprehend the attributes of the person behind the face — be he friend or foe, for example — is an ecologically important event that has profound implications for social action and communication. The 'reading of faces' and the emotions expressed therein may have provided information critical to the survival of the species though out the evolutionary history of humankind. Whereas semantic processing, especially of the written word, which is centered in the left hemisphere is of relatively recent origin.

In the case of experts (such as portrait artists) who are accustomed to perceiving faces professionally, we ask, what regions of the brain are normally associated with facial perception and to what degree? In addition, are there other

regions of the brain activated in experts which may reflect a 'deeper' processing of this type of facial information? We set out to find answers to these questions using a well know British artist who drew faces while in a MRI scanner.[3]

fMRI and an Artist in Action[4]

A feasibility study was first undertaken in which the author performed a facial drawing task while in a whole-body MRI scanner. The stimuli consisted of six geometric figures and six faces that were held above the subject's face and copied. Data from the collective scans of faces were subtracted from the collective scans of the geometric figures. The results of this study indicated that clear data could be collected and the experiment reported herein was initiated.

The artist selected for this task, HO, is one of Britain's most distinguished portrait artists. His work is exhibited at the National Portrait Gallery (London), Royal Opera House (London), Wolfson College (Cambridge) and many other galleries. He has been the recipient of many awards and has presented many solo exhibitions. He specializes in portraits and has spent, on average, 4 or 5 hours a day drawing faces over the past 20 years. He was 47 at the time of testing, a male, and is right-handed. The non-artist used in this study who served as a control subject (AH) was a graduate student in psychology at Stanford University; 32 years old, right handed male with no formal training in art.

Figure 1 HO's sketch of face and geometric figure.

[3] The results of this fMRI observation have been reported elsewhere (Solso, 2001) and have been the subject of a show at the National Portrait Gallery, London April 17 to June 13 1999.

[4] The Wellcome Trust granted support for this project. We thank those who assisted in this project including Vivek Prabhakaran, John D. E. Gabrieli, Alex Huk, Humphrey Ocean, and especially John Tchalenko who initiated the 'Artist's Eye' project.

PORTRAIT vs. GEOMETRIC FIGURES

Figure 2: fMRI brain scans for an artist and non-artist as each drew a sketch of a human face

The artist, HO, was outfitted with a dental molded bite-bar and placed in the full-body MRI. A non-magnetic spiral notepad 8 cm by 10 cm (double that size when opened) with six standardized faces and six complex geometric figures was attached to the upper part of the MRI tube and appeared directly over the subject's face. The notepad was affixed to the upper portion of MRI tube by Velcro strips. The faces and figures were alternated on every other page. Half the faces were female and half male. HO was instructed to draw the portrait for 30 seconds and then flip the page to the next figure and to copy the geometric figure. A sample of his drawing is shown in Figure 1. The task continued with the next portrait drawing, the figure drawing and so on until the entire series of 12 sketches were completed. The control subject was treated identically. Technical information is found in the appendix.

The results of the geometric figures were subtracted from the faces to control for motor activity, known visual operations (e.g., primary visual cortex activity), and other perceptual-motor activities.

Data from HO's scans were compared with data from the control subject, AH, and those results are shown in Figure 2. All data was collected on the same machine in the same laboratory and by the same experimental team. However, in interpreting the results of this study some caution is advised. Here we looked at the brain scans from only two subjects. The data from one (the non-artist) was subtracted from the other (the artist). Variations in brain activity therefore, could be a reflection of the unique way the non-artist processed facial information. In addition, the measured differences could also be a reflection of the way the artist and the non-artist processed geometric forms. The study is restricted in this sense as it measures only the differences observed between two people — an expert artist and a control subject who is presumed to reflect 'normal' processing of visual forms. Further testing of additional non-artists is required before definitive claims may be made. Nevertheless, some tentative observations may be made with the anticipation that our original use of the MRI in investigating a working

artist will encourage other researchers to adopt this paradigm in the pursuit of artistic performance and brain processes.

Discussion of Experimental Results

Of particular interest in the fMRI scans of HO is the increase in blood flow activity in the right posterior parietal (A1). This site is consistent with other observations (Kanwisher *et al.*, 1997) where facial processing activity would be expected to occur. Also, in the novice subject marked right posterior parietal involvement is observed (see A1 and A2). However, the degree of activation in the novice appeared relatively *greater* than in the artist. These preliminary results are of interesting in two respects: first, they confirm that an area of the brain frequently associated with facial identification was specifically activated. This is in contrast to the visual processing of geometric figures. Second, the lower level of activation of the artist indicates that he may be more efficient in the processing of facial features than the novice. While the artist, who sees and thinks about faces professionally, may require less involvement in this area of the brain normally associated with facial processing. Whereas, the novice may require greater involvement suggesting he is processing faces at a 'lower' level, which deals with features rather than the 'meaning' behind the face. In effect, the novice seems to be 'copying' the face; the artist is 'seeing beyond' the features.

The artist showed greater activation in the right middle frontal area (Fig. 2, 3rd and 4th panels from the left) than did the novice. This part of the brain is usually associated with more complex association and manipulation of visual forms. Thus, these two main findings considered together suggest that an expert portrait artist, who frequently sees and draws faces, dedicates relatively less energy to the processing of faces and more to the processing of these features in terms of their associated correlates. In a phrase, the artist thinks portraits more than he 'sees' them. The involvement of the right frontal part of the brain suggest that this skilled artist is engaging in a type of 'higher order' interpretation of the perceived face and may be relying on an abstracted representation of the face. Such consideration is consistent with the artist's own impression of his thoughts during the process and is mentioned here because it may be that different artists have different thoughts as they draw a picture. Also, it is plausible that different types of artists, for example, landscape artists, abstract artists, and surrealistic artists, may show different patterns of cerebral involvement than those exhibited by HO. We would expect less right parietal involvement, for example, with people who draw landscapes than we found with a portrait artist. Further data on various types of artists, as well as a more reliable base gathered on non-artists control subjects, is needed for confirmation of our results and interpretation. Experts from a wide range of areas, such as mathematics, music, photography, poetry, architecture and so on, may exhibit specialized patterns of cerebral activity related to their expertise. Such studies — both situational and longitudinal — are encouraged, as we believe they will answer some important questions about experts, 'gifted' people, and the origin of talent.

Finally, the results of this experiment address a methodological issue in fMRI research. Because the data from our subjects reflect previously reported activation in the right posterior parietal region we confirm the reliability of using an interactive technique. In this study the subjects were actively drawing a portrait unlike many experiments in which subjects' responses are limited to pressing a button or squeezing a bulb or simply 'thinking' about an event. We are encouraged that the results suggest that more ecologically congruent fMRI experiments are feasible. Although the present nature of MRI technology requires the subject to be somewhat constrained it is possible to elicit a wider range of mobility in an interactive task than is frequently reported in the literature. Future research efforts to use a wider range of stimuli and responses are encouraged. Subsequent work might also gather data using a wider range of subjects — both in terms of artistic diversity and a larger number of non-artists — in order to develop reliable information about artistic performance and brain structures and processes.

Appendix

Technical Information

Imaging was performed with a 1.5T whole-body MRI scanner (General Electric Medical Systems Signa, Rev. 5.5). A T2* sensitive gradient echo spiral sequence was used for functional imaging with parameters of TR = 1440 msec, TE = 40 msec, flip angle = 83(FOV = 20 cm), inplane resolution = 1.56 mm2, and sampling interval = 2.88s. Sixteen 7 mm thick slices with a 0 mm inter-slice interval were acquired in the horizontal plane of the Talairach and Tournoux atlas (1988) covering the whole brain.

Correlations between the reference function, computed by convolving a square-wave at the task frequency with a data-derived estimate of the hemodynamic response function, and the pixel response time-series were computed and normalized. The frequency of the square-wave was computed from the number of task cycles divided by the total time of the experiment. For the experiments, one task cycle duration. There were six cycles present over a 360 sec scan frequency ~0.0166 Hz). One stimulus per block was presented. To construct functional activation maps, pixels that satisfied the criterion of z>1.96 (representing a significance at <.025, one-tailed) were selected and processed with a median filter with spatial width = 2 to emphasize spatially coherent patterns of activation. For each of the 12 images 125 images were acquired continuously over the 6 minute session, TI-weighted, flow-compensated, spin-warp anatomic images were acquired for the 16 sections that received functional scans.

References

Beal, M.K. & Solso, R.L. (1996), Schematic activation and the viewing of pictures. Paper presented at the Western Psychological Association, San Jose, CA, April, 1996.
Courtney, S.M., Ungerleider, L.G., Kell, K., & Haxby, J.V. (1997), 'Transient and sustained activity in a distributed neural system for human working memory', Nature, **386**, pp. 608–11.

Crick, F. & Koch, C. (1995), 'Are we aware of neural activity in primary visual cortex?', *Nature*, **375**, pp. 122–3.

Gabrieli, J.E.E., Desmond, J.E., Demb, J.B., Wagner, A.D., Stone, M.V., Vaidya, C.J. & Glover, G.H. (1996), 'Functional magnetic resonance imaging of semantic memory processes in the frontal lobes', *Psychological Science*, **7**, pp. 278–83 .

Goguen, J.A. (1999), 'Editorial introduction', *Journal of Consciousness Studies*, **6** (6–7), pp. 5–16.

Haxby, J.V., Grady, C.L., Horwitz, B., Ungerleider, L.G., Mishkin, M., Carson, R.E., Herscovitch, P., Schapiro, M.B. & Rapoport, S.I. (1991), 'Dissociation of object and spatial visual processing pathways in human extrastriate cortex', *Proceedings of the National Academy of Sciences, USA.*, **88**, pp. 1621–5.

Haxby, J.V., Ungerleider, L.G., Horwitz, B., Maisog, J.M., Rapoport, S.I., & Grady, C.L. (1996), 'Face encoding and recognition in the human brain', *Proceedings of the National Academy of Sciences USA*, **93**, pp. 922–7.

Kwong, K.K. *et al.* (1992), 'Dynamic magnetic resonance imaging of human brain activity during primary sensory stimulation', *Proceedings of the . National. Academy of Sciences., USA,* **89**, pp. 5675–9.

Kanwisher, N., Chun, M.M., McDermott, J. & Ledden, P.J. (1996), 'Functional imaging of human visual recognition', *Cognitive and Brain Research*, **5**, pp. 55–67.

Kanwisher, N.J., McDermott, J. & Chun, M.M. (1997), 'The fusiform face area: A module in human extrastriate cortex specialized for face perception', *Journal of Neruosciences,* **17**, pp. 4302–11.

Miall, R.C. & Tchalenko, J. (2001, in press), 'The painter's eye movements', *Leonardo*.

Puce, A., Allison, T., Gore, J.C., & McCarthy, G. (1995), 'Face-sensitive regions in human extrastriate cortex studied by functional MRI', *Journal of Neurophysiology*, **74**, pp. 1192–9.

Ramachandran, V.S. & Hirstein, W. (1999), 'The science of art: A neurological theory of aesthetic experience', *Journal of Consciousness Studies*, **6** (6–7), pp. 15–51.

Sergent, J. & Signoret, J-L. (1992), 'Functional and anatomical decomposition of face processing: Evidence from prosopagnosia in PET study of normal subjects', *Philosophic Transactions of the Royal Society, London*, **B335**, pp. 55–62.

Solso, R.L. (1994a), *Cognition and the Visual Arts* (Cambridge, MA: MIT Press).

Solso, R.L. (1994b), 'Hemispheric processing of realistic, surrealistic, and abstract art'. Paper presented at the annual meeting of the *Psychonomic Society*, St. Louis, November 11.

Solso, R.L. (2001, in press), 'Brain activities in an expert versus a novice artist: An fMRI study', *Leonardo*.

Young, M.P. & Yamane, S. (1992), 'Sparse population coding of faces in the inferotemporal cortex', *Science*, **256**, pp. 1327–31.

Zeki, S. (1993), *A Vision of the Brain* (Oxford: Blackwell).

Zeki, S. (1999), *Inner Vision: An Exploration of Art and the Brain* (Oxford: Oxford University Press).

Zaidel, D.W. (1994), 'Worlds apart: Pictorial semantics in the left and right cerebral hemispheres', *Current Directions in Psychological Science*, **3**, pp. 5–8.

Sister Shimotsuma *Human Condition*

Rafael De Clercq

Aesthetic Ineffability

Abstract: *In this paper I argue that recent attempts at explaining aesthetic ineffability have been unsuccessful. Either they misrepresent what aesthetic ineffability consists in, or they leave important aspects of it unexplained. I then show how a more satisfying account might be developed, once a distinction is made between two kinds of awareness.*

I: Introduction

Discussing art clearly requires a range of (special) skills. But no matter how perceptive we are, and no matter how well we succeed in communicating our findings to others, there is some point at which even our best efforts run up against the limits of language. That is, at some point we must recognize that much of what we find of significance in art, and in aesthetic objects in general, cannot be rendered in words (without remainder) and so can never become fully our own. This observation, which I take to be in line with common sense, could also be phrased as follows: language, at least in its literal mode, is not able to capture fully the content of an aesthetic experience; aesthetic experience, therefore, may be said to put us in touch with the unsayable or 'ineffable'.

I am not claiming that aesthetic experience is unique in this respect. For all I have said, there may be something ineffable about experience in general. What I do hope to establish, however, is that there is something distinctive of 'aesthetic ineffability', which current theories fail to account for. For instance, one important aspect of aesthetic ineffability is that it is not discovered through theoretical reflection, nor, it seems, through actually putting our linguistic tools to the test. Rather it is aesthetic experience itself which rouses in us this sense of something being ineffable. So even if we were to have an account of why the content of an aesthetic experience cannot be fully articulated, we would still be in need of an account of why this residual content is also *experienced as* ineffable. In addition, we would also need an explanation of why we attach *importance* to what we seem unable to express in words. In other words, an ideal account of aesthetic ineffability should also explain why we seem to desire to express the inexpressible.

Consider, for example, the following suggestion. Our desire to express our experience of art to the full does not derive from an insight into the intrinsic

Journal of Consciousness Studies, **7**, No. 8–9, 2000, pp. 87–97

importance of what is inexpressible, but rather, from a more basic desire to resolve aesthetic disagreements. In the absence of such disagreement, we would not bother about what remains unsaid: a simple 'It's wonderful!' would just do. I think there are two problems with this proposal. First, although no doubt disagreement makes us search for more accurate and more detailed descriptions of artworks, it seems implausible to me that our desire to express the inexpressible would manifest itself only in case of disagreement. Second, the proposed explanation seems to *presuppose* an insight into the importance of what is ineffable: why else would we expect the ineffable to lend support to our aesthetic value judgment?

I shall proceed as follows. First I address the 'sceptical challenge', coming from William Kennick and Stephen Davies. In their opinion, the ineffable, as intimated by aesthetic experience, does not exist or at least is unimportant. Then I review some philosophical explanations of aesthetic ineffability, including the recent elaboration of one of them within a cognitive science framework. As I hope to show, these explanations are all defective in at least one of the following two respects: either they misrepresent what aesthetic ineffability consists in, or they leave important aspects of it unexplained. In the final section, I shall explore the possibility of developing a more satisfying account of aesthetic ineffability by making use of a distinction of Michael Polanyi's between focal and subsidiary awareness.

II: Sceptical Positions

Ineffability is, by definition, difficult to discuss (and, what might be worse, the notion carries religious connotations). Therefore, it is certainly tempting to 'quine' this alleged incapacity, that is, to deny its existence or importance, even though this is evident to most people.[1] Not surprisingly, then, there are authors who question that aesthetic experience brings us in touch with something — a meaning or content — that cannot be put in (literal, unambiguous, . . .) words. On the other hand, there are also those who doubt only the *importance* of such meanings or contents, accepting, nonetheless, their existence. Both positions are, I suspect, symptomatic of the unease with which some analytic philosophers — aspiring a maximum of clarity and explicitness — have approached the problem of ineffability. I will criticize these positions successively, in order to defend (indirectly) the commonplace belief that we are indeed confronted with something ineffable in aesthetic experience.

According to William Kennick there are no meanings that can be conveyed only by artworks and not by ordinary language (Kennick, 1961, pp. 309–20).[2]

[1] A neologism borrowed from D. Dennett's satirical philosophical lexicon: 'quine, v. To deny resolutely the existence or importance of something real or significant' (Dennett, 1990, p. 519).

[2] I do not want to commit myself here to the view that art conveys meanings, however that claim is to be understood. Nor do I want to suggest that the ineffable should be construed as a meaning that can be conveyed. For the sake of argument, however, I accept Kennick's way of putting his thesis. Furthermore, it seems reasonable to suppose that what he is attacking is not some particular conception of art, but rather the connection between 'art' and 'the ineffable' in general, whether or not 'the ineffable' is to be understood here as a 'meaning conveyed'. Kennick is very uncautious in his use of expressions

This position, radical as it is, is fairly deviant. (However, depending on how 'meaning' and 'conveying' are understood, it may or may not be reconcilable with a less sceptical view of ineffability. I will come back to this issue.) As Kennick himself observes: 'There is probably no conviction more deeply rooted in modern aesthetics than this, that works of art express what cannot be expressed in ordinary discourse' (Kennick, 1961, p. 309).[3] Kennick challenges this 'deep-rooted' conviction as it has been put forward by Prall, Langer and Dewey (i.e. mainly in terms of the difficulty of naming or describing the feelings expressed or evoked by a work of art). It is possible, however, that by doing so, he will have arrived only at a rejection of *the specific way* in which Prall, Langer and Dewey conceived of the problem of ineffability: it is not guaranteed that a general argument, tackling the very idea of an ineffable content, can be obtained from this. Equally, Kennick's central thesis that it is misplaced to formulate the problem of ineffability as a complaint about the adequacy of ordinary language does not in itself entail anything as regards the existence of ineffable contents.

It could also be objected that Kennick's position — as presented here — is bound to lead to the so-called 'heresy of paraphrase'. On the one hand, Kennick acknowledges that non-verbal works of art are irreplaceable and that poems can never be translated (without loss) into a literal, prosaic text.[4] But on the other hand, he refuses to admit that there are meanings that only certain artworks can express.[5] This *might* seem untenable. For if artworks lack special untranslatable meanings, why would they be irreplaceable? One could say, as Malcolm Budd does, that artworks are irreplaceable, not because of the special *meaning* that accrues to them, but because of the unique *experience* they afford (Budd, 1996, pp. 84–5). However, in this manner one avoids the heresy of paraphrase, but not the problem of ineffability, which simply returns as the question of whether there exist any ineffable experiences (the content of which cannot be verbally expressed).

Stephen Davies is remarkably positive about Kennick's article on ineffability, but does not go so far as to claim that ineffability belongs to the (black) list of philosophical pseudo-problems. Davies is primarily concerned with minimizing the importance of what is, or what seems to be, ineffable in aesthetic experience. More specifically, he argues that we should not yield to the inclination to relate the ineffable to fundamental or deep or otherwise important truths:

like 'meaning', 'expressing', 'communicating', 'conveying', etc. But I think the message is nevertheless clear.

[3] Diana Raffman opens her book with exactly the same observation (Raffman, 1993).

[4] Cf. 'Works of art do have 'values and meanings' not ordinarily found in common or scientific discourse . . . Works of art, even poems, novels, and plays, cannot be 'translated' into prose discourse . . .' (Kennick, 1961, p. 320).

[5] Cf. 'it is to deny that there are meanings that cannot be said or communicated by means of language but can be said or communicated by works of art' (Kennick, 1961, p. 320). In the light of these quotations (see also note 4), it could be argued that there is an ambiguity in Kennick's text to the extent that he seems to distinguish between 'having' a meaning on the one hand, and 'saying' or 'communicating' a meaning on the other hand. However, considering that he does not clarify his use of these expressions, I regard this apparent ambiguity as insignificant (at least for the time being).

> The temptation should be resisted. Even if some kinds of perceptual knowledge pro-
> vide access to truths that are literally inexpressible, there is no reason to think that such
> truths have a special importance. As [Diana] Raffman emphasizes, the most mundane
> perceptual experiences lead to the acquisition of ineffable truths — for example, that
> the apple in front of me has a distinctive hue. Such facts are usually of no importance
> (Davies, 1994, p. 161).

So, on Davies' account, there is no real reason to suppose that the indescribable
aspects of an aesthetic experience are more significant than the indescribable
remainders of a normal perceptual experience (for example, certain shades of col-
our). However, he does not explain why only in the first — the aesthetic — case
an impression may arise that we are dealing with something important, for exam-
ple, with a deep truth about life. Nor does he explain why we should ignore this
impression, unless we are presupposing already that it is deceptive. Whether or
not it is deceptive, an explanation is needed of why in an aesthetic case an impres-
sion of deep significance may arise. (Note that what I say here does not commit
me to the view that works of art convey deep truths about life. I simply notice that
people *tend* to think of art as providing us with ineffable insights. Personally, I
think the word 'insight' might be misleading in this context. But what it rightly
indicates, I think, is that the ineffable is not experienced as something entirely
trivial or obvious.)

III: Explanations of Ineffability

Kennick and Davies should be seen, I think, as exceptions. After all, that is why I
said that I would defend a commonplace belief. However, I also think that most
authors hold the commonsense position for the wrong reasons.

In order to give evidence for the existence of ineffable contents, the concrete-
ness or *fine-grainedness* of (perceptual) experience is often contrasted with the
generality of our concepts or terms. Recently, this argument has been refined by
Diana Raffman within the framework of cognitive psychology.[6] According to
her, the ineffable resides in nuances, for instance of pitch, which can be heard but
not 'categorized' (or 'type-identified'), because we lack the appropriate schemas.
However, if this argument is sound it establishes only a *relative* form of ineffabil-
ity, one that is relative to our 'immediate lexical resources' (Danto, 1973,
pp. 47ff.). As such it can be overcome, in this case by invoking a scientific vocab-
ulary, by making use of ostension, or maybe even by practice.[7] But the impression
remains, I suspect, even after ostension or intensive training has taken place, that
something important eludes communication.[8] Hence there must still be a different,

[6] Recently, another attempt has been made to explain ineffability within the framework of cognitive sci-
ence (McMahon, 1996, pp. 37–64). However, I believe that it suffers from the same flaws as the
approach I am about to discuss.

[7] Cf. '[I]t is entirely possible that some of us, with a great deal of practice, could acquire schemas more
fine-grained than our present chromatic ones' (Raffman, 1993, p. 84).

[8] According to Raffman, ostension does not make 'nuance-ineffability' disappear, because of (physical)
differences in our 'discrimination profiles'. The question is whether these differences also have a role
to play in our communication of describable contents. Moreover, Raffman herself assumes, maybe for
that reason, that the discrimination profiles of trained listeners are the same (Raffman, 1993, pp. 88–9).

if not more important, kind of ineffability than that resulting from the rather trivial difficulty of designating certain pitches or colour hues with general terms. For these reasons, I suppose, Jerrold Levinson remarked that 'the ineffability of greatest interest' cannot be equated with the difficulty of denoting certain nuances:

> . . . the ineffability of greatest interest, if it exists, resides in notable, fully effable musical *structures*, rather than individual, maximally nuanced instantiations of those structures. The more important kind of ineffability in music, if it exists, concerns what music conveys, or at least gives the impression of conveying, about human life . . . (Levinson, 1995, p. 201).

It is questionable, furthermore, whether Raffman's 'nuance-argument' could explain why we attach importance to what is unsayable. Raffman herself notices that we do not feel an urge to communicate (perceptual) nuances in daily life (Raffman, 1993, pp. 95–6).[9] But why, then, would we suddenly want to do so when we are dealing with a musical performance? Raffman's explanation is that in the latter case the nuances are *intended* by a performer. Be that as it may, it does not explain why we may also have an experience of ineffability when contemplating *natural* beauty (where there are apparently no intentions or performers involved).

A variant (and, in fact, a precursor) of Raffman's explanation has it that general terms are unable to designate exactly the feelings we have in the course of an aesthetic experience.[10] Obviously, ostension is not of any help here, since what is to be captured — a certain state of mind — is not observable. However, this explanation faces an important (phenomenological) difficulty, namely the fact that aesthetic experience does not direct our attention inward, to our own felt feelings, but outward instead, to an aesthetic object. And it is, at least in the first place, something about this object that is experienced as ineffable. This objection could be met by considering not our own, private feelings as what is to be described but rather the feelings expressed by the artwork.[11] Ineffability would then consist in the difficulty of reporting precisely what is expressed by a given artwork, or more generally of conveying all the nuances of an artwork's meaning. But then little progress has been made. In fact, it seems as if the problem we started with is merely repeated: the meaning of an artwork cannot be communicated adequately

[9] Cf. 'Note, though, that such ineffable features are not peculiar to artistic performances, since car engines may have them as much as violins' (Cooper, 1992).

[10] One can think here of the positions of Prall and Dewey as presented (and criticized) by Kennick (1961), pp. 310ff. Diana Raffman also accepts 'feeling ineffability' (as she calls it). Moreover, she offers an interesting explanation of how we are made aware of this kind of ineffability: 'My suggestion [is] that music's grammatical structure creates the expectation of a semantics — something effable. What we get instead are the ineffable musical feelings of tenacity, beat strength, tension, resolution, stability, and so forth. . . . This ineffability violates our semantic expectations, and so we notice it' (Raffman, 1993, p. 61). However, on this account, even the most trivial pieces of music would generate an experience of ineffability. Moreover, it remains unexplained why can also have such an experience when our semantic expectations are *not* frustrated, for example, when we read a good poem (see Scruton, 1997, pp. 200–1).

[11] See Kennick, pp. 182ff., and Roger Scruton's discussion of Croce's theory of expression (Scruton, 1997, pp. 143–4).

by means of words. No explanation has been provided of how artworks succeed in having a meaning that lies beyond the reach of ordinary words and sentences. Moreover, and more importantly, it remains unclear why we should *value* (be interested in) all nuances of whatever is expressed by an artwork.

Yet another variant of Raffman's theory refers to the individuality of the aesthetic object, which descriptions, being general, can never fully capture. No doubt the individuality of the aesthetic object has some part to play in any plausible explanation of aesthetic ineffability. However, merely mentioning it will not suffice, because in a sense *any* object is unique, if only because of its spatio-temporal location or causal history. What needs to be specified is what makes aesthetic objects unique in some special, interesting way. Their expressive content or meaning? But this, as already noted, would merely amount to a restatement of the initial problem. In other words, 'the meaning of the artwork is ineffable' is equivalent to, but not explained by, 'the meaning of the artwork can be expressed only by the artwork'.

Finally, it has also been suggested that aesthetic ineffability derives from the impossibility of letting the first-person perspective merge into the perspective of a third person. According to Roger Scruton, for example, the aesthetic experience of music makes us participate in a first-person perspective different (in a way) from our own, as when we feel ourselves into a gesture or a facial expression (Scruton, 1997, pp. 360–4). What is experienced in such an act of empathy, Scruton contends, can never be completely described (from the perspective of a third person), because it is based on an acquaintance which a description cannot possibly convey.

Now whatever the merits of this account may be for the experience of music, it is difficult to see how Scruton's explanation can account for experiences of ineffability related to the aesthetic contemplation of nature, ordinary artifacts, and certain works of visual art. What would it be like to empathize with a lake, a screwdriver, or one of Donald Judd's aluminium constructions, for instance? In fact Scruton's explanation suffers from three more fundamental defects. First, it seems rather counter-intuitive to identify the ineffable with the 'knowledge by acquaintance' we gain through (adopting) a first-person perspective, because, on the face of it, the ineffable seems to be the intentional object of a thought or an experience, however diffuse, rather than the specific subjective quality (the 'what it is like') of having that thought or experience. Second, Scruton does not tell us *whose* (first-person) perspective we are putting ourselves into when listening to music. One suggestion would be a 'musical persona' (an imaginary subject), as in Jerrold Levinson's theory of expression, but Scruton does not accept this sort of construct (Scruton, 1994, p. 511).[12] So there is a gap in his explanation. Finally, Scruton explains little by invoking the first-person perspective. More specifically, he leaves open why (participating in) this perspective is so particularly valued in aesthetic experience. As Michael Tye writes, 'fully understanding the essential nature of *any* given experience or feeling requires knowing what it is

[12] For Levinson's theory, see Levinson (1996), pp. 91–125.

like to undergo it (and that, in turn, demands a certain experiential perspective)'
(Tye, 1995, p. 56). But it is highly uncommon for us to feel at a loss for words
when this perspective is no longer available. I believe Scruton fails to explain
why this is so.

IV: An Alternative Explanation

A quite different perspective on the subject of ineffability can be derived — by
means of some interpretative reconstruction — from *Meaning*, a rather unnoticed
work by Michael Polanyi (Polanyi & Prosch, 1975). This work contains a further
development of Polanyi's well-known analysis, expounded in *Personal Knowl-
edge*, of the kind of attention involved in the exercise of all sorts of skills (reading,
riding a bicycle, doing science, etc .). This analysis led to a distinction between
what is subsidiary and what is focal, introduced to capture the characteristic
'from–to' structure of all attention or awareness.[13] According to Polanyi, we
always attend *from* certain (so-called 'subsidiary') elements *to* a focal integration
of these elements. But the elements we attend from do not always have the same
interest. This variable interest is precisely what marks an important difference
between the attention involved in, for instance, reading a text or riding a bicycle,
on the one hand, and the attention involved in aesthetic experience on the other
hand.

The ordinary understanding of words and sentences is directed exclusively
toward their meaning, which is the object of focal attention. The concrete words
(sounds, inscriptions), attended to in a subsidiary manner, have only an instru-
mental value: they carry a meaning that could have been communicated by some
other means (a paraphrase) just as well. As a consequence, we can forget them as
soon as we have grasped their meaning. In this connection, Polanyi mentions an
occasion on which he remembered what was conveyed by a certain letter, while
having forgotten the specific language it was written in (Polanyi, 1967b, p. 306;
1974, pp. 57,91). This anecdote illustrates the purely instrumental value of what
is subsidiary in ordinary, purposeful communication.

In aesthetic experience, however, both the subsidiary and the focal are appreci-
ated in their own right. On the one hand, we focus intensely on the aesthetic char-
acter (say, the beauty) of an object. Yet on the other hand, we retain an awareness,
equally intense, of something that lies outside the focus of our attention.[14] To be
more precise: while focussing on the aesthetic character of the object, we attend
in a subsidiary manner to whatever it is that lends this focal object its special
significance (Figure 1). According to Polanyi, what we bring to bear upon the
focal (aesthetic) object are day-to-day experiences immersed in our diffuse mem-
ories of them. However that may be, because of the so-called 'unspecifiability of
the subsidiary' it is impossible to make fully explicit what is responsible for the

[13] For an interesting discussion of empirical evidence supporting this distinction (as it applies to visual
awareness), see Iwasaki (1993), pp. 211–33.

[14] See A. Burms (1990), pp. 11 ff. on 'concentration without elemination'. Not unrelated to this is
Sperber (1975), pp. 119ff. on the combination of 'focalization' and 'evocation'.

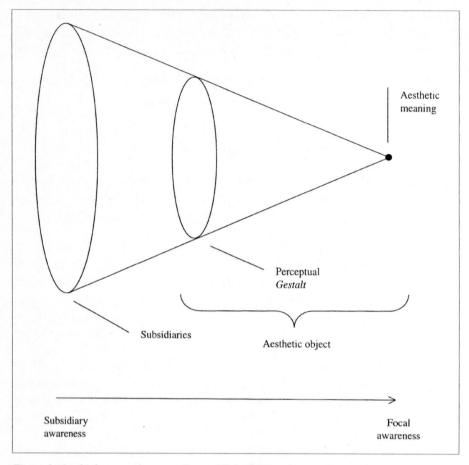

Figure 1. Aesthetic perception according to Michael Polanyi

striking character of an aesthetic object. (The subsidiary is considered unspecifiable, because as soon as we shift our attention to it, and start to examine it focally, its meaning changes, that meaning being, in fact, the focus upon which it used to bear.)[15] In other words, it is impossible to grasp focally how an aesthetic object acquires its special meaning.[16] We can only relate to it in a subsidiary (that

[15] The unspecifiability of the subsidiary is a result of the two following facts. First, the subsidiary elements bear upon a focus which is their *joint meaning* (Polanyi, 1967a, p. 13). Second, focal and subsidiary awareness are *mutually exclusive*: it is impossible to attend both focally and subsidiarily to an object (Polanyi, 1974, p. 56; Polanyi, 1975, p. 38) As a result, it is impossible to bring subsidiary elements into focus without changing their meaning. For example, when I focus my attention on the sensory qualities of a word (it's sound or visual appearance), then it becomes deprived of the (linguistic) meaning it has when attended to in a subsidiary manner.

[16] This resembles David Cooper's idea that the ineffable is to be identified with 'the background as such', that is to say with 'the background as it obtrudes and penetrates in its role as the condition of meaningful talk and experience' (Cooper, 1991, p. 14). The background here spoken of equals, I believe, the 'subsidiary' in Polanyi's theory.

is, indirect) manner, through its reflection in a concrete, aesthetic object.[17] None-theless, Polanyi contends, we place a special importance on it (as he infers, I sup-pose, from the way we are disappointed by paraphrases).

To a certain extent, it is possible to articulate what makes an aesthetic object so striking, and in fact this is constantly being done.[18] But what is remarkable about such attempts is that they usually sound rather banal. This, however, is exactly what we should expect. It is just an example of the loss of meaning ('sense depri-vation' Polanyi would say) that occurs inevitably when we shift our focal atten-tion to what was before subsidiary. Thus, the banality of what must pass for an explanation of the captivating character of an aesthetic object is analogous to the meaninglessness of a word that is repeated time and again. There, too, our focal attention is eventually drawn to what is normally assigned a subsidiary role.

Polanyi's account meets quite well the criteria (set out at the beginning) for an ideal account of aesthetic ineffability. He explains, first, why there is always something ineffable in aesthetic experience. He does so by referring to the two-fold structure of our attention in general, and, more specifically, to the essential 'unspecifiability of the subsidiary'. (The question is whether the object of subsid-iary awareness can be said to be 'expressed' or 'conveyed' by the artwork. If not, then Polanyi's theory is not at odds with Kennick's thesis, namely that art does not convey or express a meaning that ordinary language is not able to convey or express.) Second, Polanyi provides the basis for an explanation of why it is only at certain moments, for instance in the course of an aesthetic experience, that the object of subsidiary awareness is also *sensed as* ineffable. Roughly, one could suggest — in line with Polanyi's account of aesthetic attention — that this sense issues from the contrast (or tension) felt in combining a heightened awareness of, or interest in, the subsidiary with a maintained interest in the focal.

At this point the following objection could be raised. In aesthetic experience we attend to many things with subsidiary awareness: the formal properties of a poem, the bass line of a musical piece, the canvas of a painting, etc. But these are not ordinarily 'sensed as ineffable'. So how can it be said that the 'object of sub-sidiary awareness is sensed as ineffable' in aesthetic experience? Even if there were to be such a sense, it would at best be a misleading one. After all, we manage to say a great deal about the formal properties of a poem, for instance, and it is unclear what more we would ideally wish to say about them.

Recall that, according to Polanyi, we *can* become focally aware of (all) the sub-sidiary 'clues' entering into an integrated action or meaning. It is possible, at least in principle, to identify all the subsidiaries involved in achieving a particular inte-gration. However, when focal attention is directed to what was formerly serving as a subsidiary, it becomes a 'different kind of thing, deprived of the meaning it

[17] It may be noteworthy here, that there is an important phenomenal aspect to the relation between focal and subsidiary awareness: what is perceived subsidiarily appears in terms of the focal object (Polanyi, 1967a, p. 11; Polanyi, 1974, pp. 82, 92; Polanyi & Prosch, 1975, p. 35). A well-known word, for instance, has a distinctive appearance when compared to a foreign word: it looks transparent, as it were, because it is attended to in terms of a focal meaning.

[18] Cf. '[A]ny particular element of the background can be brought to light and speech' (Cooper, 1991, p. 14).

had while serving as a subsidiary' (cf. a word losing its transparency when we start staring at it) (Polanyi & Prosch, 1975, p. 39). So suppose I am listening to a symphony and attending with subsidiary awareness to the bassoon: the bassoon is certainly not ineffable *as such*. But there is something ineffable *about* it, something we cannot become focally aware of, and that, Polanyi would say, is what it adds to the (focal) meaning of the work (Polanyi & Prosch, 1975, p. 80). In other words, what we cannot articulate is how the bassoon affects the quality of the whole upon which it bears.

In more general terms, then, one could say that what is ineffable about a musical work or any other aesthetic object is not some particular part of it to which we are attending with subsidiary awareness (the bass line, the melody, the brush strokes, the rhyme, etc.). It is rather the way these various parts contribute to and are integrated into a whole that can move us deeply. So what is ineffable about the symphony, and, if I am right, also *sensed* as such, is not the bassoon or any other part, but rather the way the bassoon fuses with the other elements of our (subsidiary) experience and enhances the significance of the whole.[19]

However that may be, it is not entirely clear (from Polanyi's own account) why a heightened awareness of, or interest in, the subsidiary is typically accompanied by a sense of something being revealed in one way or another. So as it stands, Polanyi's account fails to meet the third desideratum, that is, to explain why we attach importance to what we are unable to put in words. Nevertheless it is more promising than Raffman's, for instance, because, unlike Raffman's, it might well be possible to supplement it with such an explanation. One might, for a start, point to the natural tendency to conceive of that which gives something its importance as what is truly important.

V: Conclusion

The first section attempted to show that the literature on the subject of ineffability does not provide us with convincing reasons to doubt either the existence or the importance of something ineffable in aesthetic experience. At least, there is no good reason to put aside the *impression* that in aesthetic experience we are confronted with something ineffable of importance. The second section aimed at a critique of some standard explanations of ineffability, referring all but one to the difficulty of putting into words all nuances of a perceptual and/or aesthetic experience. The aim was again negative: indicating where the problem of ineffability should not be located. Finally, an alternative and more promising explanation was sought in the work of Michael Polanyi.[20]

[19] In the previous paragraph I tried to state as precisely as possible what is ineffable according to Polanyi (in response to a possible objection). I did not intend to paraphrase how he explains ineffability.

[20] This paper was presented at conferences in Brussels, Leuven and Oxford. I owe special thanks to Malcolm Budd, Arnold Burms, Wim De Pater, Oswald Hanfling, Graham McFee, Miles Smit, Walter Van Herck and an anonymous referee for their comments on an earlier version of this paper.

References

Budd, M. (1996), *Values of Art. Pictures, Poetry and Music* (London: Penguin Books).

Burms, A. (1990), 'Fictie, zelfbedrog, contemplatie', *Tijdschrift voor Filosofie*, **52**, pp. 3–16.

Cooper, D. (1991), 'Ineffability', *Proceedings of the Aristotelian Society*, suppl. vol. **65**, pp. 1–15.

Cooper, D. (1992), 'Ineffability', in *A Companion to Aesthetics*, ed. D. Cooper (Oxford: Blackwell).

Danto, A. (1973), 'Language and the Tao: Some reflections on ineffability', *Journal of Chinese Philosophy*, **1**, pp. 47ff.

Davies, S. (1994), *Musical Meaning and Expression* (Ithaca, NY: Cornell University Press).

Dennett, D. (1990), 'Quining qualia', in *Mind and Cognition. A Reader*, ed. W.G. Lycan (Oxford: Blackwell).

Iwasaki, S. (1993), 'Spatial attention and two modes of visual consciousness', *Cognition*, **49**, pp. 211–33.

Kennick, W. (1961), 'Art and the ineffable', *The Journal of Philosophy*, **63**, pp. 309–20.

Kennick, W. (1967) 'The Ineffable', in *The Encyclopedia of Philosophy*, ed. P. Edwards (New York: Macmillan & The Free Press) pp. 181–3.

Levinson, J. (1995), 'Review of "Language, Music, and Mind", by Diana Raffman', *Mind*, **104**, pp. 197–202.

Levinson, J. (1996), 'Musical Expressiveness', in *The Pleasures of Aesthetics* (Ithaca, NY: Cornell University Press).

McMahon, J.A. (1996), 'Aesthetic Perception', *Communication & Cognition*, **29**, pp. 37–64.

Polanyi, M. & Prosch, H. (1975), *Meaning* (Chicago: University of Chicago Press).

Polanyi, M. (1967a) *The Tacit Dimension* (New York: Doubleday Garden City).

Polanyi, M. (1967b), 'Sense-giving and sense-reading', *Philosophy*, **42**, pp. 301–25.

Polanyi, M. (1974), *Personal Knowledge. Towards a Post-Critical Philosophy* (Chicago: University of Chicago Press).

Raffman, D. (1993), *Language, Music, and Mind* (Cambridge, MA: MIT Press).

Scruton, R. (1994), 'Recent books in the philosophy of music', *The Philosophical Quarterly*, **4**, p. 511.

Scruton, R (1997), *The Aesthetics of Music* (Oxford:, Oxford University Press).

Sperber, D. (1975), *Rethinking Symbolism* (Cambridge: Cambridge University Press).

Tye, Michael (1995), *Ten Problems of Consciousness. A Representational Theory of the Phenomenal Mind* (Cambridge, MA: MIT Press).

Katherine Ehlern *For All My Lovers*

Frank Steil *Everything is Connected*

Jennifer Church

'Seeing As' and the Double Bind of Consciousness

Central to aesthetic experience, but also to experience in general, is the phenomenon of 'seeing as'. We see a painting as a landscape, we hear sequence of sounds as a melody, we see a wooden contraption as a boat, and we hear a comment as an insult. There are interesting and important differences between these cases of 'seeing as': the painting cannot literally be a landscape while the wooden contraption can literally be a boat; a failure to hear sounds as a melody may count as a shortcoming whereas the failure to hear a comment as an insult may be admirable. Here I want to focus mainly on their similarities, however — similarities that will lead us back to Kant, and to the nature of consciousness itself.

The phenomenon of 'seeing as' presents certain familiar puzzles: how is seeing a painting *as* a landscape different from *seeing* a landscape, on the one hand, and from *thinking* of the painting as a landscape, on the other? 'Seeing as' is not the same as misperceiving, nor is it the same as offering an interpretation, yet it seems related to both. These puzzles are articulated in Section I, and some candidate solutions are rejected. Section II develops a Kantian account of experience showing how the convergence of conflicting representations, achieved through imaginative syntheses, is essential to the experience of objects and to consciousness itself. Kant's insights are used to evaluate some recent responses to the so-called 'binding problem' — the problem of explaining how the contents of consciousness are bound together, and the role of the imagination is further detailed. Section III then returns to the difference between ordinary seeing and 'seeing as', offering an explanation of the latter in terms of the framework developed in Section II.

I

When we see an X *as* a Y (a painting as a landscape, say) we partake in a kind of double-consciousness, experiencing a thing in two different ways simultaneously (the painting way and the landscape way) — ways that retain their independence despite their convergence on a single object at a single time. The problem of 'seeing as' can be viewed as the problem of explaining just how such independence and convergence can coexist.

Journal of Consciousness Studies, **7**, No. 8–9, 2000, pp. 99–111

The need for independent representations of X and of Y is evident from the very grammar of 'seeing as', which indicates a three-place relation between the seeing subject, what is seen, and what that thing is seen *as*. If what is seen and what it is seen as are indistinguishable, then the three-place relation collapses into a two-place relation — that of (simply) seeing. And while we may say of someone who mistakes a bush for a bear 'She sees the bush *as* a bear,' from the point of view of the subject she simply *sees* a bear. Thus, the experience of seeing X as Y is not the same as the experience of misperceiving X or hallucinating Y, where the object perceived would be seen in just one way. Nor is it sufficient for the experience of seeing as that a subject realizes that she is misperceiving or hallucinating, for she may know that she has things wrong without having any notion of what is right; indeed, she may know that her perception of a bear is mistaken without knowing whether there is anything there at all.

To experience the independence of what is seen from what it is seen *as* one must recognize some conflict between the two representations or categorizations, even if they are not strictly incompatible. While being a painting is incompatible with being a landscape, and being a bear is incompatible with being a bush, being a comment is not incompatible with being an insult, and being a series of sounds is not incompatible with being a melody. Still, when we speak of seeing one thing *as* another, we indicate a certain reluctance to subsume one under the other; we register a certain tension or competition between two characterizations of that thing. We would not say that we see a ball *as* a toy or a box *as* a container, for example — unless, perhaps, to suggest a conflicting experience of the ball as part of a machine, or a conflicting experience of the box as simultaneously a stool. Likewise, to hear the comment 'You are very diligent' *as* an insult, one must experience a certain mismatch between hearing the comment as a compliment or an innocent observation and hearing it as an insult. In some cases, the conflict between representations seems to be a conflict between different ways of organizing or grouping the available material. In describing the experience of seeing a F as a T with an additional stroke, Wittgenstein reports, with a note of suspicion, 'The organization of the visual image changes.' — 'Yes, that's what I'd like to say too' (Wittgenstein, 1980, paragraph 535). In other cases, the conflict seems more fundamental, as when synaesthetes report seeing sounds as colours, feeling smells as textures, etc., and it is hard to understand these contrasts in terms of alternative groupings or alternative purposes. However we end up explaining any particular conflict, though, it should be clear that 'seeing as' depends on experiencing some tension between two (or more) characterizations of a thing.

Normally, we can experience conflicting properties (or conflicting groupings of properties) as belonging to the same thing only by separating them in time. It is tempting, therefore, to explicate the experience of seeing a painting as a landscape as one in which we fluctuate between seeing it as a painting and seeing it as a landscape; and it is tempting to explicate the experience of hearing a comment as an insult as one in which we go back and forth between hearing it as a mere observation and hearing it as an insult. But these explications do not do justice to our experience of seeing the landscape *through* the painting or hearing the insult

in the comment. They grant the conflicting characterizations too much independence. For while the 'as' of 'seeing as' indicates a certain independence of different ways of seeing something, it also indicates a recognition of their simultaneous applicability; we must experience a temporal as well as a spatial convergence of what is seen and what it is seen as.

As usual, Wittgenstein has an acute sense of how sensible assumptions can lead to absurdities:

> Could I have made the phenomenon [of seeing as] clear to myself, if I had been told: someone whose eyes are open sees something that is not there before him, and at the same time also sees what is before him, and the two visual objects don't get in each other's way?! (Wittgenstein, 1980, paragraph 1014.)[1]

The suggestion that, in 'seeing as', we see conflicting things in the same place at once may be tempting only until we are called upon to explain how it is that the two things can keep from getting in each other's way. And we could, on such grounds, maintain that the experience of conflicting representations converging in space and time is an illusion — perpetrated by the misleading grammar of 'seeing as', perhaps. (This is a conclusion that is sometimes drawn from Wittgenstein's writing on the topic.) But it is then incumbent on us to supply a more appropriate description of the phenomena in question.

One option would be to redescribe the conflict between the two representations or the two ways of seeing something as a conflict between seeing and thinking. On such an analysis, seeing a painting as a landscape would consist in seeing the painting while thinking that it is a landscape — or, alternatively, seeing a landscape while thinking it is a painting. Likewise, hearing a comment as an insult would amount to hearing the comment while thinking that it is an insult (or *vice versa*). No doubt there are some experiences that fit these descriptions (the Muller line illusions, for example), but they are not the experiences we are puzzling over: gazing at a painting in the knowledge that it is intended it as a landscape (while unable to see it as such), or thinking that a colleague's comment probably was an insult (without being able to hear it as such) are not experiences of 'seeing as'. 'I do not merely *interpret* a figure, but I clothe it with the interpretation' (Wittgenstein, 1980, paragraph 33).[2]

Would it help to require that the thought of the landscape, or the thought of the insult, follow immediately upon seeing the painting, or hearing the comment? That depends on what sort of immediacy one has in mind. Temporal immediacy seems irrelevant, since I may learn to *hear* a series of sounds as a melody only gradually, after repeated exposure, while the *thought* of that series as a melody may occur to me promptly, on first hearing. Nor is it inferential immediacy that matters here, since I may, for example, rather arbitrarily decide to think of a

[1] This passage follows Wittgenstein's dismissal of the explanatory relevance of physiological explanations appealing to the simultaneous activation of two images.

[2] Because this passage is in quotes, suggesting attribution to someone other than himself, Wittgenstein must be assumed to be suspicious. Still, Wittgenstein repeatedly acknowledges that something is missing from the view that 'seeing as' is no more than 'thinking as'. See, for example, Wittgenstein (1980), paragraphs 1, 26 and 874.

wooden contraption as a boat without having made any inference whatsoever ('That's just the way I want to think of it') yet still fail to see it as a boat, or I may come to see it as a boat only by making various inferences concerning the probable functions of its various parts. Justificatory immediacy seems closer to the mark, since the thought of that contraption as a boat makes it into my 'seeing as' experience just in case it is justified simply by my looking, and the thought that those sounds comprise a melody makes my experience into a 'hearing as' experience just in case it is justified simply by listening. This seems right, but as an explanation of 'seeing as', it gets things exactly the wrong way around, for it is not the justificatory immediacy of a thought that makes an experience into a 'seeing as' experience but, rather, the 'seeing as' experience that bestows justificatory immediacy on the thought. Direct justification does not create perception, it assumes it.[3]

Wittgenstein's writings on this topic are rich in ambiguities, but one suggestion that he explores sympathetically is the suggestion that seeing a painting as a landscape is a matter of having the *inclination to respond* to it as if it were a landscape.[4] The requisite conflict between two different ways of seeing is portrayed not as a conflict between images (with all the paradoxes that produces) but rather as a conflict between responses or dispositions. This is the strand in Wittgenstein's thinking that is developed more fully in Gilbert Ryle's classic account of imagining (Ryle, 1949, Chapter VIII: 'Imagination'). To see a painting as a landscape, according to this account, would be to have inclinations towards the painting that are like the inclinations one would have towards a landscape — an inclination to peer around a visual obstruction, for example, or an inclination to move forward along a particularly inviting trajectory — as well as having an inclination to feel the surface of paint, to follow the brushstrokes, etc. Similarly, to hear a comment as an insult would be to have the inclination to slap back, or to cringe, as well as having an inclination to look for evidence of its truth, an inclination to agree or disagree, and so on.

Wittgenstein's focus on inclinations is instructive in so far as it reminds us that seeing a painting as a landscape, as opposed to merely thinking of it as a landscape, stirs us and inclines us in ways that merely thinking of it as a landscape does not. Hearing notes as a melody, as opposed to thinking they must constitute the melody, requires that they move us in the appropriate way. But what, exactly, are the relevant sorts of inclinations? Thoughts, after all, also involve inclinations: when thinking that a certain set of notes constitutes a melody I am inclined to listen to those notes more closely, to anticipate their return, to try to remember them, etc. Are the inclinations that accompany seeing, or seeing as, different in kind from the inclinations that accompany (mere) thoughts? More bodily,

[3] This 'natural' way of understanding the relation between justification and perception has recently been challenged in some interesting ways by Robert Brandom (1994). Among the counterintuitive implications Brandom embraces is the claim that a physicist observing a hooked vapour trail actually sees mu-mesons (p. 223).

[4] 'What is in question is an *inclination* to do one thing or the other' (Wittgenstein, 1980, paragraph 18). See also paragraph 1012.

perhaps — inclinations to do certain things, or move in certain ways, as opposed to inclinations to have various other thoughts? More automatic, perhaps — inclinations over which we have very little control, as opposed to inclinations that we may choose whether or not to pursue?[5] However, quite apart from the difficulty of distinguishing the inclinations of 'seeing as' from the inclinations of merely 'thinking as', Wittgenstein's appeal to inclinations doesn't help much with the problem with which we began — the problem of explaining how *conflicting* ways of seeing something manage to *converge* in both space and time. For even if conflicting ways of seeing are equated with conflicting inclinations rather than conflicting images, their simultaneous occurrence is problematic: how can we be simultaneously inclined to touch the paint *and* to walk into the landscape, or to ask for evidence *and* to slap back? Why don't conflicting inclinations face the same difficulty as conflicting images when it comes to keeping out of each others' way?[6]

We remain, then, without a satisfactory account of the way in which 'seeing as' combines conflict with convergence — the way it manages to 'clothe' one perception with another.

II

It was Kant's genius to realize not only how conflicting representations *can* be made to converge in experience but, also, why they *must* converge for there to be conscious experience at all. By showing how consciousness itself depends on our ability to bring conflicting representations together in the experience of an object, he points towards a resolution of the apparent paradoxes of 'seeing as'. The Kantian insight can be summarized as follows: although seeing seems to be a two-place relation between the seer and the seen, and thinking appears to be a three-place relation between the thinker, the object of thought, and what is thought about that object, conscious seeing also requires one to distinguish an object from the way it is presented and conscious thinking also requires one to merge an object with the way it is presented. This mutual dependency of perception and thought is expressed in Kant's famous statement 'Thoughts without content are empty, intuitions without concepts are blind' (Kant, 1787/1929, B75/A51). A certain sort of 'seeing as' thus underlies both conscious perception and conscious thought, and it is what brings the two together. (How such ubiquitous 'seeing as' differs from the more specialized cases of 'seeing as' with which we started is the topic of Section III.)

Kant claims that seeing (that is, consciously perceiving as opposed to taking in information and responding 'blindly') requires us to consider conflicting presentations of a single object because we can't see an object without locating it in

[5] Wittgenstein treats inclinations to speak in certain ways as central, claiming that they are the 'primary expressions' of seeing as (see Wittgenstein, 1980, paragraphs 20 and 862). But surely one can see a painting as a landscape or hear a series of notes as a melody without being able to describe what one hears (not even as 'a landscape' or 'a melody' let alone 'a case of seeing as' or 'aspect seeing').

[6] This may be one reason Wittgenstein puzzles so over the duration of 'seeing as' — for example, in Wittgenstein (1980), paragraphs 512–32.

space (and time) and we can't locate it in space (and time) unless we recognize
that it has more than one face (or phase), that it appears differently from different
places in space and time. If an object were indistinguishable from its appearance
to a given viewer at a given time, it could not be an object *in space*; and, clearly,
when we see things we see them as located in space. But to distinguish between an
object and its appearance is to distinguish between different appearances of the
same object; so, in order to see objects we must distinguish between the different
appearances they may have. In perceiving a house, for example, we register its
three-dimensionality even though its backside is hidden from us, and in observing
a boat on a river, we recognize its pathway as continuous, even when we are not
observing it continuously. This requires us to call forth, in imagination, points of
view that are not actually ours — the view from the backside, the view from here
when we are looking the other way, and so on. Our memory of past observations
can help us to imagine some of the missing points of view, of course, but memory
is not enough to do the necessary 'filling in' since we have probably never
observed an object from *every* point of view, and since we are regularly con-
fronted with objects we have never before encountered. It is for this reason that
Kant emphasizes the importance of 'productive' as opposed to merely 'reproduc-
tive' imagining; one must be capable of imaginative projections, not merely
imaginative associations.

In just what sense, though, do we need to 'register' or 'recognize' alternative
points of view on an object in order to see it from our point of view? In what way
am I aware of the unseen back of a house or the movement of a boat when I look
away? Surely there is some distinction between what is actually seen and what is
merely remembered or imagined; otherwise, we would be hopelessly confused
about our own position. Indeed, seeing the front and the back of a house simulta-
neously seems absurd for just the reason Wittgenstein indicates: how would the
two presentations keep out of one another's way? Peter Strawson (1970), elabo-
rating on Kant, speaks of the need for perceptions to be 'infused by' what is imag-
ined, but he admits that the 'infusion' metaphor is elusive and requires more
work.[7] Patricia Kitcher offers a functionalist interpretation of Kant whereby per-
ceiving an object depends (both causally and logically) on having the capacity to
imagine various other representations of that same house — without, however,
requiring that such imagining actually be activated while perceiving any particu-
lar object (Kitcher, 1990, especially pp. 148–62). But her analysis fails to take the
convergence requirement seriously enough, losing the crucial distinction
between 'seeing as' and 'thinking as' (since a functionalist account of thought is
equally insistent on our capacity to think other, related thoughts, *at other times*).

The requisite recognition of alternative perspectives must avoid the impossi-
bility of collapsing multiple perspectives into a single image (in which case we
cease to experience the perspectives as independent) but it must also avoid the
inadequacy of being merely disposed to imagine alternative perspectives as the
need arises (in which case we cease to experience the perspectives as convergent).

[7] He also suggests the metaphors of visual experience 'irradiated by' and 'soaked with' concepts (p. 57).

What is needed, it seems, is a kind of three-dimensional image within which different perspectives are positioned as such, or a set of dispositions that can be simultaneously activated without actually triggering conflicting responses — dispositions which can be taken 'off line' as it were.[8] If this is right, seeing objects located in three-dimensional space is a bit like enclosing them in a visual hand — a hand that sees all sides instead of feeling all sides. In order to interact with a particular object (to get back 'on line'), the position that I occupy must be recognized as such; but that does not prevent my continued imagining of a more encompassing array of perspectives; indeed, I have argued, conscious perception requires as much.

Thinking, according to Kant, also depends on imagination's ability to synthesize conflicting representations. But if, in the case of seeing, the challenge was to show how seeing requires us to register conflicting representations or points of view, in the case of thinking the challenge is to show how thinking requires us to register the spatiotemporal convergence of conflicting representations. From the mere fact that thoughts are structured, it is clear that thinking presupposes a distinction between objects and their properties — between subject and predicate. Making this distinction in turn depends on the ability to attribute the same property to different objects, and different properties to the same object.[9] But why should thought require us to attribute different properties *all at once*? Why isn't it enough (for thought versus perception) that different properties be attributed at different times? The answer, I think, is this: knowing that different predicates can apply to the *same* object depends on knowing that different predicates can apply in the same place at the same time; otherwise there is no distinction between a series of predicates applying sequentially to the same object and a sequence of predicates applying to a sequence of objects. We must, therefore, be capable of experiencing a convergence of properties in space and time in order to experience them as properties of an *object*.[10] In order to think of a rose, for example, as an object — which is necessary if we are to think of it at all — we must be capable of merging representations of colour, shape, size, smell, etc. This is not to say that all thinking must be accompanied by images; sometimes thinking amounts to little more than the syntactical manipulation of symbols (as with a computer). But, as Kant realized, any such manipulation of symbols, however deft, is ultimately empty unless appropriate connections can be made to a perceived object — that is, to an object experienced as existing in space. Thus, in some important sense, neither I nor the computer succeed in thinking *of an object* unless the spatiotemporal convergence of that object and its various representations or

[8] The relevance of 'off line' simulation to thoughts of all sorts is a topic of growing interest (and controversy) of course. A collection of now-classic papers is in Stone and Davies (1996).

[9] This is what Gareth Evans (1982) requires with his Generality Constraint on thought (pp. 100–5).

[10] Daniel Dennett sometimes complains (in Chapter 6 of *Consciousness Explained*, 1991, for example) about the fallacy of confusing simultaneity of representations with representations of simultaneity. But, as Kant argued (in the First Part of the 'Transcendental Aesthetic' of his *Critique of Pure Reason*, as well as in some earlier writings), space and time cannot be mere concepts. Thus, spatiotemporal location cannot be just another attributed predicate; it must be experienced directly.

predications is actively imagined. (Descartes seems to have appreciated thought's ultimate reliance on the spatiotemporal convergence of representations, and hence on perception, when he insisted that all steps of a proof be considered simultaneously and shown to form a single, consistent 'object'. His translations of algebra into geometry were especially valued for this reason, and he advised serious thinkers to rehearse the steps of a proof faster and faster until all the steps could be seen at once.)

Kant's insights about the imaginative syntheses required for seeing and thinking are equally insights about the requirements of consciousness itself. Thinking of objects ultimately depends on seeing objects, and seeing objects depends on simultaneously imagining the different sides, or stages, of those object. The simultaneous imagining of such contrasting perspectives is only intelligible, however, insofar as the different perspectives can be relativized to different perceivers or different stages in the perceptions of a single viewer — which is to say, we must imagine various possible subject positions in order to see the position of a single object (and *vice versa*). Thus, the experience of objectivity and the experience of subjectivity are necessarily intertwined and the requirements for seeing or thinking of objects as objects are also the requirements for having conscious experiences.

This puts us in a position to see the promise but also the shortcomings of some recent solutions to the 'binding' problem — the problem of explaining just how it is that we bind together the disparate contents of our experience into a unified consciousness of a single world. It has become common to distinguish between several different binding problems: the problem of how our experiences of different properties get bound together into the experience of a single object, the problem of how our experiences of different objects get bound together into the experience of a single world, and the problem of how our different experiences get bound together into the experiences of a single subject. If Kant is right, however, these different binding problems are mutually dependent and an adequate solution to any one will provide a solution to the others as well. I consider, in turn, the recent suggestions of Daniel Dennett, of Francis Crick and Christof Koch, and of Susan Hurley, highlighting the ways in which they do or do not satisfy the Kantian requirements.

Daniel Dennett attributes the unity of consciousness to the creation of narratives — stories we tell ourselves (and others) about what we are experiencing.[11] The internal narrative, in order to be coherent, must include some elements and not others, and must order events in some ways rather than others (not necessarily the same order in which information is received). Whatever makes it into an internal narrative makes it into consciousness; and what doesn't appear in a narrative doesn't appear in consciousness. What many find missing in (at least this part of) Dennett's account is an appreciation of the phenomenal character of consciousness; but what is that? I do not think Dennett has succeeded in 'Quining qualia'

[11] I refer to his account in *Consciousness Explained* (Dennett, 1991), especially Chapter 5, which is somewhat different than previous accounts he has offered and, arguably, at odds with some other things he writes in the same book.

(by showing how we can say everything we want to say about experience without committing ourselves to the existence of so-called qualia), but neither do I think that phenomenal character is by nature inexplicable. In terms of our preceding discussion, the problem with Dennett's account is that it overlooks the convergence requirement; the phenomenal character of consciousness is missed because the experienced convergence of different aspects or appearances in space is missed. I may construct a long and detailed 'narrative' about the melody I am hearing without consciously experiencing it as a melody; so, the occurrence of something in a narrative cannot ensure its occurrence in consciousness. Dennett might claim that narratives are the means through which the experience of spatiotemporal convergence is created; but even if this is so (I think that narratives sometimes effect such convergences, but not always), it cannot be so in the first instance. For in order for narratives to be *about* what we experience, we must already have effected the syntheses necessary for consciousness. We must succeed in consciously seeing at least some objects before we can merely think about them. And if Dennett insists, as he seems inclined to, that the relevant narratives do *constitute* our perceptions as conscious perceptions, then he cannot also insist that the narrative be a narrative *of* those perceptions, for the notion of a narrative — suggesting a sequential story about various objects and events — then *presupposes* what it is meant to explain.

Francis Crick and Christof Koch (1998) offer a very different solution to the binding problem. They suggest that the contents of our minds are united, and hence made conscious, precisely when the neural vehicles of those contents oscillate in unison (at appropriate frequencies). When the oscillations of neurons become too disparate and ill-coordinated, consciousness is lost; when harmony is reestablished, consciousness is regained. Supported by some important empirical observations, the underlying thought seems to be this: as long as the activation of different representations is carefully aligned in time, we will experience different representations as representations of a single world, effecting the very unity that is necessary for consciousness. It is not always clear whether Crick and Koch are addressing the unity of representations in a single object or the unity of objects in a single world. Clearly, both sorts of unity are necessary, for objects will not register as objects unless they can be positioned within a larger, spatiotemporal framework, and a spatiotemporal framework will not register as such unless objects (and subjects) can be placed within it. But it is not clear how a single oscillation rate can accommodate the need for both sorts of unity. The oscillations that unite the neurons that represent the colour and texture and shape of this book into a single object must, it seems, be distinct from the oscillations that unite the neurons that represent the colour and texture and shape of this pen; yet both pen and book are experienced as existing simultaneously in a single world. What is missing, I think, is a recognition of the fact that different representations can be aligned with different points of view, for it is only through that recognition that we can have the experience of a single world containing multiple objects. Crick and Koch's oversight, then, is a variation on Hume's: it is not enough simply to bundle together associated representations to get the experience of an object; the

different representations must be actively imagined as varying in response to different points of view. Whereas Dennett shortchanges the fact that we need to experience a convergence of representations in order to experience consciousness, Crick and Koch shortchange the fact that we also need to experience the independence of representations in order to experience consciousness.

Susan Hurley (1998) has recently developed an account of the unity of consciousness which, unlike Dennett's account, seems to take the convergence requirement seriously, and, unlike Crick and Koch's account, seems to take the independence requirement seriously. Central to her account is the notion of a dynamic feedback system. Perceptions become conscious, she suggests, insofar as they are directly and systematically responsive to our actions in the world, and actions, in turn, are consciously intended in so far as they are directly and systematically responsive to our perceptions. The unity of consciousness, then, depends on the convergence of inputs around the actions of a single organism — actions which, by their very nature, must register the independence of objects from any particular way they may appear to a subject at a given time. This is a promising account, for which she offers both empirical and philosophical support. But I don't think it recognizes the importance of imagining the merely possible appearances of objects we are conscious of. The feedback that Hurley focuses on is always feedback between actual inputs and actual outputs, but such feedback loops are quite common in the (apparent) absence of consciousness; amoebas and beetles and ants all establish effective feedback loops with their environments, and I continually adjust my posture in response to pressure from my chair without any (apparent) consciousness of that pressure. Also, conscious thought can occur without any immediate feedback from the objects of thought — as when I consciously think of a particular building in Scotland while sitting at my desk in New York. The way to accommodate both sorts of counterexample, I suggest, is to require that non-actual feedback loops between subject and object be *imagined*. Crucial to the difference between my relation to the tree I am now staring at and the amoeba's reaction to heat is the greater flexibility of responses I am capable of; my responses are mediated by a wide range of information that is available to me not only upon further reflection, but immediately, in my current perception of the tree. (I see the perch for a bird despite the fact that no bird is now present, I see the pointed leaves despite the fact that I am not now close enough to discern their shape, I see its young age, and so on.) Hurley's feedback loops are better than Dennett's narratives or Crick and Koch's synchronized oscillations in accommodating both the independence and the convergence of representations necessary for consciousness but, I suggest, they focus too narrowly on the immediate present and overlook the crucial role that imagination plays in creating the wider range of feedback loops necessary for consciousness.

III

Let us now return to the experiences of 'seeing as' that we started with — the experiences of seeing a painting as a landscape, of hearing a series of sounds as a

melody, of seeing a wooden contraption as a boat, and of hearing a comment as an insult. The Kantian framework of the last section, demonstrating the way we experience different ways of seeing, or different appearances, as both conflicting and convergent whenever we are conscious of objects, threatens to turn ordinary seeing and thinking into instances of 'seeing as', overlooking what is special about the experiences we ordinarily label as such.

To understand what is special about 'seeing as', as opposed to what it has in common with ordinary seeing and thinking, we need to get clearer about just what it is that conflicts and converges in the case of seeing versus the case of 'seeing as'. When we see a landscape (standing on top of a hill, for example), conflicting presentations of the terrain converge as we imagine a variety of different points of view or perspectives converging on the slopes before us; the different appearances retain their independence insofar as they are imagined as appearing from different points of view, but they converge insofar as the imagined points of view are views of a single place. In the case of 'seeing as', on the other hand, conflicting presentations cannot be accommodated by relegating them to different spatiotemporal points of view. A painting does not appear as a landscape from the right and as a painting from the left (and even if this were the case, such a conflict in presentations is not resolved by appeal to different angles of vision — as it would be in the case of ordinary seeing). For it is not different angles of vision so much as different 'depths' of vision that conflict and converge in the case of 'seeing as'. What seems to be an *object* — the painting — around which various appearances converge (rough surface from this angle, smooth from that, smattering of bright colours from up close, subtle shade from farther back) will also seem to be an *appearance* of some further object — the landscape. We seem to see a landscape through a painting in much the way that we seem to see a tree through its surfaces — except that, in the case of a painting, the 'surface' is a three-dimensional object in its own right. Likewise, to hear a sound sequence as a melody requires us to hear a sound sequence both as an object in its own right (which may appear soft or loud, clipped or slurred, short or long, depending on one's listening position) and as appearances of something deeper which is made manifest through the sounds — a melody.

The experience of depth, however, just is the experience of conflicting appearances or presentations converging in space and time. This is the reason binocular vision is so important for the visual experience of depth and why stereo sound is so important for the experience of sound depth. And the more different perspectives we can bring together in an imaginary convergence, the greater our experience of depth. To look more deeply into an object, then, means to find a way to unify its various aspects or parts more fully. What makes it possible, then, to experience something as both an object in its own right and as the appearance of some further 'object' is that an object's different spatiotemporal aspects or parts can be viewed as different appearances of a still more fundamental and more unified object. In the case of a painting, this may mean that the bright area here and the blur of colour there, the rough texture to one side and the slanting lines above, can all be seen to converge when seen as the appearance of a particular landscape.

In the case of sound, it may mean the variations in pitch, the slow crescendo, and the occasional moments of silence all come together into a whole once the underlying melody is discerned. And in the case of a colleague's comment, it may mean that a particular word choice, an edgy intonation, and unusually fast timing can all be seen as manifestations of the same underlying intention to insult. Or, taking things 'deeper' still, the apparent calm of the landscape's water next to the apparent violence of its sky may be seen as two manifestations of a single nature, which is God's; the apparent harmony of a melody together with its apparent gaps may be heard as deriving from an underlying wistfulness; and the harshness of an insult together with its slyness might both be expressions of a deeper desire for revenge. Finally, in addition to viewing the different parts of individual objects as different appearances of some 'deeper', more fundamental object, we may view a variety of objects as appearances of some one underlying reality. We sometimes speak of seeing what an artist sees only by seeing whole series of paintings, or a whole collection of songs. Or, crossing mediums, like Oliver Messian (and many other synaesthetes), we may view a certain set of sounds and a certain set of colours as alternative presentations of what is fundamentally one. (Such attempts to find new and greater unity is, of course, a central part of aesthetic appreciation according to Kant.)

There is a certain similarity here between the aesthetic appreciation of paintings and sounds and the scientific appreciation of tables and chairs. In both cases, ordinary objects may be seen also as appearances of still other, less ordinary objects. It is a rare person, scientist or otherwise, however, who can really see a table as atoms in motion — that can unify the tables' many different properties all at once through appeal to something deeper. More importantly, though, in the case of science, the underlying objects (for example, the atoms) tend to be less rather than more unified than the objects through which they may appear.

In some cases, the laws of optics or the laws governing sound perception are enough to ensure that one thing is seen as another; it doesn't take an education in art history to see a photograph as a scene and it doesn't take musical training to hear a sound as growing or contracting. But usually the ability to see one thing as another is more dependent on learning. The imaginative projections required in order to see what lies 'behind' a cubist painting, or to hear what 'underlies' a piece by Ligetti are not at all automatic, and may depend on principles of translation or transformation that are highly conventional. And the discernment needed to see a boat in the wooden construction of a child, or to hear an insult in the comment of a colleague may depend on having a very strong desire to see or hear more than meets the eye. Certain schools of art, moreover (all of modern art, according to some), actually resist the experience of depth, insisting that paint be seen (in all its richness) merely as paint, that sound be heard merely as sound, and that neither be perceived as being *about* anything beyond itself.

Without some experience of a world beyond appearances, though, there will be no consciousness at all because there will be no experience of space and time and no distinction between subject and object. Consciousness, I have argued, depends on the balancing of conflict and convergence: without enough contrast between

different perspectives, our experiences lose their subjectivity; and without enough convergence between different perspectives, objects lose their objectivity. By increasing the convergence of an increased number of conflicting appearances, 'seeing as' enables us to experience a world of increased depth and objectivity which, in turn, intensifies our experience of subjectivity and consciousness itself. If aesthetic experience teaches us that we can extend the degree to which appearances converge, and extend the degree to which objects are recognized as independent of their appearances, it also teaches us that we can extend the degree to which we are conscious. The suggestion that aesthetic appreciation intensifies consciousness is not a new one, but I hope here to have defended a particular understanding of that claim in such a way that its truth can be better appreciated.

References

Brandom, Robert (1994), *Making It Explicit* (Cambridge, MA: Harvard University Press).

Crick, Francis and Koch, Christof (1998), 'Towards a neurobiological theory of consciousness', reprinted in *The Nature of Consciousness*, ed. Ned Block, Owen Flanagan and Güven Güzeldere (Cambridge, MA: MIT/Bradford).

Dennett, Daniel (1991), *Consciousness Explained* (Boston, MA: Little, Brown, and Co.).

Descartes, René (1637/1980), *Discourse on Method*, trans. Donald A. Cress (Indianapolis: Hackett).

Evans, Gareth (1982), *Varieties of Reference* (Oxford: Oxford University Press).

Hurley, Susan (1998), *Consciousness in Action* (Cambridge, MA: Harvard University Press).

Kant, Immanuel (1787/1929), *The Critique of Pure Reason*, trans. Norman Kemp Smith (London: Macmillan).

Kant, Immanuel (1790/1952), *The Critique of Judgment, First Part*, trans. James Creed Meredith (Oxford: Oxford University Press).

Kitcher, Patricia (1990), *Kant's Transcendental Psychology* (Oxford: Oxford University Press).

Ryle, Gilbert (1949), *The Concept of Mind* (New York: Barnes and Noble Books).

Stone, Tony and Davies, Martin (ed. 1996), *Mental Simulation: Evaluations and Applications* (Oxford: Blackwell).

Strawson, Peter (1970), 'Imagination and perception', in *Freedom and Resentment, and Other Essays* (London: Methuen Press).

Wittgenstein, L. (1980), *Remarks of the Philosophy of Psychology* Vol I, ed. G.E.M. Anscombe and G.H. von Wright (University of Chicago Press).

Moya Devine *Sweet Life — 'The brain mysterious, my conduit to the world'*

C.L. Hardin

Red and Yellow, Green and Blue, Warm and Cool

Explaining Colour Appearance

Painters are the experts in colour phenomenology. Their business is to use colour to affect our feelings. Psychophysicists are expert in making experimental inferences from behavioural responses to the functional mechanisms of perception. The varying aims of these two groups of people mean that much that is of interest to the one is of little concern to the other. However, in recent times several prominent psychophysicists, such as Floyd Ratliff (1992), Jack Werner (1998; Werner and Ratliff, 1999) and Dorothea Jameson (1989), have thrown much light on painterly practice. Following their lead, I would like to sketch some of the mechanisms that are responsible for many of the features of colour appearance important to the work of visual artists. I will begin with some phenomena that can be accounted for by mechanisms that are reasonably well understood, and then move to phenomena whose underlying basis is less well established. I will conclude with a suggestive experiment and, true to my calling as a philosopher, a piece of downright speculation.

Let's begin where colour perception begins, with the cones, those photoreceptors in the retina that we use for daylight vision. There are three types of cones, respectively sensitive to shortwave, middlewave and longwave light, and thus called 'S-cones', 'M-cones' and 'L-cones'. They are sometimes referred to as 'Blue-cones', 'Green-cones' and 'Red-cones', but this is a misnomer for two reasons. The first is that the peak responses for the cones are a poor match for the colours they are supposed to code; the so-called 'red' cone has its peak in the yellow–green region. The second reason is more important. Cones are the initiators but not the proper sites of colour vision. In fact, individual cone types are colour-blind; it is the comparative differences among their outputs that matter for colour. When a cone absorbs a photon, it hyperpolarizes in exactly the same way, regardless of the photon's wavelength. All that subsequent neurons can 'know' is that the cone has been stimulated, but they cannot know anything about the

Journal of Consciousness Studies, **7**, No. 8–9, 2000, pp. 113–22

wavelength of the stimulus. What some of them *can* know is the ratio of responses among the three cone types. Since the output of a cone is a logarithmic function of its input, the higher-order cells react to the *differences* of the outputs of the three cone types. The consequence of this drastic loss of wavelength information is that two stimuli may differ markedly in their spectral power characteristics, yet if they produce the same triples of response by the cones, the eye will see them as indistinguishable in colour. Two spectrally distinct stimuli that look identical in colour are called 'metamers'.

The good news about metamerism is that just three properly selected narrowband light sources can reproduce a very wide gamut of colours. When you look at televised or photographed images, all the colours that you see are metameric matches to the original scenes. The whole chromatic array is reproduced by three coloured phosphors in the one case, and by three coloured emulsions in the other. Painters and printers likewise work their magic through metamerism, realizing a dazzling variety of colours with a handful of inks or pigments.

The bad news about metamerism is that matches made by eye in one set of illumination conditions may turn into mismatches when the illumination changes. The light that reaches the eye is the product of the spectral emission of the illumination and the spectral reflectance of the surface on which it falls. Daylight, incandescent light and fluorescent light all have different spectra, and there are significant differences among illuminants of each of these three types. The colour- wise clothing customer will always take care to look at a fabric in daylight as well as in the fluorescent illumination of the store.

One can construct a light box with four different types of fluorescent bulb behind four masking panels so that each bulb illuminates a portion of the box. The light from each of these is denominated as 'white' by the manufacturer, and most people would accept each of them in isolation as providing 'white' light. Their colour-rendering properties are, however, markedly different, as one can demonstrate by inserting pieces of coloured paper into the viewing areas of the box and comparing the appearance of the same sheet under one illuminant with its appearance under each of the other illuminants. (Purple papers are particularly subject to metameric shifts under such conditions.)

Because their colour-rendering properties are so different, daylight and incandescent light require different photographic film. The human eye is not as sensitive as camera film to the difference between interior and exterior light, because it is capable of adaptation. This is one of the mechanisms responsible for the celebrated phenomenon of colour constancy — more accurately, *approximate* colour constancy — which I will touch upon a bit later; but let it be noted here that even with adaptation, the change in illuminants can be a serious problem for painters, because it can produce changes in colour balance. Famously, painters prefer north daylight in their studios, but the gallery in which the product of their labours are shown is likely to have light of a distinctly different spectrum. Metamerism can also be the bane of restorers of old paintings, who must often try to match the old pigments by

eye to new pigments that are very unlikely to have the same reflectance spectrum as their more ancient counterparts.

There are other retina-based phenomena, such as assimilation effects, that are of interest to artists. Assimilation is an anti-contrast effect that shows up when small strips of colour, for example red, are placed against a field of another colour, for example blue. A larger region of red against a blue field would, because of contrast, look yellowish, but when the red strips are small, they appear bluish instead. The assimilation effect is heavily dependent upon scale, and seems to depend upon variations in size and distribution of retinal cells that pool their inputs. In the limit, when the coloured areas are very small, their colours are blended. Thus, although a large region of red is sharply accentuated when placed next to a large area of green, when the areas are tiny, the retinal receptors blend the red and the green to give the appearance of a pure yellow. This is how a colour television set, which has only red, green and blue phosphors, can give us a convincing picture of a lemon (metamerism once again!). Seurat attempted to use the optical mixing that takes place with small regions of adjacent pigments to get purer colours than could be obtained by mixing the pigments on the palette. Since the effect is scale-dependent, there will be, in some Seurat paintings, an optimal distance from which the picture must be viewed to get the intended effect (Homer, 1964). Approach too closely, and contrast will dominate. At a considerable distance, optical mixture will occur, with assimilation dominating at intermediate distances.

Let us turn now to some important phenomena that depend on post-retinal opponent neural processes. To understand opponent processes we need to look at the features of colour phenomenology that first suggested them. If one consults a hue circle with a suitably wide variety of distinct hues, one can easily pick out a pure red, a pure green, a pure yellow and a pure blue. These, and these alone, appear to contain no admixture of any other hues, and are thus denominated *elementary hues*. Purples, on the other hand, appear to be reddish and bluish, oranges appear to be reddish and yellowish, limes appear to be yellowish and greenish, and so on. The four elementary hues are therefore known as *unique*, or *unitary* hues, whereas the others are called *binary* hues. One feature of the binary hues is particularly striking: none of them is both reddish and greenish, or both yellowish and bluish. Red blends comfortably with yellow or blue, but never with green. 'Blending' here refers to colour appearances rather than to any physical process. Of course a pigment or light that looks red can be physically mixed with a pigment or light that looks green. The result will be a brown in the one case, or a yellow in the other, but not a colour that anyone would be tempted to call 'reddish green'.

In the later part of the nineteenth century, the German physiologist Ewald Hering (1920/1964) proposed to account for these facts of colour appearance by postulating that colour vision involves four basic chromatic processes and two achromatic processes. The chromatic processes are, he said, configured in opponent pairs, with the red process opposed to the green process, and the yellow process opposed to the blue process. Chromatic processes are thus thought of as

being analogous to many other bodily systems, such as the actions of striate muscles, that are paired in antagonistic, push–pull configurations. Contemporary versions of opponent process theory call for the three types of cones to compose a first stage, with the cone outputs summed and differenced in a second stage to yield two chromatic channels and one achromatic channel. Red is signalled when the red/green channel takes a positive value, whereas green is signalled when the red/green channel takes a negative value. Similarly, a positive state of the yellow/blue channel codes for yellow, whereas a negative state codes for blue. When a channel is in equilibrium, grey is seen. If both channels are positive, the one signals red and the other yellow, with orange as the result. If the red/green channel is positive, but the yellow/blue channel is in a negative state, the resultant experience is of purple, and so on. If the red/green channel is in equilibrium, but the yellow/blue channel is negative, the organism sees unique blue, whereas if the blue/yellow channel is in equilibrium but the red/green channel is in the positive state, a unique red results. The underlying principles are very simple. Each unique hue cancels its opponent hue, and a blend of two hues can be cancelled by cancelling each of its components. Thus an orange can cancel a turquoise, since the yellow in the orange cancels the blue in the turquoise, and the red in the orange cancels the green in the turquoise. In truth, the cancellations are not as neat as I have suggested, since the linear opponent scheme that I have described here is overly simple. The blue–yellow system is in fact non-linear, so the complement of red is cyan, and the complement of green is magenta. The painter's pigment-mixing primaries, cyan, magenta and yellow (rather than the blue, red and yellow of elementary school lore), are thus the complements of the additive, light-mixing primaries — red, green and blue — that are used in video displays. This is why they are known as *subtractive* primaries.

In the opponent scheme, the achromatic channel behaves differently from the two chromatic channels. Blackness and whiteness are not mutually exclusive, for they can blend to yield the perception of grey; however, blackness is entirely the consequence of contrast with whiteness. This latter statement may strike you as wrong. Doesn't blackness arise as a direct consequence of perfect darkness? Why suppose that contrast is necessary? To understand this better you can perform two simple experiments. For the first experiment you will need a grey scale and a lamp equipped with a dimmer. If you look at the grey scale under dim light, the samples will look very similar to the middle grey. As you make the light brighter, the scale will expand in both directions. Not only will the lightest sample look whiter, the darkest sample will look blacker. Increasing the light will increase the perceived blackness. For the second experiment you will need to view a television set during the day. Turned off, the screen will look a light grey; turned on, you should be able to find a picture containing a good black. The black will, of course, seem darker than the grey of the turned-off television screen. Yet turning on the set *adds* rather than subtracts light. Once again, blackness has been generated by contrast.

Contrast is an essential characteristic of vision. Without it we should not be able to distinguish one feature from another. The eye has a tendency to accentuate

image boundaries by increasing contrast over and above that found in the ambient array. The effect, known as 'Mach bands', is evident when one juxtaposes a region of uniform lightness with another, darker region. At the boundary of the two regions, the edge of the lighter region will appear lighter, while the edge of the darker region will appear darker. This gives rise to a striking 'fluted effect'. A similar phenomenon also occurs in the chromatic domain. If two bands differing in hue but not in lightness are juxtaposed, there will be an accentuation of hues on the two sides of the boundaries. The mechanisms for doing this are not fully understood, but some of the phenomena can be accounted for by neural units containing several cones that synapse on the same ganglion cell. They are arranged in a 'push–pull' configuration. In the case of a unit of the 'on–centre, off–surround' type, when the cells in the centre are stimulated, the ganglion cell increases its firing rate, but when the cells in the surround are stimulated, the ganglion cell's firing is inhibited. The retina also contains 'off–centre, on–surround' cells, as well as chromatically opponent centre–surround configurations. Similar groupings of achromatically and chromatically opponent cell configurations are found in higher visual centres in the brain. These seem to be the sorts of cells one would like to have as mechanisms for simultaneous contrast. They do seem to be sufficient to explain the sort of edge accentuation that is characteristic of so-called Mach bands, but whether suitable populations of them will suffice to explain longer-range contrast effects is not at all clear.

Whatever its mechanisms, colour contrast operates according to well established principles. A region of colour that surrounds another will tend to induce in the surrounded patch a colour that is the opponent of the colour of the surround. Thus, a region of red surrounding a patch of grey will have the effect of making the grey appear greenish. In every case you can predict the general direction of the contrast by using the principle that the surround induces its opponent colour in the contained area. (Excellent illustrations of contrast and assimilation may be found in Albers, 1963.) Lightness contrast is also at work; in general, lightness contrast effects tend to dominate chromatic contrasts when both of them are present.

Contrast is of course a standard instrument in the painter's tool-kit. One thinks of Delacroix's famous remark: 'Give me mud, let me surround it as I think fit, and it shall be the radiant flesh of Venus.' Having neither mud nor radiant flesh available for illustrative purposes, I shall content myself with three uses of simultaneous contrast that are to be found in the paintings of Monet. In the first of these, *London, Houses of Parliament* (1904), orange and blue intensify each other to achieve a powerful effect. Orange and blue are the opposite poles of the warm–cool scale, but more of this later. In the second example, *Haystack in Winter* (1891), Monet observes something that Goethe made famous: coloured shadows (Goethe, 1840/1970). The shadow of the stack cast by the yellow sunlight is not simply a darkened version of the local colour of the ground cover, as it would have been in a more traditional painting, but has a decidedly bluish cast, which arises from the combined action of skylight and simultaneous contrast. The coloured shadow effect in a natural scene would, however, be rather less than Monet portrays in this instance, and in many of his other paintings. Why the

exaggeration? Perhaps the painter, always in search of more effective ways of capturing the effects of light is here coming to terms with a problem that we can express quantitatively. The intensity ratio of full sun to full shade is on the order of 40 to 1. But the pigments available to the painter have an intensity ratio of perhaps 4 to 1. What is the painter to do? One tactic is to substitute chromatic contrast, which his paints can easily afford him, for lightness contrast, which he cannot hope to duplicate.

Our third example comes from the series of paintings that Monet made at Rouen cathedral, representing that structure at different times of day. Once again, the problem is to represent vastly different light intensities with a palette that is intensity-challenged. To some extent the artist is rescued by the visual system, which tends to minimize the effects of differences in illumination from one phase of daylight to another. The eye adapts to the changes in both intensity and chromaticity that occur during the course of a day. This is one of the mechanisms that underlie approximate colour constancy, so that the surfaces of the objects that we see around us do not vary with illumination changes nearly to the extent that photometric measurements would suggest. If colour constancy helps the artist, it also poses a problem: How is one to represent the change in appearance of the cathedral from early morning to the light of midday? Unquestionably Monet carries it off; nobody here can fail to identify which is the early morning and which the midday representation. The secret is of course contrast. Just as the grey scale expands when the intensity of the lamp is turned up, the chromatic contrast of the scene increases as the sunlight strengthens. Once again, Monet trades lightness contrast for chromatic contrast.

I have mentioned colour constancy more than once, and this is the time to address it directly. Colour constancy, and its companion, lightness constancy, are capabilities that the eye has, in a wide variety of variegated natural scenes, of distinguishing the colour of the illuminant from surface colour, and of distinguishing illumination changes from reflectance changes. I have suggested that part of the explanation for constancy is adaptation, particularly when the luminance changes are gradual, and this is surely correct; but other factors are at work as well.

Here is an experiment that you can perform for yourself. Make a transparency of a scene with a variety of colours, including a good yellow. Either a natural scene or a set of coloured patches will do. Now take a piece of blue acetate that is a bit larger than the transparency. Cut a piece of the acetate so that it will fit exactly over the yellow area, and place it on that area. The yellow patch will now look green. Cut the rest of the acetate so that it will be the same size as the entire transparency, and place it over the scene. Everything in the scene will look as if it is bathed with a blue illuminant. The colours will of course be changed, but they will remain identifiable. Remarkably, the yellow region will now not look green, as it did when the blue acetate covered only that portion of the scene, but will be recognizably yellow, with a greenish cast.

It seems clear that when the eye views a complex scene it responds to the relationships among colours more than to their absolute values. Edges are read as reflectance changes, whereas gradual colour changes are seen as illumination

differences. Indeed, if an outline is drawn around the blurred boundaries of a shadow it is seen as a reflectance change rather than as the change in illumination that it actually is.

Colour constancy occurs in a variety of circumstances, and with variable strength. In the blue acetate case, there is no question that there is a change in the colour appearance of all of the objects in the scene when the acetate is laid over it. The constancy is therefore not perfect, nor is it in many other cases, such as when we compare the colour appearance of objects at noonday and at sunset. On the other hand, there are situations, such as the Adelson checkerboard illusion, in which constancy — in this case lightness constancy — is much stronger, and seems to be virtually hard-wired. (You may view an interactive version of the Adelson illusion on the Web at www.illusionworks.com.) Colour and lightness constancy are complex phenomena, and we should not expect that there will be a unitary explanation of them that will cover all cases. Psychophysicists understand many of the principles that govern constancy, but they do not yet understand the underlying mechanisms.

The term 'aperture mode' is used to describe the situation in which a colour is seen as isolated, with a neutral surround, as through an aperture or viewing tube. Seeing a colour in the aperture mode removes contrast and edge information. Viewed through an aperture, a black becomes a dark grey and a brown becomes a dim orange. Through an aperture it is impossible for the eye to separate illumination from surface reflectance, so constancy disappears. In the 'surface mode' of viewing, a colour is given together with its context, so that contrast and constancy effects have free reign. The painter who wishes to represent the colour of a natural scene correctly must work to undo the powerful effects of colour constancy by selecting colours from the palette so that they match the colours of the scene as they would appear when viewed in the aperture mode. If this is done carefully, the spectator, operating in the surface mode, will see the colours in their natural relationships.

So far, we have considered retinal effects such as metamerism, whose mechanisms are well understood, second stage opponent and contrast effects, with neural mechanisms that are established in part, and approximate colour constancy, which involves more complex cortical interactions. The particular neural mechanisms underlying colour constancy are mostly unknown, although brain scans suggest that cortical area V4 is crucially involved. Nevertheless, the general operative principles are reasonably clear.

At this point I am going to leave the domain of sober, cautious assessment based on received opinion, and venture into highly speculative territory. In other words, I am going to sound like the philosopher that I am rather than the psychologist that I am not. The phenomenon that I would like to put forward for your consideration is clear and forceful, but has remained obscure until a simple but intriguing recent experiment. The psychologist of art Rudolf Arnheim (1974) writes: 'The pure fundamental primaries can hardly be called either warm or cold. Is a pure red clearly more warm than a pure blue of equal saturation? Is a pure

yellow cold or warm? But temperature quality seems to be more meaningful when applied to the admixture of color.' Art historian John Gage (1993) remarks:

> Those who cook on gas know that it is the high-energy (short-wave) blue flames which do most of the heating and even those who do not are likely to be aware that it is the even shorter, higher-energy waves, the ultra-violet, which burn our skin. Yet in common usage it is the long-wave red end of the spectrum which is felt as warm and the blue as cool. We may think of a 'universal' experience of hot red (?) sun and cool blue (?) sea but in the written record this folklore seems to go back no further than the eighteenth century; the first colour-system to incorporate coordinates of cold and hot was probably the one published by George Field as late as 1835. So what is our 'experience' of colour in this case? Why are our linguistic habits so at odds with our knowledge?

Furthermore, experiments to link physiological reactions to warm or cool colours have been inconclusive, and Lawrence Marks (1978), a psychologist who has written extensively on synesthesia, has argued that the association of colours with temperatures is a question of acculturation.

On the other side of the coin, using semantic rating scales, psychologists Charles Taft and Lars Sivik (1992) found that subjects in Croatia, Russia, Sweden and the United States reliably and consistently rated standardized colour chips — including, *contra* Arnheim, 'pure' red and 'pure' blue — according to their degree of warmth or coolness. Similar results have recently been obtained in two American laboratories (personal communications). How is all of this to be sorted out? It will be useful to distinguish two issues here. First, what is the basis of the perceived resemblance between reds and yellows on the one hand, and blues and greens on the other? Second, why are the reds and yellows denominated 'warm' and the blues and greens called 'cool'?

Insight into the first question was provided by Katra and Wooten in an experiment that, as far as I know, remains unpublished. Their subjects, Brown University undergraduates, were asked to rate eight equally spaced colour chips from the Natural Color System atlas. They consistently rated the orange sample as warmest and the unique blue sample as coolest. These results were consistent with the ratings for subjects in other experiments and with most of the texts in colour theory, going back to Goethe's *Theory of Colors* (1840). The next step is the interesting one. Katra and Wooten measured their subjects' opponent responses using a standard colour cancellation procedure, compared the average summed and normalized chromatic response with the average warm–cool ratings, and got a good fit between the two curves. Here is the experimenters' comment on this result:

> The remarkable correspondence between the obtained ratings of warmth and coolness and the activation levels in the opponent channels . . . suggests that the attribution of thermal properties to colors may be linked to the low-level physiological processes involved in color perception. Higher ratings of warmth corresponded with levels of activation of the opponent channels in one direction, while cooler ratings corresponded with activation in the opposite direction. This suggests that a link to the activation level of the opponent channels, rather than the psychological quality of hue, drives the association of temperature with color, and that the association is more than simply a cognitive process.

I would be inclined to put this a bit differently. The perceived similarities of colour between the members of the warm set on the one hand, and the members of the cool set on the other, are the result of the one being signalled by positive opponent channel activity, and the other by negative opponent activity. In other words, hue is the natural expression of the neural coding. This gives us at least part of the first result we were after, to explain the commonalities and differences of quality. So I would amend the last sentence by Katra and Wooten to read: 'This suggests that a link to the activation level of the opponent channels, which is also expressed in the psychological quality of hue, drives the association of temperature with color, and that the association is more than just a cognitive process.'

Think, if you will, of what is commonly said about warm and cool colours: the one is arousing, the other calming; the one is advancing, the other receding; the one is active, the other passive. If I were to ask you which is 'positive' and which 'negative', taking care to inform you that I do not take these words here to connote preference, I think that most of you would have little difficulty assigning 'positive' to the warm colours and 'negative' to the cool ones. What is common to these antonyms is really the sense of polarity. We may then see the terms 'warm' and 'cool' as giving a concrete expression to this felt polarity.

You will have noticed that we have finally ventured into the realm of feeling and affect that are at the soul of painting. Warmth and coolness are feelings that alert us to the need for action. How did these needs for action come to be linked with the experience of colour? Let's do a bit of speculative prehistory. DNA evidence tells us that the blue–yellow system in human beings, and probably other trichromatic mammals as well, is much more ancient than the red–green system (Mollon, 1989). So let's take a couple of giant leaps and conjecture that in general animal lines with colour vision had ancestors with just one chromatic pair in an opponent configuration. Suppose that in the most primitive ancestors the two poles of this chromatic visual system were hard-wired to behavioural mechanisms, one activating the animal, one inhibiting it. As animals became more complicated, the connection between wavelength and behaviour became less immediate and direct, and lingers in us as diffuse affect. When a painting speaks to us, we perhaps discern the faint voices of our forebears.

There is a bit of evidence to suggest that this may not be wholesale fantasy. We know that in many animals, colour is a powerful biological trigger, though usually in a rich natural context. But is the context essential? Some years ago, Nicholas Humphrey (1971) put monkeys in a room with a wall that could be illuminated by one of four coloured lights: red, yellow, green or blue. When the wall was made red the monkeys became highly agitated, but when the wall was made blue the monkeys grew calm. When the monkeys could select the colour by pulling a lever, they invariably chose blue. Their preferences were a direct function of wavelength. Here is the behavioural effect of contextless colour. Indeed, the agitation shown by those monkeys to the red wall may well have been due to the lack of context. Red! Be alert! Do something! But what? The isolated colour is mute on that crucial point. Directionless imperatives lead to high anxiety.

Human beings are of course more complicated. Numerous studies show that our colour preferences are not linear, and are strongly conditioned by cultural circumstances. Even if one could isolate some set of universal preferences or dispositions to behaviour for single colours, the fact is that colours almost always occur in complex combinations with other colours, and we cannot expect that their effects would sum in some linear fashion. You may well have a marked abstract preference for blue, but that is not likely to be the colour you would choose for your mate's skin.

Right now, the study of the affective character of colour is rich in folklore and unsupported assertion, but very poor in solid scientific knowledge. If colour science is still in its Galilean stage, the experimental study of aesthetic response to colour is almost pre-Socratic. How do colours affect us? How do these affects interact? What is due to our shared nature and what to nurture? These problems are hard and, very likely, ill-posed. Making progress on them will require unusual people with an understanding of visual science, cognitive science and art — perhaps someone reading these words.

References

Albers, J. (1963), *The Interaction of Color* (New Haven: Yale University Press).

Arnheim, R. (1974), *Art and Visual Perception* (Berkeley and Los Angeles: University of California Press).

Gage, J. (1993), *Color and Culture* (Boston, Toronto, London: Little, Brown and Company).

Goethe, J.W. (1840/1970), *Theory of Colors*, trans. Eastlake (Cambridge, MA: MIT Press).

Hardin, C.L. (1993), *Color for Philosophers: Unweaving the Rainbow*. Expanded Edition. (Cambridge, MA and Indianapolis: Hackett Publishing Company).

Hering, E. (1920/1964), *Outlines of a Theory of the Light Sense*. Translated by L.M. Hurvich and D. Jameson (Cambridge, MA: Harvard University Press).

Homer, W.I. (1964), *Seurat and the Science of Painting* (Cambridge, MA: MIT Press).

Humphrey, N.K. (1971), 'Colour and brightness preferences in monkeys', *Nature*, **229**, pp. 615–17.

Hurvich, L.M. (1981), *Color Vision* (Sunderland, MA: Sinauer Associates).

Jameson, D. (1989), 'Color in the hands of the artist and eyes of the beholder', *Color Research and Application*, **14** (6).

Marks, L.E. (1978), *The Unity of the Senses* (New York: Academic Press).

Mollon, J.D. (1989), ' "Tho' She Kneel'd in That Place Where They Grew . . .": The uses and origins of primate colour vision', *Journal of Experimental Biology*, **146**, pp. 21–38.

Ratliff, F. (1992), *Paul Signac and Color in Neo-Impressionism* (New York: Rockefeller University Press).

Taft, C. and L. Sivik (1992), 'Cross-national comparisons of color meaning', *Göteborg Psychological Reports*, **22** (3).

Werner, J.S. (1998), 'Aging through the eyes of Monet', in *Color Vision: Perspectives from Different Disciplines*, ed. W.G.K. Backhaus, R. Kliegl and J.S. Werner (Berlin and New York: Walter de Gruyter).

Werner, J.S. and F. Ratliff (1999), 'Some origins of the lightness and darkness of colors in the visual arts and in the brain', *Techne*, **9–10**, pp. 61–73.

Alva Noë

Experience and Experiment in Art

The danger that lies in describing things as more simple than they really are is today often very overestimated. This danger does actually exist in the highest degree for the phenomenological investigation of sense impressions. These are always taken to be much simpler than they really are. — Ludwig Wittgenstein (1964, p. 281).[1]

To be an artist is not a matter of making paintings or objects at all. What we are really dealing with is our state of consciousness and the shape of our perception. — Robert Irwin (1972a).[2]

A significant impediment to the study of perceptual consciousness is our dependence on simplistic ideas about what experience is like. This is a point that has been made by Wittgenstein, and by philosophers working in the Phenomenological Tradition, such as Husserl and Merleau-Ponty. Importantly, it is an observation that has been brought to the fore in recent discussions of consciousness among philosophers and cognitive scientists who have come to feel the need for a more rigorous phenomenology of experience. (See, for example, the papers collected in Varela & Shear, 1999; also Pessoa *et al.,* 1998; Noë *et al.,* 2000).

The central thought of this paper is that art can make a needed contribution to the study of perceptual consciousness. The work of some artists can teach us about perceptual consciousness by furnishing us with the opportunity to have a special kind of reflective experience. In this way, art can be a tool for phenomenological investigation.

The paper has three parts. First, I present what I call the problem of the transparency of experience. This is a problem for philosophy, for art, and for cognitive

[1] My translation of the German original.

[2] This passage is cited in the brochure accompanying Irwin's 1998 exhibition at the Dia Center for the Artsin New York entitled Part I: Prologue: x183, Part II: Excursus: Homage to the Square3, April 12, 1998–June 13, 1999. Elsewhere Irwin writes: 'The act of art has turned to a direct examination of our perceptual processes' (Irwin, 1972b). This is also cited in the same brochure.

Journal of Consciousness Studies, **7**, No. 8–9, 2000, pp. 123–35

science. Second, I present an alternative conception of experience as a mode of interactive engagement with the environment. Finally, against the background of this conception, I discuss, briefly, the work of the sculptors Richard Serra and Tony Smith.[3]

I: The Transparency of Perceptual Experience

Part of what makes perceptual consciousness so difficult to grasp, whether in science or art, is its transparency. We can illustrate this by means of a fable. Once upon a time there were artists who sought, in their art, to depict reality. For these 'realists', art was a way of investigating the world. Then someone noticed that knowledge of the world can be an obstacle to its successful depiction. What matters is not how the world is, but how it presents itself to us in experience. 'Free the eye from the dominion of the understanding' became the slogan of the new 'experientialist' artists who thus came to overthrow realism. But before long experientialism, in its turn, is thrown in to crisis. For to capture in a picture how the world presents itself to us in experience — to make a picture of how things truly appear — is just to make a picture of that which is experienced, of that which appears, namely the world. The subject matter of art-making, then, is not experience itself, but the experienced world, and so art must direct itself to the world. Experientialism in this way collapses back into realism and the struggle begins all over again. An oscillation ensues between realism and experientialism.

This fable is meant to get at the following idea. When we try to make perceptual experience itself the object of our reflection, we tend to see through it (so to speak) to the objects of experience. We encounter *what* is seen, not the qualities of the seeing itself. This idea was noticed by Grice, who wrote:

> If we were asked to pay close attention, on a given occasion, to our seeing or feeling as distinct from what was being seen or felt, we should not know how to proceed; and the attempt to describe the differences between seeing and feeling seems to dissolve into a description of what we see and what we feel (1962, p. 144).

This is a familiar theme in philosophy. An accurate description of visual experience will confine itself to those objects whose presence is guaranteed by the experience itself, e.g. blobs of colour. Or so at least Hume (1740/1978), and philosophers working in his tradition, such as Price (1940) and Ayer (1973), have argued. When we talk of what we see (e.g. deer grazing on a lawn), we 'go beyond' what is strictly given to us in experience.

Kant (1787/1929) attacked this idea of Hume's and insisted that we falsify experience when we attempt to describe it in these supposedly neutral terms (as noticed by Strawson, 1979). I am not *more* faithful to my experience of the deer, but less, when I try to describe it in terms of my experience of brownish blobs on a

[3] Images of works of Serra and Smith may be viewed at various sites on the internet.
 Interested readers may want to visit <http://www.artcyclopedia.com/artists/serra_richard.html> and
 <http://www.artcyclopedia.com/artists/smith_tony.html>.

Figure 1

Mach (1886/1959). The visual field.

green background. To be faithful to experience, I must talk about the way the experience purports to represent the world (Strawson, 1979). To describe experience *is* to describe the experienced world. And so experience is, in this sense, transparent.

The transparency of experience, it should be clear, poses a problem for any attempt to make perceptual experience itself the object of investigation in the way that has interested philosophers. But it is important to recognize that this problem of transparency arises no less for the empirical (psychological, neuroscientific) study of consciousness.

Consider Ernst Mach's famous drawing (figure 1) of the visual field (Mach 1886/1959). The drawing is meant to serve as a representation not of the room, but of the visual experience itself, capturing on paper the distinctive character of visual awareness (as the artist sits with fixed monocular gaze looking out on his room). Notice that the drawing indicates the presence of the nose, moustache, belly, body at the periphery, that it represents the field as in sharp focus and uniform detail from the center out to the periphery, where things go indistinct.

Mach's drawing fails (as noticed by Wittgenstein).[4] The picture does not capture what the visual field is like. It is true that the visual field is indistinct at the periphery. But the character of this indistinctness is not captured by the fade-to-white. That is, it doesn't seem to us as if the visual field fades to white at the edges. Consider also that the visual field is not in this way uniformly detailed and in sharp focus from the centre out to the periphery. You only see sharply that which you fixate, but you don't fixate such an expanse all at once.

Mach, it seems, misdescribes what it is like to see. At best, he succeeds in depicting his room. We see the familiar oscillation at work. He tries to direct himself to his experience, but , like the experientialists of the fable, he directs himself instead to the world. Experience, when thought of along these lines, is too transparent to capture in thought or on paper.

II: Experience as a Temporally Extended Pattern of Exploratory Activity

The puzzle of the transparency of experience results from thinking of experiences as like inner pictures and from thinking of reflection on experience as like turning one's gaze inward to those pictures. But this is a false characterization of experience. In experience we are aware not of inner pictures, but of the things around us in the environment.

To defend this claim, consider Mach's drawing again. We noticed that the drawing represents the visual field as too sharp throughout, as too defined, and that the characteristic indistinctness of the visual field at the periphery is not captured by the fade-to-white. We can summarize the picture's misrepresentation of experience as follows: the picture gives expression to the idea that when you see, you have all the environmental detail *in your consciousness at once*. Let's call this the 'details in the head' conception of perceptual (or visual) experience.

[4] Wittgenstein remarked that Mach's drawings is one of the clearest examples of confusion between physical and phenomenological modes of description. Referring to the inadequacy of Mach's representation of the blurredness of the visual field by means of a different kind of blurredness in the drawing, Wittgenstein remarked: 'No, one cannot make a visible picture of the visual field' (1964, p. 267; my translation). See Thompson *et al.* (1999) for more on this. A point very similar to Wittgenstein's is made by Dennett (1991, p. 55), who writes: 'One can no more paint a realistic picture of visual phenomenology than of justice or melody or happiness'.

It is worth noticing that the 'details in the head' conception is, in fact, shared by many visual and perceptual theorists. Indeed, visual scientists have long tended to think of their central task as that of trying to determine how the brain give rises to richly detailed picture-like experiences of this sort, on the basis of the paltry information about the environment projected onto the retina.[5]

Consider an example from touch that illustrates this established problematic.[6] Suppose you hold a bottle in your hands with your eyes shut. You feel it. You have the feeling of the presence of the whole bottle even though you only make finger-to-bottle contact at a few points. The standard account of this phenomenon proposes that the brain takes the little information it receives (at the isolated points of contact) and uses it to build up an internal model of the bottle (one capable of supporting the experience).

But consider: this positing of a process of construction of an internal representation may be an unnecessary shuffle. For the bottle is right there, in your hands, to be probed as occasion arises. Why should the brain build models of the environment if the environment is present and so can serve as its own model, as an external but accessible repository for information (as has been argued by Brooks, 1991; O'Regan, 1992)?

Recently a good deal of empirical support as been found for this 'world as its own model' view (e.g. work on change blindness (reviewed by Simons, 2000), inattentional blindness (Mack & Rock, 1998), animate vision (Ballard, 1991), and embodied cognition (Brooks, 1991). But anecdotal evidence will suffice to make us suspicious of the need for an internal model. Consider that we have all encountered the following familiar stunt. You are dining with a friend. You give a start and exclaim 'Hey isn't that so and so?' Your friend turns around. While she looks away you take a french fry. When she turns back, you shake your head and say that you must have been mistaken. She didn't see you take the fry. She doesn't notice that a fry is missing. Why does she fail to notice that the fry is missing? A number of candidate explanations suggest themselves. One such candidate is as follows: in examining her food she never built up a detailed internal model against which to compare her impression of the now altered pile of fries.

But there is a deeper problem with the 'details in the head' conception of experience. It is phenomenologically wrong-headed. (For more on this, see Noë et al., 2000).

Consider the bottle again. It is quite true that you have a sense of the whole bottle as present in your grasp. But surely it does not seem to you as if, all at once,

[5] Recently this consensus has begun to come undone. A group of new thinkers have come to endorse what I have called the new scepticism about visual experience (Noë, in press). Traditional scepticism about experience questions whether we can know, on the basis of experience, that things are as we experience them as being. The new scepticism, in contrast, questions whether we even have the experience we think we have. Whereas traditional visual science wondered how we can have such rich visual impressions on the basis of such impoverished retinal input, the new visual science that takes its start from the new scepticism targets a rather different question: why does it seem to us as if we see so much when, in fact, we see so little! The leading spokesperson for the new scepticism is Daniel Dennett. See Noë (in press) for extended discussion of this point.

[6] This often used example is due to Donald MacKay (1962; 1967; 1973).

when you hold the bottle, you in fact make contact with each and every part of its surface! No. It seems to you, rather, as if the bottle is there in your hands and as if you have access to it by movements. You are, in fact, as a perceiver, master of the sensorimotor skills required to exploit such access. The basis, then, of the feeling of perceptual presence of the bottle is just this skill-based confidence that you can acquire the information at will by probing the world (O'Regan, 1992; O'Regan and Noë, under review).

And so for vision. When you see, you take yourself to be aware of a densely detailed world, to be sure. But you do not take yourself to have all that detail in consciousness all at once. The 'details in the head' model falsifies experience. Rather, you take yourself to have access to the detail by the flick of the eye or the turn of the head. The seeing, the experiencing of all that detail, is not something static, but something temporally extended and active.

The upshot of this discussion is that perceptual experience, in whatever sensory modality, is a temporally extended process of exploration of the environment on the part of an embodied animal. This is the key that unlocks the puzzle of transparency and so the problem of phenomenology. If perceptual experience is in fact a temporally extended process, then to investigate experience we need to turn our gaze not inward, but rather to the activity itself in which this temporally extended process consists, to the things we do as we explore the world.

III: Toward an Art of Experience

I have proposed that to investigate visual experience — that is, to do visual phenomenology — we must investigate the temporally extended pattern of exploratory activity in which seeing consists. I now propose that to study some works of art is to undertake precisely this sort of investigation. The study of such works of art can serve as a model of how to study experience and can also reveal how art can be, in the sense of Irwin's quote given at the outset, not only concerned with the making of objects, but more significantly with the investigation of perceptual consciousness.

I will focus on Richard Serra, whose work perfectly exemplifies the ideas I have in mind. However, there are and have been numerous other artists whose projects are *experiential* in the sense I have in mind (e.g. Smithson, Irwin, Turell, to name only three).[7] What I shall argue is that Serra's work (and also the work of these other artists) enables us to catch ourselves in the act of perceiving and can allow us thus to catch hold of the fact that experience is not a passive interior state, but a mode of active engagement with the world. In this way, Serra brings to rest the troubling oscillation between experientialism and realism.[8]

[7] My use of the term 'experiential art' is similar to the use made by Rinder and Lakoff (1999) of the term 'consciousness art'.

[8] Some readers might be struck by the fact that I now turn to sculpture after developing the to-be-criticized conception of experience with reference to a drawing of Mach's. Mach's drawing, I think, illustrates the problematic conception of experience that is my real object. It is not my intent, however, to suggest that there is an intrinsic connection between drawing as a medium and the problematic conception. For reasons that will, I hope, become clear, some sculpture provides an apt method

Figure 2

Richard Serra *Spin Out: For Bob Smithson* 1972–1973. Illustration by Miriam Dym.

Before turning to the work itself, let me be very clear about what I am doing and about what I am not doing. I am *not* arguing that the conception of experience I advocate fixes or solves any aesthetic problems. I argue, rather, that — against the background of this conception of experience — we can appreciate how Serra's work (and the work of others) helps clarify certain theoretical problems about consciousness. Now it might in fact be the case that the analysis here offered does in fact help to solve certain puzzles of an aesthetic nature about Serra's and Smith's work. If so, this remains secondary to the main purpose.

A final preliminary: I do not claim that the interpretation of Serra and Smith here offered is particularly original. Since developing these ideas I have learned that others — Rosalyn Kraus, Yve-Alain Bois, Hal Foster — have anticipated me

for investigating experience thought of as a form of activity. But it is no part of my purpose to suggest that picture-making cannot also perform this role. Cézanne is an excellent example of a painter who is, in my sense, an experiential artist. Merleau-Ponty (1948/1964) has made much the same point when he observed that Cézanne's is an art directed to the phenomenal which nevertheless avoids the 'ready-made alternatives' that preoccupied impressionism (e.g. 'sensation versus judgment', 'the painter who sees against the painter who thinks'). Merleau-Ponty emphasizes that although Cézanne remains faithful to the phenomenal, there is a clear sense in which he 'returns to the object'. He does so in a way, however, that allows him to discover a 'lived perspective' that is at once experiential and also directed to the world. Cézanne's pictures represent the environment as experienced. In this way, he is able to discharge the tension between experientialism and realism.

Figure 3

Richard Serra *Running Arcs (For John Cage)* 1992. Each plate is 13' 1$^1/_2$" x 55' 9$^3/_8$" x 2".
Illustration by Miriam Dym.

in this or that respect. I am not, however, aware of anyone who has coordinated these various points in relation to philosophy and cognitive science in just the way I have attempted to do.

I turn now to the large-scale sculptures in metal that have been central to Serra's work since the 1970s. A striking example is *Spin Out: For Bob Smithson*, which consists of three large plates of steel (each ten feet by forty feet by one and

a half inches), each embedded into the earth along the side of a hill in a roughly circular array, as illustrated in figure 2.[9]

Let us note four characteristic features of Serra's sculptures. First, many of them are, as I will put it, *environmental*. That is, they are *intrinsically* site-specific. What I mean by this is that the sculptures are not merely enhanced by their locations, but are made for their locations and are meant to become part of the environment. Some pieces (such as, for example, works in the recent *Torqued Ellipse* series) lack site-specificity, in so far as they can be moved from one site to another. But it would be a mistake to conclude from this that these works are not environmental. Crucially, these pieces are able to transform a location and so produce a new environment.

Second, like Borges' map of the world which is built on the same scale as the world itself, most of Serra's sculptures are *lacking in perspicuity*, that is, you cannot take one in at a glance. This has to do not only with their scale, but also with their complexity; to be understood they need to be explored.[10]

Third, a typical Serra sculpture, thanks to its scale, its surprising curves and apparent tilt, is overwhelming and disorienting, sometimes even frightening, almost always intimidating. It demands a reaction. Fourth, and as a consequence of the first three points, the pieces are, as I shall put it, particulars. By this I mean that they are unique, concrete entities. To encounter a Serra sculpture is to get to know an individual. The significance of this point will emerge in a moment.

With these features in mind — environmental character or site-specificity, lack of perspicuity, overwhelming scale, and particularity — we can start to lay out the method of phenomenological investigation deployed by the artist in these works. When one first encounters a piece, such as *Running Arcs (For John Cage)* (figure 3), one is liable to be struck by the scale and the visually inscrutable orientations and distributions of weight. One not only notices these qualities, but one is disturbed by them. One puzzles: what stops these giants from falling over? To wander around or through a piece such as this can cause a loss of balance. In this way the works make us reflect on how we *feel*, perceptually, in their presence. And they direct our attention to the complexity of our experience, a complexity we easily overlook. The loss of balance, for example, introduces us to what are strictly non-visual (e.g. vestibular, kinesthetic) components of our 'visual' experience.

If we press on and explore a piece by walking into or around it, we come to feel at ease in or near it. In this way, we gain a kind of practical knowledge. We gain knowledge about the spaces they occupy as places, or niches or environments.

[9] In an interview, Serra described the piece as follows: 'The plates were laid out at twelve, four and eight o'clock in an elliptical valley, and the space in between forms an isosceles triangle, 152 feet on the long side, seventy-eight and seventy-eight feet on the legs. Each plate is ten feet high by forty feet long by $1^1/_2$ inches thick hot-rolled steel sunk into the incline at an equal elevation' (1973, p. 16).

[10] The aim of philosophy, Wittgenstein held, is the attainment of a 'perspicuous overview' (übersichtliche Darstellung) of a region of grammar or conceptual space. To gain such a perspicuous representation is to gain understanding and to see things aright. My use of the term 'perspicuity' is meant to invoke this idea. Serra's sculptures provide us opportunities to understand the environment we live in by exploring bits of it in order to attain a perspicuous overview where at first there is none.

Figure 4

Tony Smith *Cigarette* 1961. Illustration by Miriam Dym.

The process of exploring the piece is a process of exploring the place. It is like-
wise a process by which we come to understand how experience can be, in this
way, a form of openness to the environment. In light of the foregoing discussion
of perceptual experience as a mode of active exploration of the world, it should be
clear that the process of exploring the art work (and thus the environment in
which it is situated), is at once a process of exploring one's experience of the
world. And the knowledge one thus attains is knowledge of the character of one's
experience.[11]

In this way, Serra's work brings the oscillation between experientialism and
realism to a halt. Perceptual experience is transparent to the world precisely

[11] The dynamic character of the appreciation of the work of art is underscored by Serra in his discussions
of the pieces. Consider further his remarks about Spin Out: 'First you see the plates as parallel; when
you walk left, they move right. As you walk into them, they open up, and there's a certain kind of cen-
trifugal push into the side of the hill. In fact the people at the Kröller-Müller wanted to call the piece
"Centrifugaal" in Dutch. They talked a lot about vorticism. And then when you walk above it, there's
another path which connects the two sides of the valley. . . . There's a ridge which encircles the whole
space at about 150 feet. When you walk on the ridge, there's a contraction and the space becomes ellip-
tically compartmentalized, which you can't see as you walk through it, and it's a different way of
understanding your relation to the place: you're overhead looking down' (1973, p. 16).

because experience is an activity of engagement with the world. To attend to the exploration of the world is thus to attend to the quality of experience. We can think of Serra's work, and that of other experientialist artists, as providing opportunities for first-person phenomenological investigation.

Now there is of course a sense in which one could say of *any* object (and certainly any work of art) that it provides its viewer with an opportunity to reflect on what it is like to perceive it. What I am calling *experientialist art* is art that finds its home in this self-reflective moment. While just about anything can be made the occasion of such a self-reflective act, it is important to notice that not all forms of art and not all artists undertake their activity in this vicinity. We can deepen our grip on what distinguishes Serra's project *as experientialist,* by contrasting his works with those of a superficially similar, and no less important artist, the sculptor Tony Smith (see Figure 4).

There are similarities of scale and material in the work of Smith and Serra — each makes metal sculptures suitable for outdoor installation at least twice the height of a normal person. Smith's work, however, in contrast with Serra's, is utterly non-psychological. Where Serra's works are experimential, Smith's works are *geometrical* or *mathematical.* Smith's sculptures may be compared with what mathematicians call constructive existence proofs. A constructive existence proof demonstrates the existence of a mathematical entity by actually producing a relevant instance. Smith's constructions realize certain ways of combining shapes (e.g. tetrahedrons) in order to fill out space and so demonstrate that it is possible thus to fill out space. The space we learn about when we understand a Smith sculpture is not the space we experience. Rather, it is the objective, abstract space of mathematics.

It is this mathematical character of Smith's work that explains another important feature that places it in direct opposition to that of Serra. Serra's pieces are, as I've emphasized, particulars whose effectiveness depends on their environmental character, their scale and their complexity. They confront a person the way a steep incline on the way home from work confronts a person. In contrast, Smith's pieces are *representative* or universal. A crucial fact about a geometrical construction is that it instantiates in the particular what are in fact wholly universal relations. The particular triangle on which the geometer builds his or her construction stands for all triangles of the relevant kind (equilateral, say). Its particularity does not matter. It is irrelevant to the significance of the demonstration whether it is written in chalk on the board or on pencil and paper, or whether it is drawn to one scale or another. (This is a Kantian point. See Kant, 1787/1929, pp. 576–93.) In precisely this sense, Smith's sculptures have a kind of *immateriality.* That is, their material is immaterial. They are multiply- realizable, lending themselves to reproduction on different scales and out of different materials.[12] They lack site-specificity.[13]

[12] The same cannot be said of Serra's work. Small-scale maquettes of the Torqued Ellipses utterly lack the aura of their full-scale counterparts.

[13] It is interesting to note that if this reading of Smith is right, then Fried (1967/1998) was mistaken to select Smith as an example (indeed, as the example) of 'theatrical art'. Smith's works are self-standing

Serra once wrote that he is not interested in sculpture 'which is solely defined by its internal relationships' (Serra, 1973). Smith said in an interview: 'I don't make sculpture, I speculate in form' (Gossen, 1981, cited in Storr, 1998). These comments brings out the difference between their projects. Smith is concerned precisely with the sculpture of internal relationships, with geometry, with form. Serra's is a sculpture of consciousness.

Conclusion

My aim in this paper has been to propose that we can think of the work of certain artists (but not all) as providing methods for the study of experience. Serra's works, I have suggested, constitute experiments in a kind of phenomenological psychology. A Serra sculpture is an object for us to experience which functions to draw our attention to what we do when we experience it and to how things are with us perceptually. In doing so, I have suggested, the work enables us to appreciate that experience is a mode of direct contact with and exploration of the world. In this way, the works enable us to understand both how experience can be transparent and why its transparency is no obstacle to scientific, philosophical and artistic investigation of experience. Experience is transparent to the world because it is just a mode of active engagement with the world. A phenomenological study of experience is not an exercise in introspection, it is an act of attentiveness to what one does in exploring the world. To reflect on the character of experience, one must direct one's attention to the temporally extended, fully embodied, environmentally situated activity of exploration of the environment. Experiential art enables us to do this.

Acknowledgements
This paper is based on talks presented at the California College of Arts and Crafts in July 1998 and October 1999, at the Getty Research Center in May 1999, and at the meetings of the College Art Association in New York in February 2000. I am grateful to audiences at those meetings for helpful criticism, especially to Patricia Churchland, Tom Crow, David Freedberg, Ellaine Scarry and Barbara Stafford. In addition, several people have read earlier versions of this paper and have helped me to improve it. I would like to thank Miriam Dym, Daniel Guevara, David Hoy, Alexander Nagel, Hans Noë, Lawrence Rinder, Alexi Worth and Erika Belsey Worth. I am very grateful to Miriam Dym for her illustrations of the art works.

wholes; they are concerned with the exploration of objective space (as it were) and not with provoking a reaction in a viewer. In contrast, I have been emphasizing ways in which Serra's work is theatrical. Serra's pieces perform their phenomenological function only as completed by the presence of a spectator. Indeed, Bois (1978, p. 52) has remarked that 'all of Serra's oeuvre is an implicit reply to Michael Fried's text' (cited in Taylor, 1997).

References

Bois, Y-A. (1978), 'A picturesque stroll around *Clara-Clara*', in *Richard Serra*, ed. E-G. Güse (New York: Rizzoli).

Ayer, A.J. (1973), *The Central Questions of Philosophy* (New York: Holt, Rinehart & Winston).

Ballard, D.H. (1991), 'Animate vision', *Artificial Intelligence*, **48**, pp. 57–86.

Brooks, R. (1991), 'Intelligence without representation', *Artificial Intelligence*, **47**, pp. 139–60.

Dennett, D.C. (1991), *Consciousness Explained* (Boston, MA: Little, Brown & Co.).

Fried, M. (1967/1998), 'Art and objecthood', in *Art and Objecthood*, ed. M. Fried (Chicago, IL: University of Chicago Press).

Gossen, E.C. (1981), 'Tony Smith: 1912–1980', *Art in America*, **69** (April), p. 11.

Grice, H.P. (1962), 'Some remarks about the senses', in *Analytical Philosophy*, ed. R.J. Butler (Oxford: Basil Blackwell).

Hume, D. (1740/1978), *A Treatise of Human Nature: Analytical Index by L. A. Selby-Bigge*, Second Edition (Oxford: Oxford University Press).

Irwin, R. (1972a), 'The state of the real. Part I. A conversation with Jan Butterfield', *Arts*, **46**, no. 10 (June).

Irwin, R. (1972b), 'Reshaping the shape of things. Part 2', *Arts* **47**, no. 1 (September).

Kant, I. (1787/1929), *Critique of Pure Reason*, trans. Norman Kemp Smith (London: Macmillan).

Mach, E. (1886/1959), *The Analysis of Sensation*, trans. C.M. Williams (New York: Dover).

Mack, A. & Rock, I. (1998), *Inattentional Blindness* (Cambridge, MA: The MIT Press).

Mackay, D.M. (1962), 'Theoretical models of space perception', in *Aspects of Theory of Artificial Intellegence*, ed. C.A. Muses (New York: Plenum Press).

Mackay, D.M. (1967), 'Ways of looking at perception', in *Models for the Perception of Speech and Visual Form*, ed. W. Wathen-Dunn (Cambridge, MA: The MIT Press).

Mackay, D.M. (1973), 'Visual stability and voluntary eye movements', in *Handbook of Sensory Physiology, Vol. VII/3A*, ed. R. Jung (Berlin: Springer).

Merleau-Ponty, M. (1948/1964), *Sense and Non-Sense*, trans. H.L. Dreyfus and P.A. Dreyfus (Chicago, IL: Northwestern University Press).

Noë, A., Pessoa, L. & Thompson, E. (2000), 'Beyond the grand illusion: what change blindness really teaches us about vision', *Visual Cognition*, **7** (1/2/3), pp. 93–106.

Noë, A. (in press), 'Experience and the active mind', *Synthese*.

O'Regan, J.K. (1992), 'Solving the "real" mysteries of visual perception: the world as an outside memory', *Canadian Journal of Psychology*, **46** (3), pp. 461–88.

O'Regan, J.K. & Noë, A. (under review), 'A sensorimotor account of vision and visual consciousness', *Behaviorial and Brain Sciences*.

Pessoa, L, Thompson, E. & Noë, A. (1998), 'Finding out about filling-in: a guide to perceptual completion for visual science and the philosophy of perception', *Behavioral and Brain Sciences*, **21** (6), pp. 723–802.

Price, H.H. (1940), *Hume's Theory of the External World* (Oxford: The Clarendon Press).

Rinder, L. & Lakoff, G. (1999), 'Consciousness art: attending to the quality of experience', in *Searchlight: Consciousness at the millennium*, ed. L. Rinder (New York: Thames & Hudson).

Serra, R. (1973), 'Document: Spin Out '72–'73: Interview by Liza Bear', *Arts Magazine*, April; reprinted in R. Serra's *Writings Interviews* (Chicago and London: University of Chicago Press, 1997).

Simons, D. (2000), 'Current approaches to change blindness', *Visual Cognition*, **7** (1/2/3), pp. 1–15.

Storr, R. (1998), 'A man of parts', in *Tony Smith: Architect, Painter, Sculptor*, ed. R. Storr (New York: The Museum of Modern Art).

Strawson, P.F. (1979), 'Perception and its objects', in *Perception and Identity: Essays Presented to A.J. Ayer with his Replies*, ed. G.A. MacDonald (Ithaca, NY: Cornell University Press).

Taylor, M.C. (1997), 'Learning curves', in *Richard Serra: Torqued Ellipses* (New York: Dia Center for the Arts).

Thompson, E., Noë, A. and Pessoa, L. (1999), 'Perceptual completion: A case study in phenomenology and cognitive science', in *Naturalizing Phenomenology: Issues in Contemporary Phenomenology and Cognitive Science*, ed. J. Petitot, J-M. Roy, B. Pachoud & F.J. Varela (Stanford, CA: Stanford University Press).

Varela, F.J. & Shear, J. (1999), *The View From Within: First-person approaches to the study of consciousness* (Exeter: Imprint Academic). Published as a special issue of *Journal of Consciousness Studies*, **6** (2–3).

Wittgenstein, L. (1964), *Philosophische Bemerkungen* (Oxford: Basil Blackwell).

Glen Bach *Self Portrait*

Richard P. Taylor, Adam P. Micolich
and David Jonas

Using Science to Investigate Jackson Pollock's Drip Paintings

Abstract: We present a scientific analysis of Jackson Pollock's drip paintings and show that his patterns are fractal. The analysis also shows that he refined the fractal content of his paintings over the period 1943–52. We present a novel interpretation of Pollock's work described as Fractal Expressionism — a direct expression of the generic imagery of nature's scenery.

Introduction

Can science be used to further our understanding of art? This question triggers reservations from both scientists and artists. However, for the abstract paintings produced by Jackson Pollock in the late 1940s, a scientific analysis proves to be an essential tool for investigating the patterns he painted. Pollock dripped paint on to vast canvases rolled out across the floor of his barn. Although recognized as a crucial advancement in the evolution of modern art, the precise quality of the patterns created by this unorthodox technique has, until this year, remained controversial. After fifty years of speculation, a scientific procedure recently has been used by the authors to show that Pollock's swirls of paint are composed of fractal patterns (Taylor *et al.*, 1999a). Here we describe the visual qualities of Pollock's fractal patterns and present the method used to identify and characterize them. We also discuss the extent to which this analysis of his patterns contributes to an assessment of the artistic significance of his paintings.

Fractal Analysis

In contrast to the broken lines painted by conventional brush contact with the canvas surface, Jackson Pollock used a constant stream of paint to produce a uniquely continuous trajectory as it splattered on to the canvas below (Landau, 1989; Varnedoe & Karmel, 1998; Lewison, 1999). A typical canvas would be reworked many times over a period of several months, with Pollock building a

Figure 1. Detail of non-chaotic (top) and chaotic (middle) drip trajectories generated by a pendulum and detail of Pollock's *Number 14* painted in 1948 (bottom).

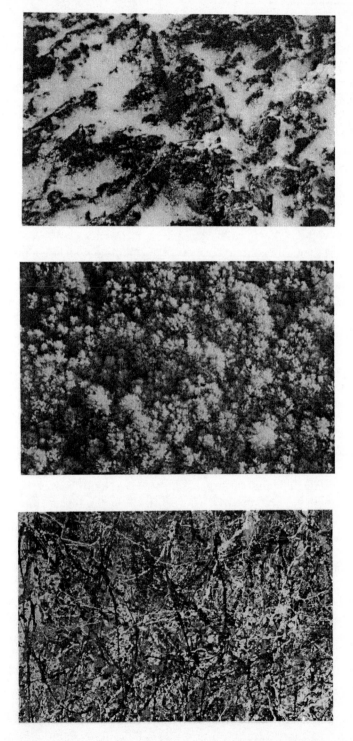

Figure 2. Photographs of (top) a 0.1m section of snow on the ground, (middle) a 50m section of forest and (bottom) a 2.5m section of Pollock's *One: Number 31* painted in 1950

dense web of paint trajectories. This repetitive, cumulative, so-called 'continuous dynamic' painting process is strikingly similar to the way patterns in Nature evolve. Other parallels with natural processes are also apparent. Gravity plays a central role for both Pollock and Nature. Furthermore, by abandoning the easel, the horizontal canvas became a physical terrain to be traversed, and his approach from all four sides replicated the isotropy and homogeneity of many natural patterns (Taylor, 1999, p. 56). His canvases were also large and unframed, similar to a natural environment. Could these shared qualities be a signature of a deeper common approach?

Many of Nature's processes follow a behaviour called chaos, where the motions within the system are extremely sensitive to the surrounding conditions (Gleick, 1987). The above similarities with Nature raise the question of whether Pollock's painting motions were also chaotic. To investigate this possibility, a simple system can be designed to generate drip trajectories where the degree of chaos can be tuned. The system consists of a pendulum which records its motion by dripping an identical paint trajectory on to a horizontal canvas positioned below. When left to swing on its own, the pendulum follows a predictable, non-chaotic motion. However, by knocking the pendulum at a frequency slightly different to the one at which it naturally swings, the system becomes a 'kicked pendulum' (Taylor et al., 1999b). By tuning the kick, chaotic motion can be generated. Example sections of non-chaotic (top) and chaotic (middle) drip paintings are shown in figure 1. For comparison, the bottom picture is a section of Pollock's dripped trajectories.

A striking visual similarity exists between the drip patterns of Pollock and those generated by the chaotic drip system. If both drip patterns are generated by chaos, what common quality would be expected in the patterns left behind? Many chaotic processes form fractal patterns (Gleick, 1987; Mandelbrot, 1977). Whereas chaos theory describes the dynamics of Nature's processes, fractals are the visual record left behind by this chaotic process. Nature's fractal patterns contrast sharply with the smooth surfaces of artificial shapes. Instead they obey a rule called statistical self-similarity. Patterns exist at many different magnifications and, although they are not identical, the patterns observed at the different magnifications all share the same general characteristics (i.e. they are described by identical statistics). It is interesting to note that, although fractals are a generic quality of most natural scenery, it wasn't until 1977 that they were discovered (Mandelbrot, 1977). Previously, it had been assumed that natural objects were disordered and had no pattern at all. It is clear, then, that fractal patterns are a relatively subtle visual phenomenon — one which is not easily detected on a purely 'conscious' level (see later). However, there are visual clues which help to identify the statistical self-similarity of Nature's fractal patterns. The first relates to a quality called 'fractal scaling'. The visual consequence of obeying the same statistics at different magnifications is that it becomes difficult to judge the magnification and hence the size of the pattern being viewed (Taylor, 1997). This is demonstrated in figure 2 (top) and figure 2 (middle) for Nature's fractal scenery, and in figure 2 (bottom) for Pollock's painting. Are these patterns several

millimetres or several metres across? It is hard to judge because of their 'fractal scaling'. A second visual clue relates to 'fractal displacement', which refers to the pattern's property of being described by the same statistics at different spatial locations. As a visual consequence, the patterns gain a uniform character and this is confirmed for Pollock's work in figure 3, where the pattern's spatial density ρ remains constant across the canvas.

These visual clues to the fractal character of Pollock's drip paintings can be confirmed rigorously by calculating a parameter called the fractal dimension D. This parameter was introduced by Benoit Mandelbrot (the mathematician who discovered fractals in Nature) to both identify and quantify the fractal content of a pattern (Mandelbrot, 1977). The basic concept behind the fractal dimension is summarized in figure 4a, where a fractal pattern (middle) is compared to two non-fractal patterns — a line and a filled space. Even though the fractal pattern is essentially a set of one-dimensional lines, the large amount of repeating structure within the fractal pattern causes it to occupy more space than the smooth, one-dimensional line (left) but not to the extent of completely filling the two-dimensional plane (right). By examining the way patterns observed at different magnifications occupied space, Mandelbrot showed that a fractal pattern has a fractional dimension lying somewhere between one and two. This intermediate dimensionality expresses the essence of a fractal pattern — that the pattern's characteristics repeat at different magnifications — and can be detected by analysing the amounts of area that the pattern covers when viewed at different magnifications. If the value of D lies between one and two the pattern is said to be fractal. Furthermore, as the complexity and richness of the repeating structure increases, D moves closer to the value of two. The value of D therefore quantifies the repeating structure of the fractal pattern.

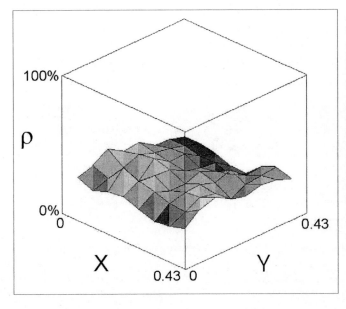

Figure 3. A plot of how the pattern's spatial density ρ changes at different locations across the canvas. The plot is for the painting *Number 14, 1948.* The X and Y labels indicate the locations in the length and height directions respectively. To calculate P at a given location of the canvas, a square of side length 0.05m is drawn at that location. Within this square, the percentage of the canvas area filled by the painted pattern is then calculated.

We calculate D using a well-established technique called the 'box-counting' method, demonstrated in figure 4b (Gouyet, 1996). We cover the scanned photograph of a Pollock painting with a computer-generated mesh of identical squares. The number of squares N(L) which contain part of the painted pattern (the shaded squares in Fig. 4b) is then counted. This count is repeated as the size L of the squares in the mesh is reduced. In this way the amount of canvas filled by the pattern can be compared at different magnifications. The largest size of square is chosen to match the canvas size (typically 2 metres) and the smallest is chosen to match the finest paint work (0.8 millimetres). D values are then extracted from a graph, such as the one shown in figure 5, using the relationship $N(L) \sim L^{-D}$. Although the derivation of this expression is beyond the scope of the present discussion (details can be found in Mandelbrot, 1977 and Taylor, 1999), the straight line displayed in the graph essentially indicates that the patterns at different magnifications (i.e. different L) obey the same statistics. The value of D can be calculated from the gradient of this line. The result of figure 5, therefore, shows that Pollock's drip painting *Number 14, 1948* is fractal and that D = 1.45. For comparison, we note that typical D values for natural fractal patterns such as coastlines and lightning are 1.25 and 1.30.

Our analysis also shows that Pollock refined his dripping technique, with D increasing steadily through the years (Taylor *et al.*, 1999, *Nature*). *Untitled*, one of his first drip paintings of 1945, has a D value of 1.12. *Number 14, 1948* (1948), *Autumn Rhythm: Number 30, 1950* (1950) and *Blue Poles: Number 11, 1952*

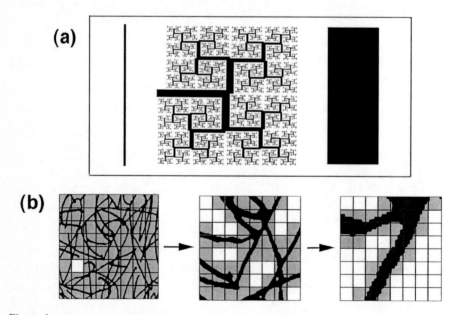

Figure 4.

(a) a comparison of a one-dimensional line (left), a fractal pattern (middle) and a two-dimensional plane (right).

(b) A schematic representation of the box counting technique used to detect the fractal quality in Pollock's patterns. See text for details.

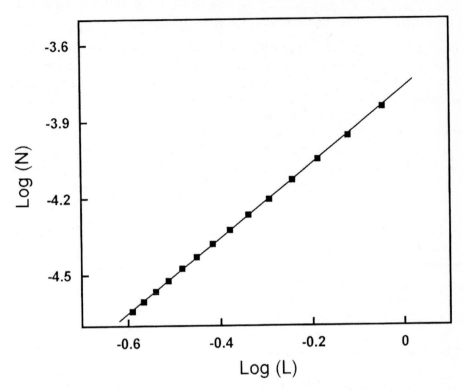

Figure 5. A plot of $\log_{10}N(L)$ versus $\log_{10}L$ for the painting *Number 14.* L is plotted in units of millimetres. The data points are represented by triangles and the straight line is a fit to these data points. For clarity, only every twentieth data point has been shown. Note that the fractal behaviour continues beyond the range of L shown in this graph.

(1952) have values of 1.45, 1.67 and 1.72. In many of his paintings (though not all), he introduced the different paint colours more or less sequentially: the majority of trajectories with the same colour were deposited during the same period in the painting's evolution. To investigate how Pollock built his fractal patterns, we have therefore electronically de-constructed the paintings into their constituent coloured layers and calculated each layer's fractal content. We find that each of the individual layers consist of a uniform, fractal pattern. As each of the coloured patterns is re-incorporated to build up the complete pattern, the fractal dimension of the overall painting rises. Thus the combined pattern of many colours has a higher fractal dimension than those of the individual coloured contributions. The layer he painted first plays a pivotal role — it has a significantly higher D value than subsequent layers. This layer essentially determines the fractal nature of the overall painting, acting as an anchor layer for the subsequent layers which then fine tune the fractal dimension. Remarkably, the fractal analysis of a film sequence recording the construction of this anchor layer indicates that this crucial foundation layer took less than one minute to define (Taylor *et al.,* 2000). The above results emphasize Pollock's systematic approach to the fractal construction process and dismiss a common myth that his work was haphazard and random.

The Context of Fractal Analysis

Whereas fractal analysis has met with spectacular success in the investigation of a diverse range of natural patterns (Mandelbrot, 1977; Gouyet, 1996), our application of the same technique to the painted patterns of 'abstract' art is new. So can science be 'used' to 'understand' Pollock's art in this way? The analysis we have used to look at Pollock's work clearly does not constitute a traditional 'act of observation'. Modernism, whether in science or art, recognizes the importance of the observer — a measurement depends not only on the properties of the object under investigation, but also on the way in which the measurement is carried out (Gribbin, 1993). For example, a painting will be viewed differently by, say, an art historian than by, say, a scientist. Extending this argument, a computer will view a painting in a different way to a person. This is for a number of reasons. A computer's programming — what it 'knows' — will differ from a person and therefore the context of the observation will be different. Also, a computer calculates the parameters of the object in a different fashion. People observe the many different parameters of the painting — e.g. size, shape, texture, colour — at the same time, capturing the 'full impact' of the painting. In contrast, the computer separates information, calculating each parameter in isolation. It is reductionist. Partially as a consequence of these two differences, there are, of course, parameters which a computer can not possibly assess (for example, emotional response, expression, beauty, etc.) but which a human observer might record in response to witnessing the painting. These fundamental differences in observation raise the question that, if art is meant to be observed by a person, is a computer's assessment of an art work valid? Clearly a graph of data produced by a computer analysis of a painting (for example the graph in figure 5) does not replace the painting itself (for example, *Number 14, 1948* shown in figure 1), nor is it the impression that a human observer would record in response to the observation.

So is the computer's observation therefore simply inferior or can its unique qualities add to the knowledge of the painting, particularly when used in conjunction with human observation? Just as viewing a reproduction of Pollock's work within the pages of a textbook cannot hope to capture the full impact of seeing the painting in 'the flesh', so, too, the computer undergoes only a selected experience. The painting's physical characteristics are significant contributing factors in determining its visual impact (Taylor, 1999, p. 95). For example, whether a pattern is formed within a heavily sculpted surface of thick paint rather than a thin layer clearly is important. Similarly, whether the patterns are painted on a canvas which fills the observer's vision as opposed to one which is only several feet wide also has crucial implications for the observer's experience. It is important to emphasize therefore that the computer's fractal analysis does not assess these physical factors. Instead, the technique limits itself to an assessment of the patterns themselves — the way the painted trajectories map out the surface of the canvas rather than their texture, colour, etc. Within this context, the scanning process presents the necessary visual information for the computer to determine if Pollock's patterns are fractal. For example, fractal studies of Nature also often are

based on photographed images. Although a photograph of a natural scene does not record the full impact felt by being present in that environment, it does supply the necessary information to determine if it is fractal. The computer then treats the scanned image of Pollock's canvas as an experimental subject, and in the brief time that his patterns come under this scientific spotlight, the computer employs its superior computing power (it calculates over six million patterns lying within the canvas) and precision (it examines patterns down to sizes of 0.8 millimetres) to determine whether the patterns are fractal.

How crucial is this fractality in assessing the visual character of Pollock's patterns? It turns out to be essential. Computer analysis of art is of course reductionist — it concentrates on individual parameters (see above). It is necessary, therefore, to question whether the fractal analysis is overly reductionist. Does it strip the information down to the extent that the individual parameters have no bearing on the overall painting? In contrast to other pattern detection techniques, fractal analysis is holistic — it looks at how component patterns relate to each other in order to build the whole picture. Furthermore, based on their visual qualities, all patterns can be characterized into generic families and fractal geometry is one such family. Fractality is not, therefore, merely one of a range of parameters which could be used to assess Pollock's patterns. Instead, by assessing fractality, the analysis determines the pattern's generic type — the basic building blocks used to assemble Pollock's swirls of paint. In terms of Pollock's patterns, the fractal analysis is therefore important in determining both what the patterns 'are' (i.e. they belong to the same geometry as Nature's patterns) and also what they look like (see the earlier discussion of 'fractal scaling' and 'fractal displacement', both of which contribute to the visual character of the pattern).

The strengths of the computer analysis technique — precision and objectivity — are highlighted by an intriguing practical application for our work, one which arose from discussions with James Coddington at The Museum of Modern Art in New York: 'It seems to me that all of this overlaps a good deal with traditional connoisseurship where similar patterns of marking are the source of judging authenticity The technique may be identifying the hand of the artist' (Taylor, 1999, p. 160). Since all of Pollock's drip paintings that have been analysed have a fractal composition, this appears to be the trademark of his authenticity — his 'hand' as Coddington describes it. Thus, this raises the possibility of using the fractal analysis to identify fake Pollock paintings. For example, if the analysis identified a newly discovered 'Pollock' painting as being composed of random patterns rather than of fractals, this result would question seriously the authenticity of its origin. Developing this argument one step further, the analysis also may be used to date an authentic Pollock painting. The value of the fractal dimension of Pollock's work rose through the years, following a predictable trend. Charting this progress, it should be possible to determine the fractal dimension of the painting and from this to suggest an approximate date (Taylor et al., 1999, Nature). These intriguing possibilities for further development of the work emphasize the accuracy with which the fractal analysis can identify the 'hand' of Pollock.

These assessments are, of course, limited to 'pattern analysis' and are devoid of any 'artistic judgement'. The computer simply establishes what sort of pattern lies on Pollock's canvas. Previous theories attempting to address the artistic significance of Pollock's patterns can be categorized loosely into two related schools of thought — those which consider 'form' (i.e. the patterns' significance as a new approach to aesthetics) and 'content' (i.e. the subject or message the patterns convey) (Landau, 1989; Taylor, 1999). Clearly, identification of Pollock's patterns as fractal is a vital step for understanding their artistic significance both in terms of 'form' and 'content'. However, it is not the whole story. For example, Nature's patterns are fractal but they are not art. To understand the artistic significance of Pollock's fractals it is necessary to understand Pollock's role in generating them — the 'artistic process'. Therefore, having established what Pollock's patterns 'are', we have to leave the pattern analysis tools behind and interpret his fractal works in terms of what they actually 'mean'. The profound nature of Pollock's contribution to modern art lies, not only in the fact that he could paint fractals on a canvas, but in how and why he did so.

Artistic Implications

The motivation for the fractal analysis discussed in this paper is to characterize Pollock's patterns in the hope that this will stimulate a new debate in terms of their artistic significance. To answer such a question requires a balance between the scientific pattern analysis discussed here and art theory. It requires a bridge between scientific and artistic research. Although the fractal analysis is restricted to quantifying his patterns, it does provide information about how he constructed these patterns. This information provides clues which, coupled with a knowledge of Pollock's history, can be used to interpret Pollock's role in producing the fractals. We briefly will discuss Pollock's role in the light of some of the facts provided by the fractal analysis and also by recent perception studies of fractal patterns (Pickover, 1995; Aks, 1996; Taylor, 1998). We stress that the following discussion concentrates on a few interesting points of speculation and that a fuller assessment of the artistic significance of Pollock's fractals will require a broader discussion than the one presented here.

The first revealing fact is that fractal patterns aren't an inevitable consequence of dripping paint (for example, the drip painting shown in the top image of figure 1 is not fractal). Instead, the fractal analysis indicates that Pollock's fractals were the product of a highly systematic process, one which Pollock refined through the years (as charted by the steady rise in fractal dimension). This systematic process consisted of establishing an anchor layer which determined the paintings fractal content and then adding subsequent layers of paint which fine-tuned the fractal dimension. The analysis showed that the crucial anchor layer was defined within a remarkably quick time frame — within less than one minute. These facts raise fundamental questions, not just in regard to Pollock's role, but also in terms of the limits of human behaviour. How could someone paint such intricate and complex patterns, so precisely, so quickly and do so twenty five years ahead of their

scientific discovery? These facts suggest that Pollock's actions weren't driven purely by conscious deliberation.

In fact, Pollock always maintained that the source of his imagery was the unconscious mind. Of course, Pollock's achievements may not have matched his intentions: just because Pollock believed he was painting from his unconscious doesn't mean he was doing so. However, the frequency with which Pollock expressed this belief means that it should, at the very least, be given some serious consideration. It is also important to stress that his understanding of the unconscious would have been influenced by views prevalent within society at the time of his painting. A narrative of a popular film released at Pollock's peak (*The Dark Past* from 1948) describes the unconscious in dramatic Freudian terms:

> You don't know anything of what happens down here, the unconscious; like the bottom of an iceberg, submerged beneath the sea, it's there, but you don't see it. What's more, the conscious mind, this upper part, absolutely refuses to have anything to do with the lower part. So to keep anything from pushing though, the conscious builds a wall (Leja, 1993, p. 193).

Pollock believed that he could liberate the imagery of his unconscious by exploiting a painting technique called psychic automatism. Developed in the 1920s by the Surrealists, the artists painted rapidly and spontaneously, with such speed that conscious intervention and censorship was thought to be suppressed. In this way, their gestures were regarded as being steered by the unconscious. During this process, the artists viewed themselves as spectators at the birth of their work; like a 'modest recording device' (Ades, 1974, p. 126) or a medium who, instead of providing a gateway to the supernatural, instead connected to the unconscious. However, Pollock also believed that conscious intervention played a crucial role in his painting process. In her 1949 *Life* magazine article on Pollock, Seiberling wrote, 'Once in a while, a lifelike image appears in the painting by mistake. But Pollock cheerfully rubs it out because the picture must retain a life of its own'. She also quoted Pollock's own description of this conscious censorship: 'I try to stay away from any recognizable image; if it creeps in I try to do away with it . . . I don't let the image carry the painting . . . It's extra cargo — and unnecessary.' *Portfolio* magazine re-enforced these ideas in 1951:

> The conscious part of the mind, he says, plays no part in the creation of his work. It is relegated to the duties of a watchdog; when the unconscious sinfully produces a representational image, the conscience cries alarm and Pollock wrenches himself back to reality and obliterates the offending form (Rosenthal, 1951).

Critics have questioned whether psychic automatism can be achieved in reality. For example, Arnheim rejected the idea that the relaxation of conscious control would 'open automatically the resources of wisdom that, according to the romantic version of psychoanalysis, hide the treasure house of the unconscious' (Arnheim, 1953). Arnheim argued that the relaxation of the conscious control released several kinds of actions (motivational strivings, cognitive processes, acquired skills, aimless doodlings and chance operations) with 'fairly disorganized result'. However, as we have seen in this paper, the imagery pouring onto

Pollock's canvas was not disorganized — it was fractal. Whether or not Pollock succeeded in mastering psychic automatism, the speed of his actions suggests they weren't controlled by a purely conscious deliberation. Furthermore, without aligning to any particular model of the human psyche, what is also clear is that his ability to paint such intricate patterns well before they were discovered suggests that his fractal generation process was not a skill he acquired explicitly — he didn't consciously learn how to do it. Instead, this ability was either instinctive or was learnt implicitly (i.e. the skill was acquired in the absence of a deliberate learning procedure). Certainly it seems unlikely, almost impossible, that he adopted the drip technique in order to deliberately paint fractals. Rather we speculate that he started to drip paint with the intention of achieving other artistic goals (Landau, 1989; Varnedoe & Karmel, 1998; Taylor, 2000) but once he started to drip paint, this unintentionally 'triggered' an implicit or instinctive recognition of the fractal imagery pouring onto his canvas.

Given that the natural environment is composed of fractal patterns, an instinctive or implicitly acquired 'appreciation' of these patterns seems a reasonable proposition. Human perception of fractal patterns constitutes a relatively new research field within perception psychology. In a recent survey of people's responses to fractal drip paintings (Taylor, 1998), images similar to those shown in figure 1 were used and people were asked to identify whether fractal or non-fractal paintings were the most 'visually appealing'. The images deliberately were presented as patterns rather than art works so the judgment was based on 'pattern recognition' rather than artistic value. Out of the 120 people questioned, 113 preferred examples of fractal drip patterns. As described earlier, the visual characteristics of fractals are not immediately obvious. When asked why they preferred the fractal patterns, no one could identify the precise visual quality which attracted them. It is interesting to speculate therefore that the choice was not based on an explicit understanding of the patterns' qualities but was based on either an implicit or instinctive pattern recognition process. Although the survey is regarded as highly preliminary, this initial result of over 90 per cent preference for the fractal imagery is significant. Other recent surveys have been conducted to quantify aesthetic preferences for fractal patterns with different D values. In one survey subjects expressed a preference for patterns with a D value of 1.8 (Pickover, 1995), close to the value towards which Pollock's drip paintings evolved (painted in 1952, *Blue Poles: Number 11, 1952* was Pollock's last major drip painting and was characterized by a D value of 1.72). Although a subsequent survey reported a much lower preferred D value of 1.26 (Aks, 1996), this second survey indicated that self-reported creative individuals have a preference for higher D values, compatible with Pollock's quest to paint patterns with high D values. Comprehensive surveys, involving a diverse range of fractal patterns, are planned to further investigate the nature of people's perception of fractal patterns. However, from these initial surveys it is interesting to speculate that Pollock's development towards fractal paintings with high D values was driven by an implicit or instinctive appreciation of Nature's fractal patterns.

Conclusion

We have adapted an analysis technique previously used to identify fractals in natural systems and used it to examine the drip patterns of Jackson Pollock's paintings. In doing so we have established that his painted patterns are fractal. Pollock was not the first artist to attempt to record fractals. For example, amongst others Leonardo Da Vinci and Katsushika Hokusai both attempted to illustrate fractals well before Pollock did (Taylor, 1999, p. 76). Da Vinci drew turbulence in water (*The Deluge*), composing it from swirls within swirls and Hokusai captured a wave crashing on the shore (*The Great Wave*), showing waves within waves. However, these were symbolic representations of fractals. The images are not actually fractal — the repeating patterns can not be described by a fractal dimension. Pollock, on the other hand, didn't simply mimic what patterns in Nature looked like in the way that da Vinci and Hiroshige did but instead used Nature's motion — chaos — in his painting technique and hence generated 'pure Nature' in his paintings (Taylor, 1999, p. 83). His patterns stand as examples rather than imitations of Nature — they can be described by a fractal dimension just like Nature's patterns can. Pollock adopted the same rules of construction as Nature — statistical self-similarity — and hence captured the essence of Nature. As Pollock himself noted, 'Painting is self-discovery. Every good painter paints what he is' (Rodman, 1957, p. 82), concluding, 'I am nature' (O'Connor, 1951, p. 226). Previously Pollock has been described as an Abstract Expressionist. From the work presented here, it is clear that his patterns are far from abstract and therefore a more appropriate description of Pollock is that of a Fractal Expressionist.

References

Ades, D. (1974), 'Dada and surrealism', *Concepts of Modern Art*, ed. Nikos Stangos (London: Thames and Hudson).

Aks, D.J. and Sprott, J.C. (1996), *Empirical Studies of the Arts*, **14**, p. 1.

Arnheim, R. (1959), 'Accident and the necessity of art', *Journal of Aesthetics and Art Criticism*, **16**, p. 18.

Gleick, J. (1987), *Chaos* (New York: Penguin Books).

Gouyet, J. (1996), *Physics and Fractal Structures* (New York: Springer-Verlag).

Gribbin, J. (1993), *Schrödinger's Cat — Quantum Physics and Reality* (London: Corgi).

Landau, E.G. (1989), *Jackson Pollock* (London: Thames and Hudson).

Leja, M. (1993), *Reframing Abstract Expressionism* (New Haven: Yale University Press).

Lewison, J. (1999), *Interpreting Pollock*, (London: Tate Gallery Publishing).

Mandelbrot, B.B. (1977), *The Fractal Geometry of Nature* (New York: W.H. Freeman and Company).

O'Connor, F.V. and Thaw, E.V. (1951), *Jackson Pollock: A Catalogue Raisonné of Paintings, Drawings and Other Works* (New Haven: Yale University Press).

Pickover, C.A. (1995), *Keys to Infinity* (New York: Wiley).

Rodman, S. (1957), *Conversations with Artists* (New York: Devin-Adair).

Rosenthal, G.S. and Zachary, F. (1951), 'Jackson Pollock', *Portfolio*, p. 92.

Seiberling, D. (1949), 'Is he the greatest living painter in the United States?', *Life*, **August**, p. 45.

Taylor, R.P. (1997), 'Jack the Dripper: Chaos in modern art', *Physics World*, **November**, p. 76.

Taylor, R.P. (1999), *Jackson Pollock: Nature, Chaos and Fractals*, Thesis, Master of Art Theory, University of New South Wales, Sydney.

Taylor, R.P. (1998), 'Splashdown', *New Scientist*, **159**, pp. 30–31.

Taylor, R.P., Micolich, A.P. and Jonas, D. (1999a) 'Fractal analysis of Pollock's drip paintings,' *Nature*, **399**, p. 422.

Taylor, R.P., Micolich, A.P. and Jonas, D. (1999b), 'The story of a chaotic pendulum: Where science and art meet', *The Physicist*, **36**, pp. 93–6.

Taylor, R.P., Micolich, A.P. and Jonas, D. (2000), 'The evolution of Jackson Pollock's drip paintings', *Leonardo* (forthcoming).

Varnedoe, K. and Karmel, P. (1998), *Jackson Pollock* (New York: The Museum of Modern Art).

Glenn English

Reframing Consciousness

Review Article

Reframing Consciousness[1] is a collection of sixty-three papers that were presented at the Second International CAiiA Research Conference, 'Consciousness Reframed: Art and Consciousness in the Post-biological Era', at the University of Wales College, Newport, in August 1998. CAiiA stands for the Center for Advanced Inquiry in the Interactive Arts. Many of the presenters in this book are among the foremost people in their fields and several are current or former PhD candidates of the CAiiA programme. Roy Ascott, the editor of the book, is also the founder-director of the programme. Ascott has worked with interactive media and its implications for several decades, and the fact that he is frequently referenced throughout the book suggests that he has had a strong influence on many of its contributors. Considering the fact that decades ago he was dealing with ideas that are currently considered cutting-edge, this seems reasonable.

The subject of this book, the intersection of art, mind, and technology is extremely riveting because of its potential and vitality. Unfortunately, in a book with sixty-three papers, it isn't surprising that many of the papers are more concerned with academic posturing and obfuscation than communication. Too many of them hide behind abstruse language, private jargon, and unexplained references as a way of obscuring the fact that they are making somewhat simplistic observations. This is a shame because those papers will be completely inaccessible to anyone who isn't already very familiar with the ideas that they are contemplating.

However, there are some papers in the book that make an effort to communicate and therefore serve as wonderful introductions to the topics they address. Peter Anders' paper, 'The Cybrid Condition: Implementing Hybrids of Electronic and Physical Space' does a superb job of painting a picture of cybrid architecture (hybrids of physical and cyberspaces). His language is clear and concise, and he provides stimulating and informative ideas about what possibilities his medium potentiates.

[1] **Roy Ascott (ed.)**, *Reframing Consciousness*, Exeter: Intellect Books, 2000; 314 pp., $49.95/£29.95, ISBN: 1841500135 (hbk).

Journal of Consciousness Studies, **7**, No. 8–9, 2000, pp. 151–5

Another excellent introduction is Dew Harrison's 'Mind Memory Mapping Metaphor: Is Hypermedia Cognitive Art?' His approach is honest and communicative. The paper is easy to follow and contains succinct definitions and skilfully articulated background information. The clarity of his knowledgeable presentation illustrates his contemplative mastery of the subject matter. One shortcoming is the final section, in which Harrison falls into the trap of using dated metaphors about right/left brain attributes that cognitive science has since discarded. Romanticization of the right brain in the 1970s lead to many major misunderstandings in the art world. Unfortunately, falsely attributed metaphors of binary opposition in the hemispheres have continued to haunt consciousness studies long after they were discredited.

Roy Ascott, as editor, included his paper, 'Seeing Double: Art and the Technology of Transcendence' which is a well-written and informative introduction to his ideas about reframing consciousness by expanding the sense of self through bio-telematics (technologies that extend our sense of self and help us to act at a distance). His arguments did not entirely convince me that the term 'art' has enough elasticity to withstand his projection of where it should be headed, because he steps so far away from the historical discourse that defines it. Nonetheless, what he proposes sounds like an interesting possibility whether it's art, post-art, or something else altogether.

Missing from Ascott's paper was any acknowledgement of or strategies for negotiating our relationship with the unavoidable commercial intentions and applications of the technologies that he argues are the tools for expanding our consciousness. Without an effective strategy for countering the commercial purposes that structure those technologies, transcendent aspirations are destined to be derailed.

Ascott concluded his paper by saying, 'One thing seems certain, the technoetic principle will be at the centre of art as it develops, and consciousness in all its forms will be the field of its unfolding.' I'm not sure of what would make him feel certain about this. Fine art has been marginalized to the point where many schools, even universities, don't offer classes in it anymore. A minuscule percentage of the world's population concerns itself with contemporary art, and among them only a tiny portion are concerned with techno-art. It seems to me that if the technoetic future that Ascott posits is to be actualized for more than a marginalized handful of people, its thrust will need to be generated from beyond the pale of fine art. Of course, he has been ahead of the crowd in the past, so he might just be right about this too.

Ascott is exceptionally enthusiastic about the artistic potentials of new technologies, to a point that will probably not sit well with some readers. If techno-idealism rubs you the wrong way, this book is probably not for you. As with many techno-idealist manifestos, some of the papers display a glassy-eyed infatuation with technology that evokes comparisons to cargo cults (Pacific island tribes that created religions around modern goods dropped off by cargo planes). Not that that is entirely undesirable — a little unrestrained romantic idealism can be a breath of fresh air in these cynical postmodern times.

Nevertheless, I often found the idealism unbalanced because so many of the papers either barely acknowledged or completely ignored the unavoidable commercial foundations that inform and define the communication technologies being discussed. There were a few exceptions, notably the papers by Paul O'Brien and Clive Myer. Because both of these papers are found toward the very end of the book, there may have been more of an even-handed feel throughout the book if they had been located closer to the beginning.

The majority of the papers have a metaphysical or spiritual bent, which may be a deterrent for many readers. Ascott himself is a techno-shaman and many of the papers cover themes that would most commonly be found in the occult section of the bookstore, such as ESP, remote viewing, and the paranormal. For many people, art devoid of metaphysics and spirituality makes no sense at all, so it is understandable that they would include those concerns in their approach to the subject. In fact, I have never heard a cogent argument for the continued practice of making art if there were no metaphysical, spiritual, or transcendental element. If art is merely useful as some sort of creative methodology to augment scientific discovery, as some would argue, we're going about making and appreciating art in an entirely ineffective manner.

Nevertheless, I do have a problem with the way that spiritual and scientific ideas are mixed in many of the papers, as if there were no difference between the systems. The way that some of them use scientific facts to support their spiritual intuitions is not scientifically meaningful, and invalidates their arguments rather than lending the desired legitimacy. If science is invoked, it only makes sense to employ reasonable attention to the scientific considerations. For example, in Kristine Stiles's paper, 'Parallel Worlds: Representing Consciousness at the Intersection of Art, Dissociation and Multidimensional Awareness', she cites the CIA's research into remote viewing to support her provocative claim that traumatic dissociation can lead to enhanced psychic abilities. The problem is that she fails to mention that the CIA publicly announced that in its years of research, all of their attempts failed and they discovered no evidence of the existence of remote viewing abilities in any of their subjects. Perhaps the CIA was being deceitful and covering up the real evidence, but she offered no such claim.

I use Stiles' omission as an example because it illustrates how important continuity is to scientific evidence. Of course, science is paradigmatically based; I am not claiming that science is not based on assumptions, but it is expected to remain consistent with those assumptions. That's what makes science such a useful system.

However, spirituality and metaphysics do not have the same requirements for continuity, and that is why the papers that mixed the two systems as if they were interchangeable fell apart when care was not taken to identify and accommodate the structural differences of each system. In fact, while contradiction is undesirable (although not always avoidable) in science, it is actually a necessary element of most if not all spiritual systems. For example, consider Kali, the Hindu goddess of creation and destruction, or try to wrap your mind around Christianity's Holy Trinity. Better yet, consider the Tantric practice of squaring the circle. It requires

the practitioner to impose thoughts of squareness (for the same organizational principles that make it the basis of architecture and design) onto thoughts of circularity (because the shape has no beginning, end, or points of differentiation). For the practitioner, this exercise in organizing chaos is a means of balancing the mind. In spiritual systems of thought, contradiction frequently serves as a useful tool for pondering the sublime.

It should be noted that the spiritual practice of contemplating contradictions is epistemically distinct from rationalist traditions such as dialectical materialism because the goal of the former is to accept the paradoxical nature of both beliefs as a method of glimpsing the intangible, rather than resolving them with a tangible synthesis as is the case with the latter. In contrast, dialectical theology, with its emphasis on paradox and unknowability, is an apt example of the nonrationalism that spiritual systems employ.

Another disappointing aspect of the book was that very few of the authors draw on cognitive science research. Notable exceptions are Amy Ione's excellent paper on non-optical imaging and Dr. Mladen Milicevic's paper, 'Consciousness and Music'. Most of the papers that discuss consciousness don't draw on cognitive science as a resource at all. There is an abundance of fascinating, directly relevant information coming from recent research in brain imaging and perceptual studies and it is a tragedy that so few of the authors took time to explore how that wealth of information could help them shape or even reinvent their ideas. Many of the papers are concerned with reframing consciousness with art, but they fail to recognize the paramount importance of learning about how consciousness frames art production and appreciation. Without the benefit of research into the ways that the structure of our minds shapes art, significant progress in reframing the mind through art is shut down. You have to know the rules in order to break them.

I think it might be more productive to read many of the papers in the book as if they were poems rather than academic papers, because a poem is first and foremost responsible for conveying the sublime rather than staying consistent with reason. Perhaps poetry, without allegiance to continuity or reason, is a more effective means of talking about art than academic papers.

Thelonius Monk once said that talking about music is like dancing about architecture. I think this analogy is equally appropriate for talking about any of the fine arts. If art were reducible to words, there would be no reason to make it. Poetry can be an effective way of evoking imagery beyond the lexical, by utilizing the space between the lines. After all, that is where art resides. For example, Rudolph Glanville's paper, 'Acts Between and Between Acts' can best be appreciated as a poem along the lines of Dr. Seuss's *Cat in the Hat*. Consider the first few lines:

We observe observing.

Our observing is not of: it is. If we insist it is of, the it is of observing. We do not observe things. We observe observing. If we insist there should be things to be observed, these things come about through our constructing.

Another criticism that I have of *Reframing Consciousness* is that many of the papers lack visual aids that are needed to complete their meanings. Because of

this, some of the contributions are frustratingly difficult to follow. Part of the problem is that many of the papers were clearly intended as presetations to be accompanied by slide shows or projections of Web pages.

In some respects, it seems an odd choice to have produced the papers in book form at all. Many of them are about the advantages of hypertext over traditional linear formats, so there is a level of hypocrisy in using such a traditional format. Because so many of the papers are about Web-based art projects or refer to Web sites, this book would have been a perfect candidate for new media. Perhaps publishing costs were a major factor, but several recent books and magazines successfully utilize hypertext devices in print form, and it is too bad that this book doesn't.

In fact, much of the copyediting is frustratingly clumsy. There are myriad typos and basic grammatical errors, which often make it difficult to read. Also, it is not laid out in an especially user-friendly format. One frustrating example is that page numbers aren't listed for each paper in the table of contents, which makes it difficult to locate papers by author.

If the reader is already well versed in the sort of literature that frequents the intersection of art, technology, and consciousness, the inaccessible language of many of the papers will be taken in stride, as will the paranormal tangents. Such a reader will probably already know whether or not this is going to be her cup of tea. If the reader has a general background in the areas involved and is looking for an informative introduction to the topics, she will have to decide whether or not it is worth her time to sift through the material to get to the useful pieces. If possible, the most effective strategy might be to attend the conference next time around, because visual aids and an interactive environment would greatly expand the communication of content in most of these presentations.

Then again, the best scenario might be for the proceedings of the next conference to be presented as a hyperlinked Web presentation which would allow the reader to experience and interact with the related projects in a manner that is meaningfully congruous with their subject matter. If that were the case, the ideas would not only transcend the finite circumscriptions of the linear format of the book, they could even continue beyond the parameters of the conference to create an infinitely open and organically expanding resource. I would certainly look forward to such a project with great anticipation.

Michael Coleman

Ranko Bon *Brain–Brand–Hand–Mold–Mind*

Joseph A. Goguen

Visual Space Perception

A Review

This book[1] is a good survey of a large body of important work in the experimental psychology of visual space perception. Although much has been left out, the quality of author's selection is a strong point of the book. I particularly enjoyed the material on Gibsonian psychophysics, which is still unusual in textbooks. I think workers in many fields could benefit from this book, not least those in consciousness studies, philosophy, and art, many of whom may be weak on the facts of vision.

I would have liked to see a little more on the historical development of the subject (for example, Wilhelm Wundt is not mentioned at all, and Hermann von Helmholtz gets only a parenthetical citation), but this would take up more space, and is perhaps asking too much of the author, since the history of a science is a rather different discipline from the science itself. Understandably, there is nothing on color vision, on art as such, or on consciousness. But there is an extensive bibliography, and enough interesting technical material to keep the serious reader busy for quite some time.

While I applaud Hershenson for using Gibson, I also consider that the way he has used Gibson is a bit too limited. The nature of the problem is illustrated by the book's very first sentence, which says

> The study of visual space perception begins with the assumptions that the physical world exists and that its existence is independent of the observer.

Although Gibson would have accepted these assumptions (Gibson 1977; 1979), I think he would also have agreed that they are not the best place to *begin* the study of visual phenomena. So despite its laudable treatment of several Gibsonian topics, this book does not take a Gibsonian perspective. Readers of this issue of *JCS* will have easy access to the introductory essay by Eric Myin (2000), which contains an excellent short review of Gibson's anti-representationalist approach to vision, which questions the interpretation of many classic experiments, because they produce artificially fragmented perceptions.

[1] **Maurice Hershenson**, *Visual Space Perception: A Primer* (Cambridge, MA: The MIT Press, 1998); 248 pp., $23.95, ISBN: 0262581671 (pbk).

Journal of Consciousness Studies, **7**, No. 8–9, 2000, pp. 157–60

My plan for this review is to go further than Gibson himself went, and then use this as a basis for re-examining the starting point of Hershenson's book. While I consider this an exploration of some deeper implications of Gibson's work, I have little doubt that many readers will consider it a significant reinterpretation. I would however emphasize that a strengthened Gibsonian perspective does not undermine the experimental results in Hershenson's book, but only challenges some of their interpretations, especially at the higher, more philosophical levels. Nor do I wish to deny that there is a physical world that is independent of the observer, but instead would advocate trying to proceed without that assumption. One can think of this as a phenomenological approach, although I actually learned this way of thinking from my study of Buddhism; however, I will try to bring out the ideas using a language that is more familiar to students of consciousness.

Let's start with Gibson's notion of 'affordance', which can be seen as an ingenious bridge over the infamous subject-object gap, precisely by *not* assuming the prior existence of a world of objects (or its necessary complementary assumption of a knowing subject). Using a language that is still somewhat dualistic, we might define an *affordance* to be 'a capability for a specific kind of action, involving an animal and a part of its environment'.

For example, a cup provides an affordance for drinking. An affordance consists of the sensory-motor schemata (to use the suggestive terminology of Piaget, though with a different flavour) that support its particular class of actions, such as drinking coffee from a cup. One way to see the importance of this, is to notice that instead of constructing, storing, and then using (massively large and complex) representations of objects, such as cups, from the external world, we rely upon the world to provide us with exactly the information we need, exactly when we need it, in order to carry out actions, such as drinking coffee; this can be seen as an 'offloading' of representation into the world, providing an enormous gain in efficiency, as has been verified in some recent AI research.[2] (Rudolph Arnheim, 1969, who is also not mentioned in Hershenson's book, may be considered another precursor in merging subject and object).

It is clear that subjects can never know objects 'as they are', but only partially, at a particular time, from their own perspective, based on their own capabilities and prior experience. The knowledge associated to an affordance cannot be captured by passive predicates, and even the currently popular paradigm of active perception does not capture its essence; both perception and action are better understood in terms of affordances. Affordances are *tacit* in an essential way: no one can describe accurately and in detail how they actually drink coffee from a cup, but given a cup with coffee, they can do it. Of course, there can be many different affordances for a cup, and even many different affordances for drinking coffee from a cup. But they are all *embodied*, not just in individuals, but also in particular social and physical circumstances; for example, we may drink

[2] See articles in Nehaniv (1998), especially those by Brooks *et al.*, by Dautenhahn, and by Beynon; see also the classic articles of McDermott (1987) and Brooks (1991a,b).

differently from a very hot cup than from a cold one, and differently at a very high-toned party than at breakfast at home.

An affordance only has real existence as a relation between a particular subject and a particular object, at a particular time and place; it does not make sense to separate the subject and object from each other[3] or from the relation, because each only shines forth in view of its participation with the others in that particular occurrence. But it does make sense to take the notion of affordance as free-standing, without reference to either subject or object. Gibson (1977) wrote

An affordance cuts across the dichotomy of subjective-objective and helps us to understand its inadequacy.

But once we have taken this step, we may also begin to have doubts about the notion of an autonomous subject, who exists independently of the world. For is it really clear that there is some core identity that persists through all the changing affordance relations? Or is what we call the subject just a placeholder in those relations?

It was Martin Heidegger (1927) who pioneered the discussion of human being (which he termed 'Being-in-the-world') without the subject-object split. His well-known notion of 'ready-to-hand' is a close relative of Gibson's affordances, more sophisticated philosophically, but with less empirical content. What I wish to suggest is the desirability of bringing together the perspectives of Gibson and Heidegger.

Finally coming back to space perception, it seems that an approach like that sketched above could have significant implications for spatial perception. A starting point would be the observation that seeing involves the deployment of complex sensory-motor schemata that embody important learned relationships; for this reason, spatial perception should be understood in terms of the affordances that are involved in actually doing spatial perception. This of course is Gibson's own approach.

Despite Hershenson's less than fully convincing attempts at neutrality between (weak) Gibsonian and traditional representation-based theories, I think a thoughtful reading of this book will convince most *JCS* readers that Gibson was on a promising path, and I hope that this review will also persuade them that it would be worthwhile considering what it might mean to go further down that path than this book will take them.

References

Arnheim, R. (1969), *Visual Thinking* (University of California Press).

Brooks, R. (1991a), 'Intelligence without reason', *Proceedings of 1991 International Joint Conference on Artificial Intelligence*, pp. 569–95.

Brooks, R. (1991b), 'Intelligence without representation', *Artificial Intelligence*, **47**, pp. 139–59.

McDermott, D. (1987), 'A critique of pure reason, *Computational Intelligence*, **3**, pages 151–60.

Nehaniv, C. (ed. 1998), *Computation for Metaphors, Analogy, and Agents*, Lecture Notes in Artificial Intelligence, vol. 1562 (Heidelberg: Springer).

[3] In Buddhism, this is summarized in principles called 'egolessness of self' and 'egolessness of dharmas', or 'emptiness of self' and 'emptiness of other', and similar phrases.

Gibson, J.J. (1977), 'The theory of affordances', in *Perceiving, Acting and Knowing: Toward an Ecological Psychology*, ed. R. Shaw and J. Bransford (Hillsdale, NJ: Erlbaum).

Gibson, J.J. (1979), *An Ecological Approach to Visual Perception* (Boston, MA: Houghton Mifflin).

Heidegger, M. (1927), *Being and Time*, trans. J. Macquarrie and E. Robinson (Oxford: Blackwell,1962).

Myin, E. (2000), 'Two sciences of perception and visual art,' *Journal of Consciousness Studies*, **7** (8–9), pp. 43–55.

Journal of Consciousness Studies

Volume 11 (2004)

Journal o
Consciousnes
Stud

Volume 11, No.6-7

controversies in science and the humanities

Trusting
the Subject?
Part 2

Journal of
Consciousness
Studies

controversies in science
& the humanities

Volume 11, No.1 (2004)

Are there neural correlates
of consciousness?

'With *JCS*, consciousness studies has arrived'
Susan Greenfield, *Times Higher Education Supplement*

If you've enjoyed this volume of *Art and the Brain*, you may like to have a look at the other two:

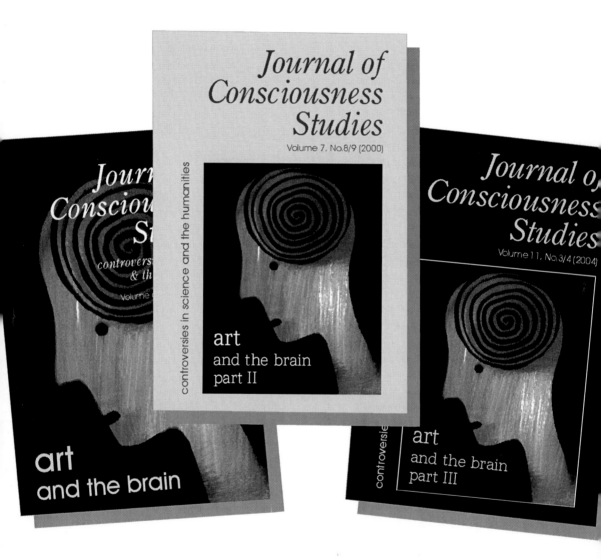

www.imprint.co.uk/art